THE
NATIONAL
GALLERY

VISITOR'S
GUIDE

WITH 10 SELF-GUIDED TOURS

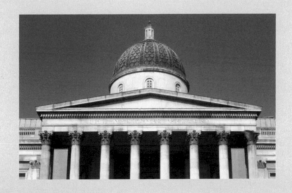

First published in Great Britain in 2009 by
National Gallery Company Limited
St Vincent House, 30 Orange Street
London WC2H 7HH
Reprinted 2010
www.nationalgallery.co.uk
PUBLISHER: Louise Rice
AUTHOR: Louise Govier
PROJECT EDITOR: Claire Young
PICTURE RESEARCH: Maria Ranauro
PRODUCTION: Jane Hyne and Penny Le Tissier

525540
ISBN: 9781857094435

Created and produced for The National Gallery by
IVY CONTRACT LIMITED

CREATIVE DIRECTOR: Peter Bridgewater
MANAGING EDITOR: Claire Saunders
PROJECT EDITOR: Robin Pridy
ART DIRECTOR: Lisa McCormick
ASSISTANT EDITOR: Cynthia McCollum
PROJECT DESIGNER: Bernard Higton
ILLUSTRATIONS: Alan Gilliland

COVER DESIGN: Smith & Gilmour, London

British Library Cataloguing-in-Publication Data
A catalogue record is available from the British Library
This edition printed in Hong Kong by Printing Express

Please note that National Gallery paintings could be moved from
display. Please consult www.nationalgallery.org.uk or ask staff at
the Information Desks around the Gallery to find out if any of the
paintings used in these tours have been moved.

Author acknowledgements
Special thanks to Nicholas Penny, Betsy Wieseman, Jennifer
Sliwka and the Information and Education Teams at the
National Gallery; Jan and Anna Larcombe; and most of all,
to the many National Gallery visitors whose comments,
questions and valuable insights have made exploring these
paintings so interesting.

Foreword

On behalf of Credit Suisse, welcome to The National Gallery.

As Partner of the National Gallery, we're proud to support this guidebook and we hope it serves as a useful companion as you explore one of the world's greatest art collections.

One of the pleasures of a visit to the Gallery is discovering the unexpected, or seeing a familiar work of art in a completely new light. This holds true for the Gallery's most famous works by masters such as Botticelli, van Gogh and Constable, but it applies equally well to works by lesser-known artists throughout the collections. We encourage you to explore them as fully as possible; this book contains self-guided tours to assist you.

Credit Suisse has a long tradition of supporting the arts and our partnership with the National Gallery is evidence of our commitment to the communities in which we work and live. We're especially pleased that the partnership has helped us enrich the lives of hundreds of children who have visited the Gallery and taken part in workshops organised by the youth education philanthropies we sponsor across the United Kingdom.

This guidebook is part of the most comprehensive effort yet to open up the entire Gallery – its buildings, collections and history – to visitors. It is full of fascinating facts and detail, making it ideal not only to use during a visit, but to enjoy afterwards. We hope it will inspire you to return again and again.

Partner of the National Gallery

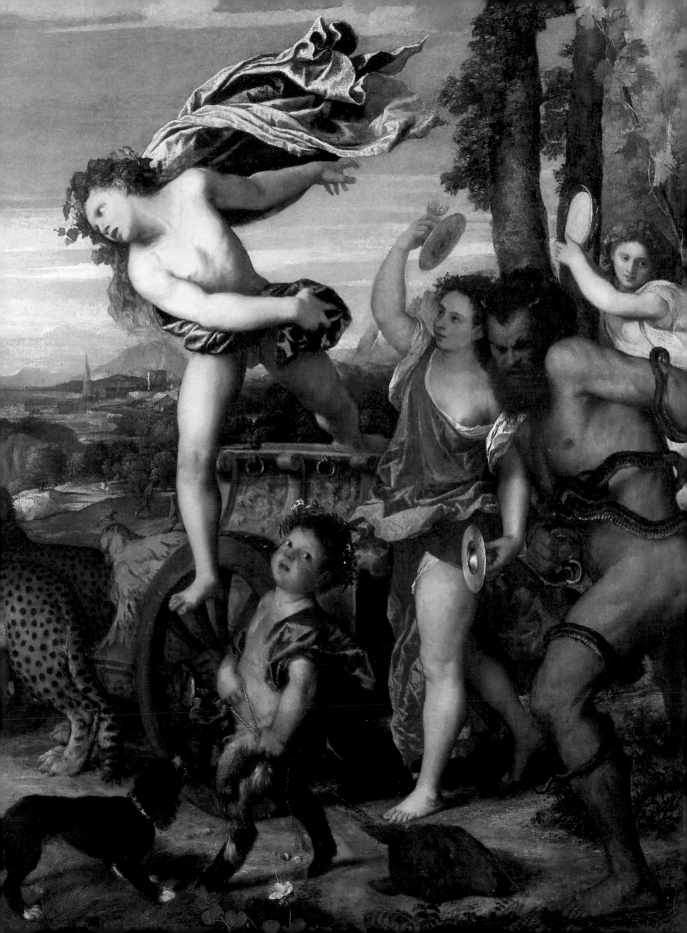

1

Introduction to the Gallery

A National Gallery for all

The National Gallery's aim has always been to give all people the chance to enjoy the best of western European painting. In 1824, the Gallery's founders were keen that Britain should have a world-class collection of Old Master paintings on permanent display. They were also motivated by national pride: Paris had the Louvre, Madrid had the Prado, yet London lacked an equivalent.

Although much esteemed, the Royal Academy of Arts only held exhibitions of contemporary art, while the British Museum's collection focused on antique objects.

The Gallery's founders believed that great paintings from the past would inspire young artists, giving them superb examples to study. They also hoped that such an institution would provide accessible culture to people who might not otherwise encounter it. Some politicians argued that there could be a highly positive social impact if the working classes

| 1800 | 1825 | 1850 | 1875 | 1900 |

1824 The founding collection
The House of Commons agrees £57,000 for the purchase of 38 paintings that had belonged to the Russian banker John Julius Angerstein: these were to form the nucleus of a national collection. Bequests by Sir George Beaumont (1828) and Reverend Holwell Carr (1830) added another 55 paintings.

1840–50 Trafalgar Square is completed
Sir Charles Barry's scheme for the development of the square includes an upper terrace next to the Gallery, linked to a lower square by a staircase. Nelson's Column is erected in 1843.

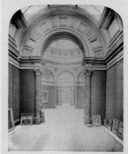

1876 Expanding the new building
After public criticism of Wilkins's building, the architect E M Barry is asked to submit designs for rebuilding the entire Gallery. After much discussion, it is decided that the existing building should remain, and a new wing be added. This is completed in 1876. See pp. 98–9 for more.

1911 New additions
Trustees battle for a long time to secure expansion space for the Gallery. Despite the barracks at the rear of the Gallery being gutted in 1901, it isn't until 1911 that new galleries in its place are opened to the public. See pp. 98–9 for more.

1824 Displaying the collection
The pictures are first displayed in Pall Mall, London, in the house of the late John Julius Angerstein.

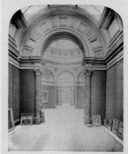

1831 Finding a site
The growth of the collection and public criticism of the Pall Mall building – which is compared unfavourably with other national art galleries and ridiculed in the press – leads to the decision to construct a purpose-built gallery. In 1831, Parliament agrees to construct a new building, designed by William Wilkins, at Trafalgar Square. See pp. 96–7 for more.

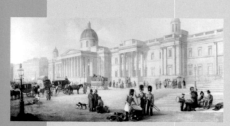

1838 The National Gallery is opened by Queen Victoria
The Royal Academy of Arts occupies the East Wing and the National Gallery the West Wing. A grand central staircase divides them. The Royal Academy moves to a new building in Piccadilly in 1869, leaving extra space for the National Gallery.

1896–7 The National Portrait Gallery moves, Tate Gallery opens in Millbank, London
The National Portrait Gallery, opened in 1857, finds a new home behind the National Gallery in 1890; its new building opens in 1896. The Tate Gallery opens the following year to house the National Gallery's British paintings as well as Sir Henry Tate's own collection.

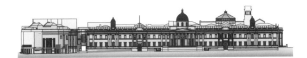

The front elevation
Despite initial public criticism of the building, today the National Gallery is a much-loved feature of the London landscape.

were exposed to the wonders of art, and were also able to mix freely with the middle and upper classes. Museums were increasingly seen as civilising spaces; indeed, it was suggested by a Parliamentary Bill of 1834 that museums should 'draw off by innocent pleasurable recreation and instruction, all who can be weaned from the habits of drinking'.

Of course, this aim was not always achieved – early accounts by some visitors to the National Gallery describe them having picnics on the floor, allowed to eat in the building because they had offered a drink of gin to the policeman on guard duty! However, the hope that access to art might improve the lives of ordinary people was a sincere one, and it provided the basis for an art gallery that was designed to be for everyone.

These pages provide an introduction to the Gallery, from its sculpture and mosaics to a short history on how the collection and the building itself has progressed. For more on the Gallery's history, funding and future, see pp. 96–106.

1925	1950	1975	2000	2025

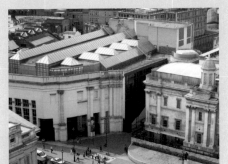

1928–33 Mosaics
The National Gallery commissions Boris Anrep to lay mosaic pavements in the vestibule of the Main Hall to illustrate *The Labours of Life* and *The Pleasures of Life*. In 1952, Anrep lays a third pavement in the vestibule, depicting *Modern Virtues*. See pp. 8–9 for more.

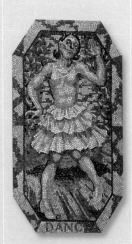

1991 The Sainsbury Wing
In 1985 Lord Sainsbury of Preston Candover and his brothers The Hon Simon Sainsbury and Sir Timothy Sainsbury generously agree to finance the construction of a new wing for the Gallery. The Sainsbury Wing opens in 1991, to display the entire Early Renaissance collection. See p. 102 for more.

1975 The Northern Extension
The Northern Extension opens, providing considerable extra exhibition space: nine large rooms, and three smaller 'cabinet' rooms. See pp. 98–9 for more.

2004–6 Development of the East Wing Project
This project begins with the opening of the Sir Paul Getty Entrance, which makes the main building accessible to the public at street level directly from Trafalgar Square for the first time. The second stage of the project involves the redevelopment of the Main Entrance Hall and restoration of the original nineteenth-century J D Crace ceiling decoration in the Staircase Hall. See p. 103 for more.

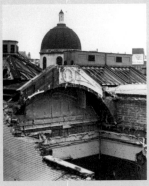

1939–45 World War II
During the War the entire collection is evacuated to a slate quarry at Manod in Wales, and the Gallery suffers bomb damage in 1940. See pp. 100–1 for more.

7

Sculpture and mosaics

Although the National Gallery's purpose is to display paintings, the building itself offers all sorts of sculptural and decorative delights. It's always worth looking up to the ceilings and down at the floors – some of the best surprises lie beneath visitors' feet.

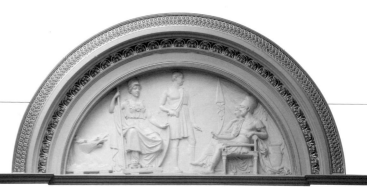

Below left: A statue of George Washington (1732–1799) stands on the front lawn of the National Gallery.

Above: Lunette showing the ancient sculptor Phidias presenting a statue to Pericles.

Sculpture

William Wilkins had planned sculpture to decorate the outside of the National Gallery, but in order to save money he was instructed to use statues originally made for John Nash's triumphal gateway, Marble Arch. Designed by John Flaxman and mostly executed by John Rossi, these sculptures had been intended to commemorate the naval and military successes of Nelson and Wellington, but Wilkins was forced to adapt them. The female figures over the Getty Entrance and West (staff) Entrance were originally personifications of victory. The weapons they held were taken away, and they were given olive wreaths as a sign of peace; those over the Getty Entrance were given paintbrushes and other artistic tools to hold. On the Gallery's front lawn are two statues: James II (1633–1701; bronze, 1685) to the west of the Portico Entrance, by British sculptor Grinling Gibbons; and

George Washington (1732–1799; bronze, 1921) to the east, which apparently stands on soil imported from the United States, and was a gift from the state of Virginia.

Look up when walking around the Gallery's interiors and you'll see sculptural busts of great artists from the past. In the Central Hall, Rembrandt, Leonardo and Correggio look down from their positions above the doors, as do Titian, Raphael and Rubens.

The Old Masters are joined by British painters in the roundels beneath the dome of Room 36; the suggestion is that Britain has now produced artists who can stand alongside the Continental greats. Plaster reliefs in the lunettes around the dome depict the major visual arts: architecture, shown by Michelangelo presenting a model of St Peter's to Pope Julius II; sculpture, represented by the ancient Greek sculptor Phidias; and painting, personified by Raphael receiving a patron in his studio. The fourth lunette, of beauty, displays a bust of Queen Victoria accompanied by cherubs holding elements from Hogarth's *The Analysis of Beauty* (1753).

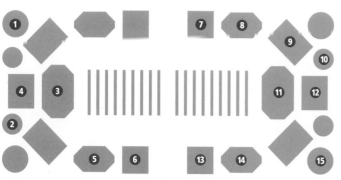

Plans of the Anrep Mosaics

West Vestibule: The Labours of Life (1928)

East Vestibule: The Pleasures of Life (1929)

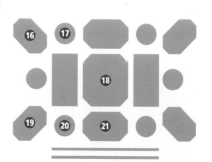

North Vestibule: The Modern Virtues (1952)

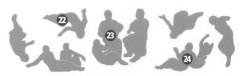

Landing: The Awakening of the Muses (1933)

The Anrep mosaics

The mosaics decorating the entrance spaces behind the Gallery's Portico were created by charismatic Russian artist Boris Anrep between 1928 and 1952. Anrep was a great character whose life experiences included Resistance work in occupied France and competing in the men's doubles competition at the Wimbledon tennis tournament. He said that the idea to decorate the Gallery's floors came from seeing pavement artists working outside in Trafalgar Square. The Director and Trustees of the Gallery supported his plan, and he spent a quarter of a century on the project.

The finished works combine ancient mosaic techniques with contemporary subject matter. Anrep did much of the work himself, as well as employing fellow Russian refugees, and included portraits of many of his artist and writer friends.

For features to look out for, see the panel below.

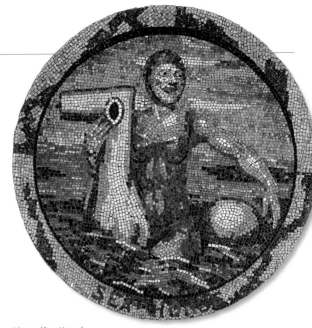

Above: 'Sea-Horse' in *The Pleasure of Life* (1929) on the floor of the East Vestibule.

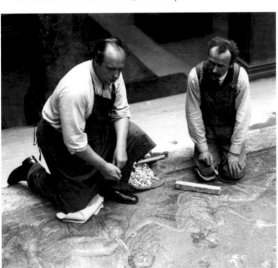

Left: The mosaicist Boris Anrep (left) at work, 1933.

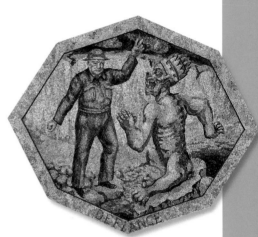

Right: 'Defiance' at the centre of *The Modern Virtues* (1952) in the North Vestibule.

The Labours of Life
Idiosyncratic choices from Anrep include:
1 Theatre;
2 Music, and;
3 Sacred Love. All appear as labours, while Dance (14) is included as a pleasure. Other labours include:
4 Art (a sculptor modelling a statue);
5 Engineering (a man working an electric drill);
6 Farming (a woman washing a pig).

The Pleasures of Life
7 Cricket;
8 Speed (a girl on a motorbike; this excited much comment from the 1920s public);
9 Contemplation;
10 Christmas Pudding;
11 Profane Love (a man and two girls);
12 Conversation;
13 Football;
14 Dance (a girl dancing the Charleston);
15 Sea-Horse (a girl playing in the sea).

The Modern Virtues
For this scheme, Anrep selected qualities that he considered important in modern society at the time. The mosaic also incorporates portraits of famous people, and includes many eminent public figures. These include:
16 Sixth Sense, featuring the poet Edith Sitwell;
17 Lucidity, represented by philosopher Bertrand Russell, who is shown plucking a mask from the figure of Truth.

18 Defiance, represented as Sir Winston Churchill standing before the white cliffs of Dover, defying an apocalyptic beast in the form of a swastika;
19 Delectation, showing ballerina Margot Fonteyn listening to writer The Hon Edward Sackville-West playing the harpsichord;
21 Compassion, personified by Russian poet Anna Akhmatova, surrounded by the horrors of war and visited by an angel.

20 The mosaic includes a picture of the tomb of the artist himself, which displays his sculptor's tools, his profile and the inscription 'Here I lie'.

The Awakening of the Muses
22 Melpomene, muse of tragedy, here depicted as the film star Greta Garbo;
23 Bacchus, god of wine, depicted as art critic Clive Bell;
24 Clio, muse of history, personified as writer Virginia Woolf, with pen.

Development of the collection

 Although John Julius Angerstein and Sir George Beaumont (left) laid the foundations of the collection, further important bequests and acquisitions have remained crucial to the success of the Gallery. The nineteenth century saw bequests from Reverend Holwell Carr and Wynn Ellis as well as an important acquisition of mainly Dutch and Flemish paintings by Director William Boxall.

In the twentieth century, bequests and acquisitions were still vital, and were accomplished under adverse conditions when necessary. In March 1918, Paris was under German bombardment, with a real fear that France might fall – yet a collection of unimaginable worth was up for sale, that of the late painter Edgar Degas. The Gallery's purchase grant had been suspended on account of the War, but painters Duncan Grant and Vanessa Bell urged economist Maynard Keynes to pursue the sale. Keynes managed to persuade the

1800	1850	1900

- ● **Blue dates** denote Bequests
- ● **Red dates** denote Acquisitions

1828 Sir George Beaumont's gift includes Rubens's *A View of Het Steen*, 1636, and Canaletto's *The Stonemason's Yard*, 1727–8. His favourite painting, Claude Lorrain's *Hagar and the Angel*, 1646, which he often carried with him when travelling, is also donated.

1853 Sir Charles Eastlake is appointed as the first National Gallery Director.

1856 Turner bequest leaves paintings, drawings and watercolours, including *Calais Pier*, 1803 (pictured), to the nation.

1910 The Salting bequest is the largest to date, with 192 paintings given to the National Gallery – 164 of these are retained.

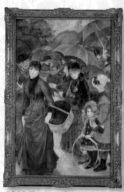

1830 Reverend Holwell Carr dies, having bequeathed 39 paintings to the Gallery, including Guido Reni's *Saint Jerome*, 1624–5 (pictured), and Tintoretto's *Saint George and the Dragon*, about 1560.

1876 The Wynn Ellis bequest includes mainly Dutch paintings.

1918 The Lane bequest provides 33 Impressionist paintings, including Renoir's *The Umbrellas*, 1881–6 (pictured). The bequest is shared with the Hugh Lane Gallery in Dublin, Ireland.

1824 The Gallery purchases 38 paintings that had belonged to the Russian banker John Julius Angerstein, including: *The Raising of Lazarus*, 1517–9, by Sebastiano del Piombo; *Pope Julius II*, 1511, by Raphael; Rembrandt's *The Woman taken in Adultery*, 1644; and Hogarth's *Marriage-A-la-Mode*, about 1743.

1897 Foundation of Tate Gallery (many of the Gallery's British paintings move there).

1871 Director William Boxall makes his most spectacular acquisition when, in 1871, 77 paintings from the Peel collection are bought for £75,000. These consist mainly of Dutch and Flemish paintings, including Hobbema's *The Avenue at Middelharnis*, 1689, and Rubens's *'Le Chapeau de Paille'*, 1622–5 (pictured).

1843 By the end of the year, the collection has just under 200 paintings.

1905 The Art Fund is instrumental in purchasing Velázquez's *'The Rokeby Venus'*, 1647–51, by raising £45,000 to outbid other buyers.

PAINTINGS IN THE COLLECTION

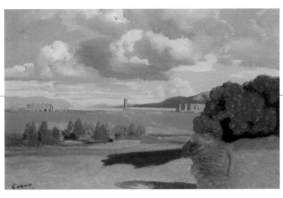

Left: *The Roman Campagna*, 1826, by Jean-Baptiste-Camille Corot (1796–1875). Bought at the Degas sales (with a special grant) in 1918, by National Gallery Director Sir Charles Holmes.

Government to make a grant of £20,000. To avoid being recognised at the sale, Gallery Director Sir Charles Holmes shaved off his moustache, donned spectacles, and proceeded

to make the journey by sea, 'with escorting destroyers and a silver airship watching overhead', and entered Paris by rail across war-torn Europe. He purchased several Impressionist masterpieces, as well as some important sketches.

After World War I, Industrial heir Samuel Courtauld's 1923 fund and the 1924 Mond bequest substantially added to the Gallery's collection. The generosity of donors continues today, with new bequests and long-term loans from supporters such as Sir Denis Mahon and The Hon Simon Sainsbury.

1950

2000

1924 Mond bequest is the Gallery's second-largest bequest, with 42 paintings.

1923 Samuel Courtauld gives £50,000 for the purchase of Impressionist and Post-Impressionist pictures for the British national collections.

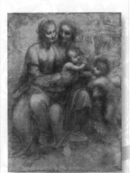

1962 Leonardo da Vinci's *Virgin and Child with Saint Anne and Saint John the Baptist*, 1491–1508 (pictured), is bought with help from The Art Fund and public donations. Once purchased by the Gallery, a quarter of a million visitors see it in four months, many making donations.

1999 Denis Mahon loan: the distinguished art historian and collector, and former National Gallery trustee, places on long-term loan 28 works from his collection of Italian Baroque paintings. Among them are masterpieces by Guercino, Guido Reni, Domenichino, Luca Giordano and Johann Liss.

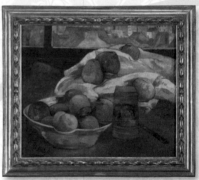

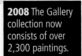
2008 The Gallery collection now consists of over 2,300 paintings.

2006 The Simon Sainsbury bequest leaves five paintings to the National Gallery. These include: two Monets, *Snow Scene at Argenteuil*, 1875, and *Water-Lilies, Setting Sun*, about 1907; and Paul Gaugin's *Bowl of Fruit and Tankard before a Window*, about 1890 (pictured).

2004 Raphael's *The Madonna of the Pinks*, 1506–7 (pictured), is bought with the assistance of the Heritage Lottery Fund, The Art Fund (with a contribution from the Wolfson Foundation), the American Friends of the National Gallery, the George Beaumont Group, Sir Christopher Ondaatje and through public appeal.

BEQUESTS AND ACQUISITIONS

Nearly a quarter of the paintings now in the National Gallery are bequests or gifts from private individuals. After Charles Eastlake was appointed National Gallery Director in 1853, guidelines for purchases were set up and, for the first time, the Gallery had a suitable acquisitions policy. For further information on funding and acquisitions, see p. 104 and 'Learn more and support your Gallery' on pp. 108–9.

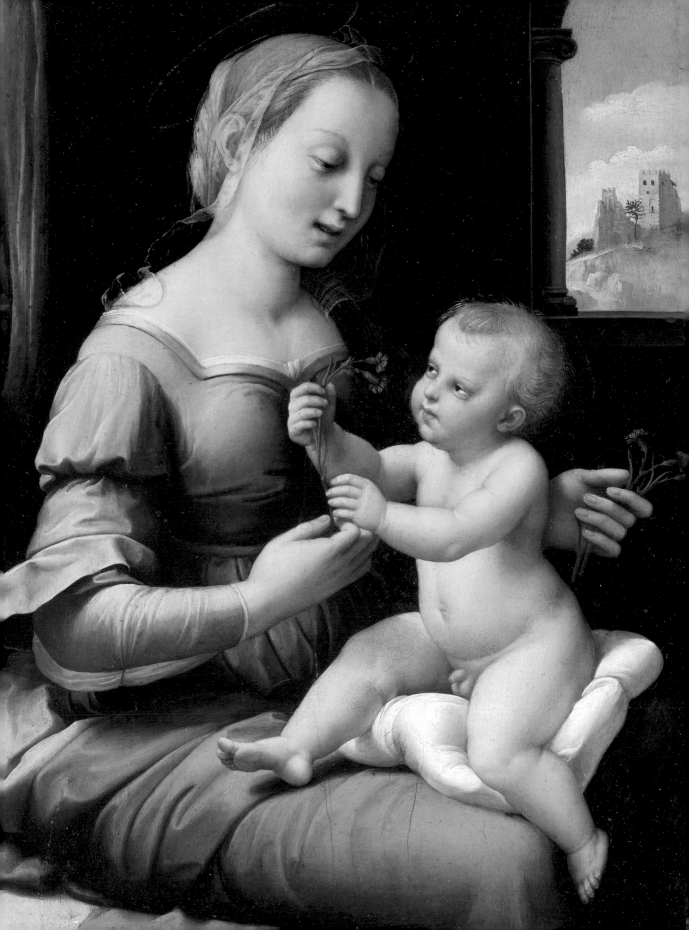

2

The Collection

Introduction to the collection

Some of the most iconic paintings in the world can be found in the National Gallery. The best of western European painting is here, from glittering altarpieces and Old Master portraits to rapidly painted Impressionist oil sketches.

How is the collection organised?

Paintings in the National Gallery are hung in broad chronological order, from artworks produced in the 1250s to pictures from the early twentieth century. This seems to be the most logical way to display a collection that, from the start, was designed to be a survey of western European painting. It doesn't try to suggest that art history is a neat progression from A to B. There is no set route to follow, and visitors can explore in different directions from most rooms, making their own connections and heading towards what catches their eye next.

Hang them high

In the earliest days of the National Gallery, paintings were hung in several rows stretching to the ceiling, creating walls seemingly covered with a patchwork of gold frames. Now, the Gallery's display tries to allow for more space around each work, making it easier for visitors to look at individual pictures as well as take in the overall effect.

Above: *A Party of Working Men at the National Gallery* (detail), E J Brewtnall, about 1870.

Exchanging ideas

Sometimes, pictures produced in the same city or country are hung together, to reveal what was happening in a certain place during one period. The same can be done with artworks made at the same time but in different locations. This shows both similarity and divergence in art production across Europe, and reminds us how new ideas could be exchanged.

Different versions of the same subject also show how quickly new developments could begin. The Gallery has paintings of *The Agony in the Garden* by brothers-in-law

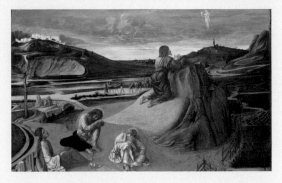

Andrea Mantegna and Giovanni Bellini, painted within a few years of each other. Both artists depict Christ's lonely night of prayer, his disciples fast asleep as he alone faces visions of his future. Mantegna's scene is carefully constructed – every strata of rock, fold of cloth and towering turret are placed to create an almost sculptural setting. In contrast, the younger painter Bellini was more interested in naturalism, recreating a very believable dawn sky and more realistic distant cliffs.

Above: *The Agony in the Garden*, about 1465, Giovanni Bellini.

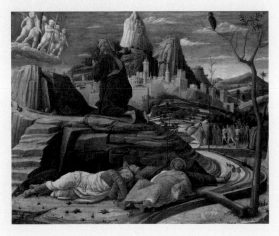

Left: *The Agony in the Garden*, about 1460, Andrea Mantegna.

> Personally, I experience the greatest degree of pleasure in having contact with works of art. They furnish me with happy feelings of an intensity such as I cannot derive from other realms.
>
> Albert Einstein

A gallery of four quarters

1250 to 1500
This period includes the earliest gilded Renaissance altarpieces and van Eyck's incredibly life-like portraits, as artists from the Netherlands and Italy developed naturalistic painting techniques.

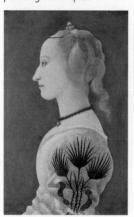

Portrait of a Lady, probably 1465, Alesso Baldovinetti.

1500 to 1600
From the famous trio of Leonardo, Michelangelo and Raphael to vibrant Venetian artists such as Titian, this period also includes extraordinary portraits by Holbein for the court of Henry VIII.

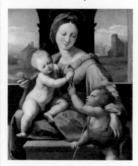

The Garvagh Madonna, about 1509–10, Raphael.

1600 to 1700
From Caravaggio's dramatic realism to peaceful Dutch landscapes and still lives; from Rembrandt's portraits, to Rubens's fleshy nudes, van Dyck's sumptuous portraits and Velázquez's kings and kitchen maids.

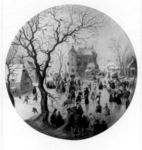

A Winter Scene with Skaters near a Castle, about 1608–9, Hendrick Avercamp.

1700 to 1900s
This period reveals Canaletto's views of Venice, Gainsborough's English portraits, the iconic landscapes of Turner and Constable as well as the French Impressionists and beyond.

Lake Keitele, 1905, Akseli Gallen-Kallela.

FACTS AND FIGURES

The smallest painting is the Gallery's *Prince Charles Edward Stuart (The Young Pretender)*, at:

The total floor area, equivalent to approximately six football pitches, is:

The largest painting in the National Gallery collection is Guido Reni's *The Adoration of the Shepherds*, at:

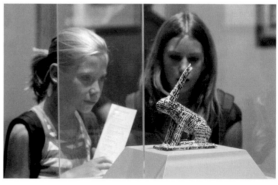

Themed displays
Art on the same subject made hundreds of years and miles apart is often brought together to reveal a theme. The temporary exhibition *Love* (2008), juxtaposed Old Master paintings with modern explorations of love, such as the ceramic hare, shown above, by British artist Grayson Perry. Look out for these exhibitions in the Sunley Room or Room 1.

Painting 1250 to 1500

The biggest idea that developed in painting from 1250 to 1500 was naturalism, the move to make realistic representations of people and places. You'll see a marked difference between the stylised faces and folds of cloth in the earliest Italian works, which were influenced by Byzantine art, and the breathtaking naturalistic illusions created by fifteenth-century Netherlandish artists such as Jan van Eyck.

them. However, naturalism didn't dominate the art world completely – some societies (for example, Siena, Italy, in the mid to late fifteenth century) still valued the way that jewel-like colours and rich gold patterning could honour their favourite saints, and they frequently opted for less realistic and more stylised decorative effects.

Local ties, international connections

Europe during this period was made up of many small city states, principalities and kingdoms, some of which were then controlled by more powerful rulers such as the Pope and the Holy Roman Emperor. Medieval Europe was dominated by the Catholic Church and the feudal system: kings granted estates to key noblemen in exchange for military service; knights fought for these noblemen and received smaller parcels of land, farmed by peasants. The Church sought to control secular rulers, which led to increasing conflict; merchants based in cities gradually grew in wealth and claimed their places in governmental structures.

Different courts developed their own distinctive styles, as local craft and trade organisations maintained standards and advanced ideals, but there was also a great deal of communication between cultural and political centres. Small panel paintings were easily transportable, and leading artists travelled, too, lured by the promise of rich rewards from cultured patrons who wanted to enhance their status by employing the best craftsmen available.

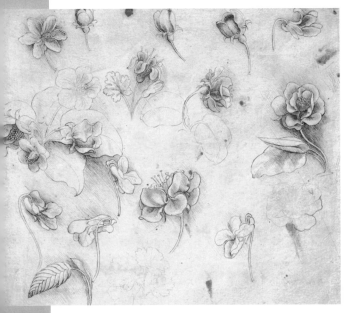

Flower Studies (detail), about 1483, Leonardo da Vinci.

The shift towards more realistic painting started in religious imagery, as influential monastic orders began to change devotional practices and saw what a vital role life-like pictures could play in telling Christian stories and encouraging prayer. From around 1400 onwards, it became more socially and morally acceptable to commission independent portraits to commemorate those who were absent through travel or death. Having a convincing likeness was crucial for those left behind, who believed that the paintings contained something of the sitter's soul, and felt a more direct connection to them as they prayed for

Workshop practices

Nearly all art from this period was produced by workshops, where groups of artists collaborated to fulfill commissions. Each was headed by a master, often the person whose name we give as the main artist. They might create or approve the design, and do some of the painting, but sometimes significant amounts of the painting and gilding would be done by apprentices and associates. Many workshops produced sculpture, metal and glasswork as well as panel painting, and artists were often consulted as engineers.

The Virgin and Child, 1475–1500, Workshop of Sandro Botticelli. This workshop version may derive from a Botticelli original, now in the Louvre, Paris.

Many panel paintings from the fourteenth and fifteenth centuries were decorated not just with brilliant colours, but also with real gold and silver. Gilding created a dazzling visual effect that both honoured the saints depicted and demonstrated the wealth and piety of the patrons who had paid for the panels. It is particularly associated with Italian paintings, but Netherlandish, Spanish and German artists all used gilding on major altarpieces.

Gold leaf
This was made by specialist gold beaters, who hammered coins until they were so thin that they were slightly transparent.

Applying and burnishing the gold
On Italian panel paintings, the area to be gilded was usually covered with a cushioning layer of bole, a greasy red-brown clay. Water or oil was brushed onto the bole to increase its stickiness, then slightly overlapping squares of gold leaf were floated on top. They were so thin that they settled in small wrinkles that needed to be smoothed out by burnishing, or rubbing carefully with a piece of very smooth stone such as amber, or a dog's tooth. This also gave the gold a highly polished appearance.

Incised and punched patterns
Tools were used lightly to press shapes and lines into the gilded surface, their marks retained by the backing layer of bole. These indentations could distinguish details such as halos from gilded backgrounds (seen in a detail of Francesco di Giorgio's *Saint Dorothy and the Infant Christ*, about 1460, right), or give surface interest to large areas of gold. Each of the 48 saints on the San Pier Maggiore altarpiece has a halo of a different design.

Sgraffito
This term means 'scratched' in Italian. The effect of gold thread in textiles was often created using this method. Egg tempera paint was applied over burnished gold leaf, and then scraped away in intricate patterns to reveal the gold, as seen in this detail on Saint Edmund's robe, from the *Wilton Diptych*, about 1395–9, far left.

Shell gold
This was powdered gold that could be mixed with a binding agent and used as paint. It was produced in tiny amounts as needed, the mixture traditionally held in mussel shells. Seen here, above left, is a detail of shell gold used for the robes in Duccio's *The Transfiguration*, 1311.

Revived interest in antiquity
Architecture, sculpture, coins and texts from the ancient civilisations of Greece and Rome had never been completely forgotten; however, they were the subject of increasing interest from the fourteenth century onwards. As scholars, collectors and artists began to debate the ideas behind antique culture, and what they might mean for their own changing world view, more stunning examples of classical sculpture in particular were being unearthed. Fewer ancient paintings survived, but classical literature describing pictures made it clear that naturalistic illusions were highly prized.

What kinds of art were made?
At the start of this period, almost all European art was religious. The panel paintings in the National Gallery were usually part of larger works, altarpieces designed for religious devotion, either in a church or at home. Realistic painting was first developed to help people understand Christian teaching, and to enable them to empathise with the saints to which they prayed. Increasingly, pictures were filled with believable people, buildings, plants and landscapes. These eventually began to be painted as subjects in their own right. Portraits and depictions of classical myths were the most popular types of secular (non-religious) art to begin with.

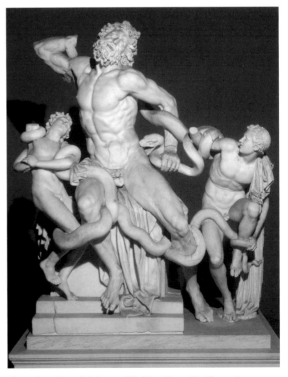

Above: *Laocoön and his Sons*, c.160–20BC, Museo Pio-Clementino, Vatican City, attributed to Agesander, Athenodoros and Polydorus.

Chronology of painting 1250 to 1500

1250	1300	1350

ART PERIODS AND STYLES

330 to 1453 Byzantine This style was associated with the Eastern Roman (Byzantine) Empire, which spread to Italy. The faces of Christ, the Virgin Mary and saints in icons were unrealistic masks and they inhabited glittering golden heavens, deliberately unlike our own mortal world.

About 1150 to 1450 Gothic This word was used to describe much medieval art and architecture. Initially a negative term, seen as uncivilised compared to later Renaissance art, in fact, 'Gothic' describes some very beautiful buildings and objects, which often use elegant pointed arches, intricate patterns, rich colours and gold to honour Christian saints.

Coronation of the Virgin, detail, 1370–7, attributed to Jacopo di Cione.

The Virgin and Child Enthroned, with Narrative Scenes, 1260s, Margarito of Arezzo.

TECHNIQUES AND NEW DEVELOPMENTS

Wood panel Up to 1500, this was the most common support for paintings, covered with layers of smooth white chalk mixture (gesso).

Tempera Finely ground pigment (colour) was mixed together with either egg yolk, gum or glue, and used to achieve vibrant colours.

Gilding This was often used for religious altarpieces and paintings (see box, p. 17).

Pentecost, 1306–12, attributed to Giotto.

Did you know?
Although medieval and Renaissance painters made some pigments themselves, most colours were obtained from specialists such as apothecaries. Many remain bright today, but some have changed. 'Copper resinate' green glazes gradually turn brown when exposed to light. Red lakes were often made from dye extracted from insects; this red is 'fugitive', its colour eventually turning transparent over time.

The Virgin and Child, about 1426, Masaccio.

HISTORICAL CONTEXT

1241 Lübeck and Hamburg formed the Hanseatic League, creating northern Europe's leading trading group.

1273 Rudolph I became the first Habsburg ruler of the Holy Roman Empire, controlling much of central Europe.

1309 to 1377 The Papacy moved to Avignon in France; there was a major split in the Catholic Church.

1330 to 1351 The Black Death, or the Black Plague, killed about 24 million people in Europe, one-third of the population.

1397 to 1494 Medici bank was operating in Florence; the Medici family would dominate art patronage and government in this key Italian city state for many years.

Key artists
Giotto *1266–1337*
Duccio active *1278–1319*
Paolo Uccello about *1394–1455*
Rogier van der Weyden about *1399–1464*
Masaccio *1401–1428/9*

Piero della Francesca about *1415/20–1492*
Jan van Eyck active *1422–1441*
Andrea Mantegna *1430–1506*
Botticelli about *1445–1510*
Giovanni Bellini active *1460–1507*
Hans Memling active *1465–1494*

1400 **1450** **1500**

About 1300 to 1450 Early Renaissance
Term meaning 'rebirth', describing an intellectual and artistic movement inspired by the revival of the values and artefacts of the classical world. Early Renaissance artists often tried to paint naturalistically, aiming to make three-dimensional bodies and spaces look realistic.

About 1450 to 1520 High Renaissance
Exchanges of ideas and technical developments between Netherlandish and Italian artists led to realistic oil paintings designed on classical principles of balance and harmony, seen by nineteenth-century art historians as a peak of perfection.

The Donne Triptych, about 1478, Hans Memling.

Mond Crucifixion, about 1502–3, Raphael.

Development of oil paint
In the 1430s, artists in the Netherlands perfected the use of drying oils to bind pigment instead of egg. Longer drying time allowed blending of colours and painting in minute detail. This enabled artists to create realistic illusions of surfaces like metal, wood and skin.

Use of linear perspective developed
This system created the illusion of three-dimensional depth by using the optical phenomenon of parallel lines that appeared to converge in a vanishing point. The formal system was developed by Brunelleschi in 1435, and described by Alberti in his treatise *Della Pittura*.

Portrait of Alexander Mornauer, 1464–88, Master of the Mornauer Portrait.

The Magdalen Reading, before 1438, Rogier van der Weyden.

1448 Gutenberg developed the printing press in Germany, using movable type (similar technology used in China around 1000AD).

1453 Mehmet II captured Constantinople (now Istanbul), ending the Christian Byzantine Empire.

1492 Spain reconquered Granada, ending Muslim rule there, and expelling the city's Jewish population.

1492 Christopher Columbus first landed in the New World.

1497 to 1498 Vasco de Gama opened up a new trade route from Europe around Africa to India.

Paintings 1500 to 1600

In this period, artists were meeting the challenge of what to do once they'd mastered the trick of creating believable illusions in paint. In Florence and Rome, such skills were often part of a move to create idealised forms that sought to improve on nature, with all her quirks and flaws.

As yet more Greco-Roman antiquities were uncovered, it was clear that sculptors and painters could imagine bodies so apparently perfect that they could lift the spirits and inspire the mind. Mannerism (a blanket term that refers to a wide range of artists and individual works) was a logical response to this development. Mannerist artists sought to create deliberately stylised, artificial, even discordant works as they aimed to surpass mere perfection.

While artists working in Florence and Rome (such as Leonardo, Michelangelo and Raphael) tended to make endless drawings and carefully calculated designs, their Venetian counterparts embraced colour rather than line. Venice was the main port through which trade was conducted with the East, and a dazzling range of pigments was available to artists there. Perhaps the atmospheric effects of this city, filled with water and reflected light, influenced its artists' approaches, too. Titian painted bold, complicated designs straight onto his canvases, using light and colour to make his forms seem three-dimensional.

Religious differences

For more than a thousand years, all Christians in western Europe had been part of the Roman Catholic Church. However, by the early sixteenth century, an increasing number felt that the Church was corrupt and abused its powers. Martin Luther, a German monk, challenged the Church to reform itself. It denounced him as a heretic, so he set up the Lutheran Church, whose followers were known as Protestants. This had a profound impact on the art world. Protestants rejected the use of imagery in their devotional practice, focusing instead on the word of the Bible. Religious art was destroyed in some areas, and in parts of northern Europe, commissions for religious paintings dropped to very low levels. This stimulated the secular art market, contributing to interesting developments in portraiture, landscape and scenes from everyday life. The Catholic authorities launched proposals to counter the Protestant Reformation, which included making art an even more vibrant, vital part of Catholic practice.

In northern Europe, there were particular innovations in portraiture and landscape painting. The full-length, large-scale standing portrait format was adopted by the German artists Cranach and Holbein, with spectacular results. Landscape was still officially the backdrop for more serious subjects. However, it was gradually becoming an area of interest in its own right, as artists began to explore how representations of the natural world could express religious, philosophical and emotional ideas, in a time of increasing turmoil.

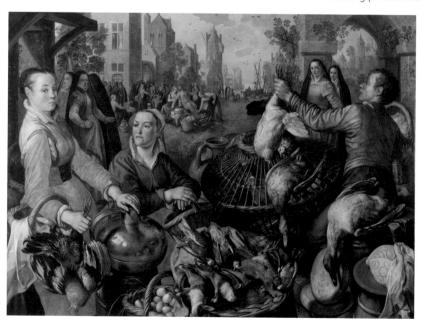

Left: *The Four Elements: Air*, 1570, Joachim Beuckelaer.

Left: *The Madonna and Child with Saints John the Baptist and Jerome*, 1526–7, Parmigianino.

Pushing against perfection – Mannerism

This term derives from the Italian word *maniera*, which means 'style' or 'stylishness'. Originally used to describe the rather elegant, elongated forms of some mid-century Italian painters, it has now come to refer to a variety of works produced between about 1520 and 1600, in particular, pieces that deliberately set out to create something very different from the balance and harmony of the High Renaissance. Tense, emotional scenes are created from figures who take up awkward poses and whose limbs often seem to have been distorted. Jarring shifts of scale, lurid colours and harsh lighting effects may all contribute to works that have been both criticised as ugly and praised as powerful and disturbing. In this Mannerist painting by Parmigianino (above), Saint John the Baptist gestures emphatically towards the Virgin and Child, his elegant but unnaturally long finger standing out against the background. Christ adopts an equally strange position, so that the limbs of both figures seem to match each other in a contrived but still rather beautiful dance.

Symbols and allegories

Paintings during this period became increasingly rich in their use of symbolic objects, which could suggest multiple layers of meaning. Whereas earlier portraits might have included one or two items that revealed something about the sitter, now there might be a wide array of objects. Sometimes artists followed accepted codes, using figures or objects to stand in for ideas in ways that were instantly recognisable. Skulls referred to death, and holding pansies showed that the subject was thinking of a loved one (after the French word for thought, *penseé*). Others used less well-known symbols, or created personalised hidden messages that may never have been intended for a wider audience.

New trends in collecting and display

This is the century when art moved out of the Church and up from the furniture to take its now familiar place on the wall. It became more common to show off your cultural aspirations by building a collection of paintings that hung in a gallery. This increased the demand for new subjects that focused unashamedly on visual pleasure: sensuous mythologies, paintings that featured lush landscapes, and visual puzzles to intrigue the erudite viewer.

Above: *The Death of Eurydice*, about 1552–71, Niccolo dell'Abate.

Building booms in cities such as Genoa in Italy created grand new homes that needed decoration. Palaces and villas across Europe were also refurbished as new leaders and influential residents sought to make their mark. For example, Titian's patron Alfonso d'Este aimed to rival his sister Isabella's carefully constructed display of contemporary art with his own 'little room', filled with depictions of Bacchus (the Greek god of wine) and his followers, drinking and flirting. He commissioned a number of leading artists, and their acceptance was a public sign of Alfonso's status as an important patron. When some of these established artistic stars (including Raphael) died, the ambitious young artist Titian took over their commissions. This continuing demand for major decorative schemes would influence the kinds of work painters produced, prompting them to develop new ways to tell stories on a grand scale.

Chronology of painting 1500 to 1600

1500	1525

ART PERIODS AND STYLES

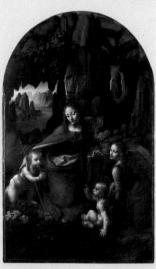

Up to about 1520
High Renaissance Realistic oil paintings designed on classical principles of balance and harmony, used the previous century's naturalistic techniques to create believable, idealised visions.

The Virgin of the Rocks, about 1491–1508, Leonardo da Vinci.

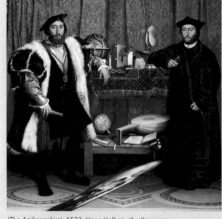

'The Ambassadors', 1533, Hans Holbein the Younger.

TECHNIQUES AND NEW DEVELOPMENTS

Aerial perspective developed
This sense of distance was created by mimicking the effect that made objects look paler and more blue the further away they were. This method was advocated by Leonardo da Vinci.

Did you know?
Fresco painting is a technique in which the pigment is mixed with water and brushed over a thin layer of wet, fresh plaster. As it dries, the colour of the pigment is fixed in the plaster. For examples, see the display on the stairs (next to Room 12), leading to Rooms B–G.

Christ taking Leave of his Mother, probably 1520, Albrecht Altdorfer.

Canvas developed From 1500, canvas was created, proving cheaper, easier to produce and more portable than wooden panels, as it could be rolled. It also provided a rougher surface that caught oil paint in interesting ways; it inspired artists to experiment with texture.

An Allegory with Venus and Cupid, probably 1540–50, Agnolo Bronzino.

HISTORICAL CONTEXT

1517 Martin Luther's Reformation challenged the tenets of the Catholic Church.

1519 to 1522 Ferdinand Magellan and crew made the first circumnavigation of the Earth.

1534 Henry VIII of England broke from the Catholic Church.

1543 Copernicus proposed that the Earth revolved around the Sun.

1545 to 1563 The Catholic Church met in Italy to launch the Counter-Reformation.

Key artists
Leonardo da Vinci *1452–1519*
Lucas Cranach the Elder *1472–1553*
Michelangelo *1475–1564*
Albrecht Altdorfer about *1480–1538*
Raphael *1482–1520*

Hans Holbein the Younger about *1497–1543*
Jan Gossaert active *1503–1532*
Agnolo Bronzino *1503–1572*
Titian active *1506–1576*
Jacopo Tintoretto *1518–1594*
Paolo Veronese *1528–1588*

1550	1575	1600

Venetian painting Flourished under Titian, Tintoretto and Veronese, who used brilliant colours to construct forms without drawing hard-edged outlines. Titian's experimental, expressive late work would be particularly influential in later centuries.

About 1520 to 1600 Mannerism This was a reaction to the 'perfection' of the High Renaissance. It was not an organised movement, but an approach by different artists that involved distorting bodies, using discordant compositions and acidic colours to create an elegant but edgy mood.

The Tribute Money, 1560–8, Titian.

The Tailor, about 1565–70, Giovanni Battista Moroni.

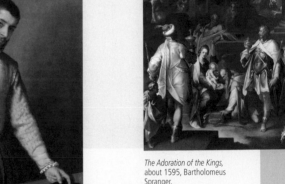

The Adoration of the Kings, about 1595, Bartholomeus Spranger.

Colours Pigments used to make colours came from a wide range of mineral, plant and animal sources: ultramarine blue pigment had been derived from the semi-precious stone lapis lazuli for many years.

Wider range of subjects Religious painting continued to be important: portraiture developed complex, sophisticated formats; grand histories and sensuous mythologies decorated the palaces of Europe. Landscape backgrounds became increasingly prominent.

The Family of Darius before Alexander, 1565–70, Paolo Veronese.

The Origin of the Milky Way, about 1575, Jacopo Tintoretto.

1555 Peace of Augsberg brought religious stability to Germany.

1568 to 1609 The Dutch rebelled against Spanish colonial rule.

1588 The Spanish Armada failed to invade England.

Painting 1600 to 1700

In this century, we see the long-term effects on art of the rise of Protestantism in northern Europe, and the strategies adopted to counter it by Catholic authorities, particularly in Italy and Spain. As Protestants rejected the use of visual imagery, Catholics made it an even more central part of their worship.

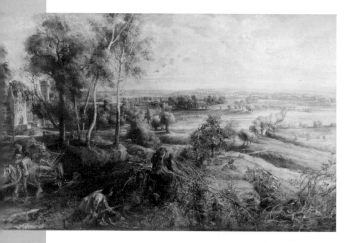

The Catholic Church urged artists to bring Bible stories vividly to life, offering ways for viewers to become emotionally involved in religious narratives.

Caravaggio responded to this ideological climate with dramatically lit scenes, whose compositions reach out towards us. He depicted ordinary models in unidealised ways; the dirty feet and ragged clothes of his figures upset some Church patrons, but also showed just how religious art could connect with even the poorest members of a congregation. Such dynamic, overtly emotional compositions dominated seventeenth-century Italian, French and southern Netherlandish art, referred to now as Baroque painting. Their lighting and naturalism would also influence artists

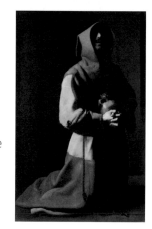

Top: *A View of Het Steen*, 1636, Peter Paul Rubens.
Above: *Saint Francis in Meditation*, 1635–9, Francisco de Zurbarán.
Far Right: Remnant from Basilica Aemilia, 2nd century BC, Rome.

in northern Europe, as many artists travelled to Rome to complete their artistic training, bringing ideas back home.

In Spain, the climate of religious fervour was even more extreme. Velázquez's sensuous *'Rokeby Venus'* had to be kept in a private chamber by its privileged young owner, so that neither patron nor artist faced the wrath of the Spanish Inquisition. But Spanish artists made their own responses to the call for moving, realistic works of art. Zurbarán's powerful images of meditating saints are closely related to local traditions for painted wooden religious sculptures.

The Dutch provinces continued their struggle for freedom from Spain, finally becoming an independent republic in 1648. As there was almost no patronage for religious art in this largely Protestant area, painters developed other subjects to the full: portraiture, landscape, still life and genre pictures (scenes from everyday life). All of these were ways for the Dutch to celebrate their new national identity, in particular, realistic views of productive, fertile land and tables laden with the exotic food and expensive goblets they could now afford. However, members of this deeply devout nation were careful to have themselves portrayed in restrained clothes, so that they did not seem too proud of their earthly riches. Instead of producing works to order, most Dutch artists made paintings speculatively to sell on the open market. In order to stand out, they usually specialised in one particular type of painting and developed extraordinary levels of skill in that field. Rembrandt was unusual, taking advantage of the financial freedom his marriage brought to experiment with a wide range of subjects and techniques.

Profession not craft – the rise of art academies

Artists increasingly complained that their work was not properly respected; many were angry that they were still treated as craftsmen. They sought to organise themselves into 'academies', professional associations that would represent their members' interests, provide centralised training and exhibition opportunities, and create a forum for theoretical discussion. Italian academies were officially recognised during this century; the French Royal Academy of Painting and Sculpture was founded in 1648; others followed in Germany and Spain.

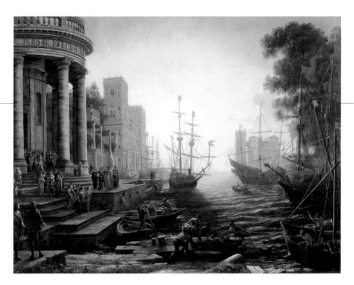

Left: *Seaport with the Embarkation of Saint Ursula*, 1641, Claude Lorrain.

Below: *Equestrian Portrait of Charles I*, 1637–8, Anthony van Dyck.

Rome, the ultimate artistic destination

As artists and patrons around Europe grew more ambitious, so they sought inspiration to elevate the artistic output in their own area. A trip to Italy was a must for any serious aspiring artist; a period spent in Rome studying ancient sculpture and Renaissance art was usually the highlight of this odyssey. The city was an artistic melting pot, with contemporary artists learning from each other as well as exploring Rome's heritage. Such visits would transform the artistic practices of Rubens and Velázquez; the Caravaggisti would export ideas back to the Netherlands that influenced even Rembrandt, who confidently said he had no need for his own Italian journey. The French painters Claude Lorrain and Nicolas Poussin both fell so much in love with the city that they never left, to the annoyance of the French Academy, which failed to lure these international celebrities back home.

Art and diplomacy

As war increasingly threw the Continent into turmoil, so leaders used art in acts of diplomacy. Both paintings and artists were sent as gifts, which resulted in the spread of artistic ideas around Europe. Rubens came to England from 1629 to 1630 as an envoy of Philip IV of Spain. As part of his efforts to negotiate peace with Charles I, he produced *Peace and War* as a gift for the king, who was eager to decorate his palaces with fine works by such a famous artist. Charles also lured the internationally acclaimed portrait painter Anthony van Dyck to his court, with the promise of a knighthood. Van Dyck's output would transform painting in Britain, demonstrating a new grandeur that other artists soon tried to emulate. Superlative horses, solid pillars, and strategically placed curtains and tree branches all framed figures elegantly swathed in fine silk or clad in shining armour.

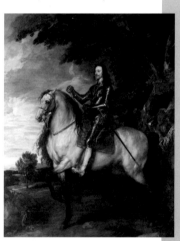

Rubens or Poussin?

Towards the end of the seventeenth century, French Academicians debated which artistic approach they should teach their students. The discussion fell into two camps. The 'Poussinistes' felt that the careful designs, firm outlines and controlled brushwork of Nicolas Poussin represented the ultimate ideal for new artists. The 'Rubénistes' disagreed violently, promoting instead the example of Rubens's expressive brushwork and forms created by colour and tone rather than line. The 'Rubénistes' won, and this would influence the development of art across Europe in the following century, as more fluid, 'painterly' techniques began to be practised.

Far left: Detail of *The Rape of the Sabine Women*, 1635–40, Peter Paul Rubens.

Left: Detail of *The Triumph of Pan*, 1636, Nicolas Poussin.

Chronology of painting 1600 to 1700

| **1600** | **1625** |

ART PERIODS AND STYLES

Caravaggisti This term described those painters who imitated the naturalism and strong contrasts of light and shade found in the work of Caravaggio. Painters from Utrecht in the Netherlands took these ideas home, where they would be particularly influential.

Baroque This was the dominant style for this century, which met the demands of the Catholic Reformation for dramatic, dynamic art that encouraged viewers to become emotionally involved in paintings of religious stories. The style quickly spread to other subjects.

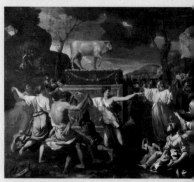

The Supper at Emmaus, 1601, Caravaggio.

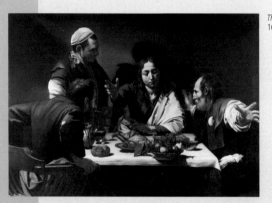

The Adoration of the Golden Calf, 1633–4, Nicolas Poussin.

TECHNIQUES AND NEW DEVELOPMENTS

Chiaroscuro This Italian term means 'bright-dark', and describes the dramatic use of strong contrasts of light and shadow used in particular by Caravaggio and Rembrandt.

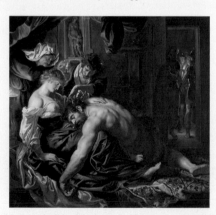

The Concert, about 1626, Hendrick ter Brugghen.

Painting 'alla prima' Italian term meaning 'at first', this describes a method of painting in which the finished surface was achieved in a single application of paint, rather than by a building up of layers. It began to be used by some artists, for example, Frans Hals.

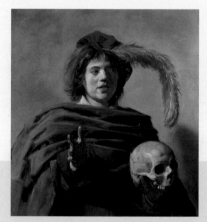

Samson and Delilah, 1609–10, Peter Paul Rubens.

Young Man Holding a Skull, 1626–8, Frans Hals.

HISTORICAL CONTEXT

1606 to 1607 British and French began to colonise North America and Canada.

1609 to 1621 A twelve-year truce was agreed between the Dutch and Spanish.

1618 to 48 Thirty Years' War dominated Europe.

1619 The Dutch imported the first twenty African slaves to Virginia.

1620 Pilgrim Fathers arrived at Plymouth, North America.

1648 The Dutch Republic was established after the Netherlands had won official independence from Spain.

Key artists
Caravaggio *1571–1610*
Guido Reni *1575–1642*
Peter Paul Rubens *1577–1640*
Frans Hals *1580–1666*
Nicolas Poussin *1594–1665*

Anthony van Dyck *1599–1641*
Diego Velázquez *1599–1660*
Claude Lorrain *1604–1682*
Rembrandt *1606–1669*
Bartolomé Esteban Murillo *1617–1682*
Jacob van Ruisdael *1628/9?–1682*

1650	1675	1700

'Golden Age' of Dutch painting
Largely Protestant by this point, the Netherlands had a thriving economy and a unique art market that encouraged painters to specialise in secular subjects, resulting in superb landscapes, still lives, portraits and genre scenes.

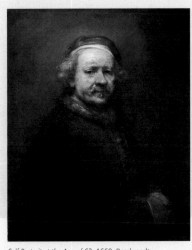

Self Portrait at the Age of 63, 1669, Rembrandt.

Did you know?
Rembrandt made a huge number of self portraits – over 90 paintings, drawings and etchings at a time when most artists usually just depicted themselves a few times, if at all. The early works were often a way of practising different facial expressions, but later self portraits seem to reflect developments in the artist's life. See Tour 5, p. 61.

New forms of naturalism This style featured earthier, less idealised visions of reality, which focused on ordinary objects and people, elevating them through serious observation and lovingly applied strokes of paint.

Impasto Thickly applied paint, which held its texture and often showed the marks of the tool used to apply it (brush or knife); both Rembrandt and Velázquez used this technique in their late works.

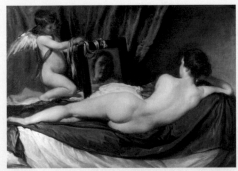

'The Rokeby Venus', 1647–51, Diego Velázquez.

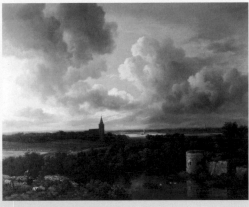

Landscape with a Ruined Castle and a Church, about 1665–70, Jacob van Ruisdael.

1649 to 1660 Britain became a republic after civil war led to the execution of Charles I.

1660 The British monarchy was reinstated, with Charles II as king.

1666 The Great Fire destroyed much of London.

1683 The Ottomans were heavily defeated at Vienna, becoming less powerful in Europe.

Painting 1700 to 1900s

The most noticeable change is that these rooms are not dominated by paintings from Italy and the Netherlands, and that very little of the work is religious. There were significant innovations in French and British art from this period, and secular subjects dominated the market, particularly in Protestant Britain.

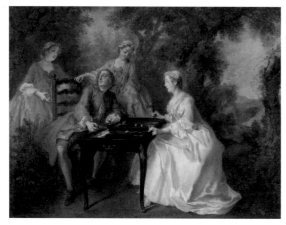

Above: *The Four Times of Day: Afternoon*, 1739–41, Nicolas Lancret.

The eighteenth century began with a move away from the emotional drama and solid forms of the Baroque period. When Louis XIV died in 1715, a more relaxed atmosphere began to pervade the culture of the French court. Rococo paintings of flirting couples secreted in fantasy landscapes were soon the height of fashion.

In Britain, increasing numbers of landed gentry sought to show off their status by commissioning portraits of themselves in country park settings. Sir Joshua Reynolds, first president of the Royal Academy of Art, imported Continental ideas into its training programmes and urged students to aim for grandeur of ideas and execution.

In the early nineteenth century, John Constable and J M W Turner took Reynolds's advice, but turned it

Left: *Colonel Tarleton*, 1782, Sir Joshua Reynolds.

The Age of Enlightenment and its aftermath

This was a broad philosophical movement during the eighteenth century, which questioned traditional institutions, morals and customs. Its key figures often held views that contradicted one another, but there was general agreement that established churches and the aristocracy ran Europe in oppressive, reactionary ways, exploiting fear and superstition. Writers argued that human beings should instead use reason to understand and organise the world. Artists were urged to make more serious, morally improving work. For a short period some did, but there was soon a backlash, as a wide range of cultural producers argued that creativity could not and should not be limited by the rule of reason. The Spanish artist Francisco de Goya was just one of many who revelled instead in the dark side of the human imagination.

Right: *The Forcibly Bewitched*, 1798, Francisco de Goya.

towards landscape painting, arguing passionately that scenery could move and inspire viewers just as much as biblical or history paintings.

Across continental Europe, tensions emerged between styles of painting that looked back once more to classical art, and a wide range of approaches that aimed to be deliberately different. The pure, severe lines of Jacques-Louis David's painting were developed further by his pupil J A D Ingres, whose sleek brand of classicism influenced French art well into the 1860s.

Romantic artists rebelled with often wild imagination, believing that intuition, instinct and individual experience were the basis of art. Their work ranges widely in its visual appearance, from Caspar David Friedrich's minutely detailed spiritual landscapes to Eugène Delacroix's far more fluid brushstrokes, bright colours and unsettling lighting effects.

The Grand Tour

From the late seventeenth to the early nineteenth centuries, a journey to the cultural centres of France, Italy, Germany and the Netherlands was considered an important finishing touch to the education of young upper-class European men. Particularly popular with the British aristocracy, the Grand Tour exposed these youths to the art and architecture of antiquity and the Renaissance, and allowed them to mingle with fashionable European society. They often enjoyed every diversion on offer in cities such as Rome and Venice, but some really did extend their knowledge, and brought back influential collections of art.

Past, present and future

Cézanne, Seurat and van Gogh were amongst the most radical painters working at the end of the nineteenth century. Each developed ways of envisioning the world and applying paint that many of their contemporaries found startling and utterly modern. Yet they all made references to the art of the past. Sometimes they chose a traditional subject matter so that their daring update would be more noticeable. They also, however, saw themselves as part of a long and vibrant artistic tradition. The National Gallery's collection shows where they came from, and how they opened up the way forward.

Realist painters also stubbornly refused to paint scenes from antiquity, instead choosing low-paid workers and the French countryside as their principal subjects. Most famously, the loose grouping of artists known as the Impressionists challenged everything from subject matter (trying to capture fleeting moments in nature, or scenes from 'modern life') and applying paint (quickly, suggestively) to where they exhibited (independently, with others also rejected by the official Paris Academy show). Their works inspired a generation of younger painters to go even further, breaking down visual forms so that they became more and more abstract.

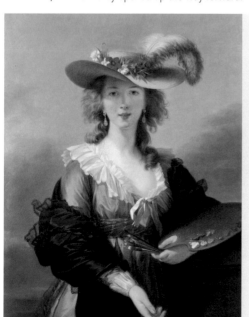

Female artists

Women struggled to gain adequate training: they couldn't attend 'life classes' to study nude models, on grounds of decency. Elizabeth Louise Vigée Le Brun overcame all of the obstacles in her path to establish a successful pan-European portraiture practice, using not just her talent as a painter but also her superb social skills to build a strong female client base. In her self portrait, she shows herself as a practising artist, but is careful to appear as a fashionable, feminine woman. Critics sometimes savaged successful female painters as 'unnatural'.

Left: *Self Portrait in a Straw Hat*, after 1782, Elizabeth Louise Vigée Le Brun.

The 1840s saw a revolution in paint storage – pre-mixed paint tubes that kept almost indefinitely. Small enough to carry around, they enabled *en plein-air* artists to work out of doors.

Chronology of painting 1700 to 1900s

1700	1750

ART PERIODS AND STYLES

Rococo This playful, pretty style of art developed about 1700 to 1760 in France, partly as a response to the weightier Baroque.

Neoclassicism A return to more severe, hard-edged forms after the softness of rococo, this style began about 1760 and carried on to 1820. Its serious, heroic subject matter drew inspiration from ancient Greek and Roman sculpture.

Romanticism This style, which started about 1780 and went through to 1850, was a reaction against rationalism of the Enlightenment (see box, p. 28) and neoclassicism. It was not a unified movement; instead, it included many different artists who valued individual experience and artistic imagination.

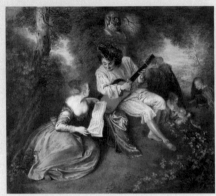

The Scale of Love, 1715–8, Jean-Antoine Watteau.

Portrait of Jacobus Blauw, 1795, Jacques-Louis David.

TECHNIQUES AND NEW DEVELOPMENTS

Palette knife This thin, flexible blade was set in a handle, and used for mixing paint and applying it to or scraping it off canvas. Constable and Courbet later pioneered its experimental use as an improvised 'paint brush'.

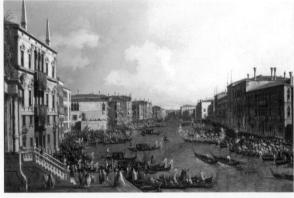

A Regatta on the Grand Canal, about 1740, Canaletto.

> **Did you know?**
>
> The term 'rococo' is a combination of the French words *rocaille* (small stones) and *coquille* (shell), both of which were used in the ornamental grottos built as lovers' hideaways in grand gardens from the period.

HISTORICAL CONTEXT

1700 Dissolution of Hapsburg Empire in Spain.

1712 The Industrial Revolution began when the first steam engine was installed in England.

1707 Unification of the United Kingdom.

1764 Englishman James Hargreaves invented the Spinning Jenny, and initiated the mass production of textiles.

1775 to 1781 The American Revolutionary War, which ended in American independence.

1789 to 1799 The French Revolution, which led to the rule of Napoleon Bonaparte.

Key artists
Jean-Antoine Watteau *1684–1721*
Canaletto *1697–1768*
Joshua Reynolds *1723–1792*
Thomas Gainsborough *1727–1788*
Caspar David Friedrich *1774–1840*

Joseph Mallord William Turner *1775–1851*
John Constable *1776–1837*
Jean-Auguste-Dominique Ingres *1780–1867*
Hilaire-Edgar-Germain Degas *1834–1917*
Claude-Oscar Monet *1840–1926*
Vincent van Gogh *1853–1890*

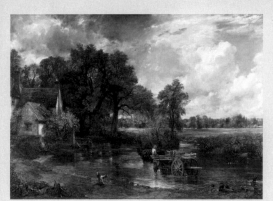

The Hay Wain, 1821, John Constable.

Impressionism This was a loose association of artists in France who, between the 1860s and 1880s, united to exhibit their radically different work when it was rejected from official exhibitions. They were interested in painting modern life and capturing fleeting atmospheric effects.

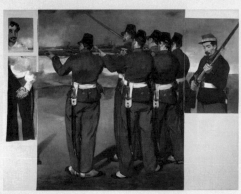

The Execution of Maximilian, about 1867–8, Edouard Manet.

Photography Developments in the 1830s by Daguerre and Fox Talbot led to a new means of image production. Artists were fascinated by effects such as blurring. Photos inspired some painters to find goals beyond creating realistic illusions.

Collapsible metal paint tubes In 1841, pre-mixed paint could now be opened and re-sealed with little wastage, which enabled painters to work outside the studio.

Modern synthetic pigments New colours became available for artists, including particularly vibrant blues (for example, Cerulean blue), yellows and greens.

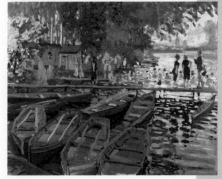

Bathers at La Grenouillère, 1869, Claude-Oscar Monet.

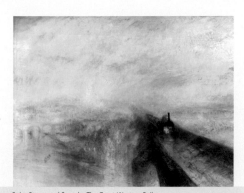

Rain, Steam and Speed – The Great Western Railway, before 1844, J M W Turner.

1807 Britain ended its involvement in the trans-Atlantic slave trade.

1848 There were rebellions against conservative rule in France, Italy, Germany and Austria.

1830 The world's first public railway opened between Liverpool and Manchester.

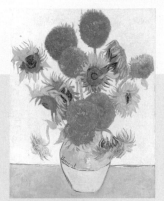

Sunflowers, 1888, Vincent van Gogh.

1861 to 1865 The Civil War in the USA.

1870 to 1871 The French were defeated in the Franco-Prussian War; the German Empire was created.

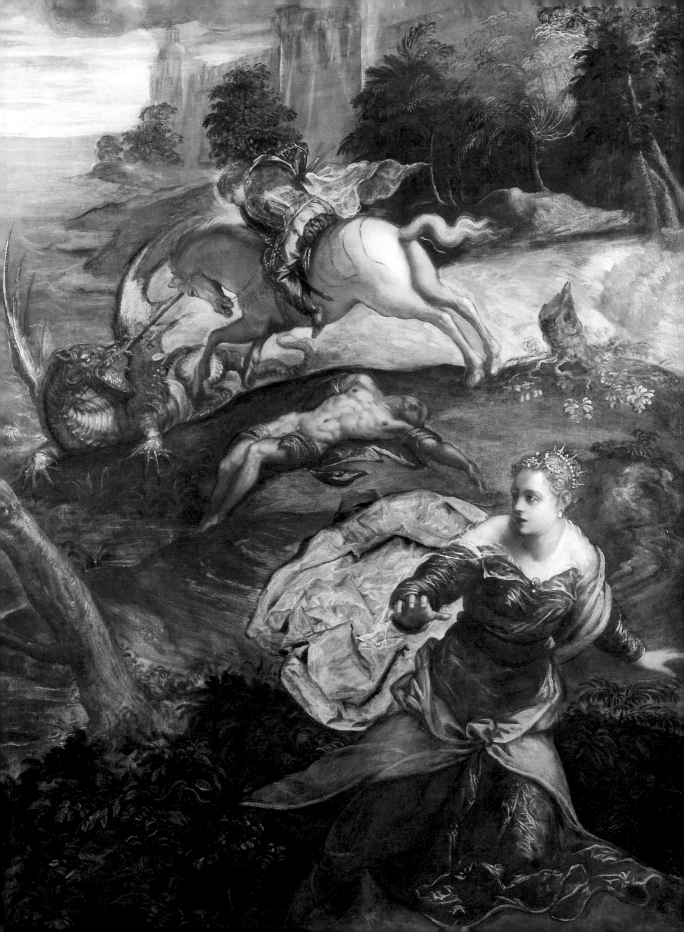

3

The Tours

Tour 1 Masterpieces

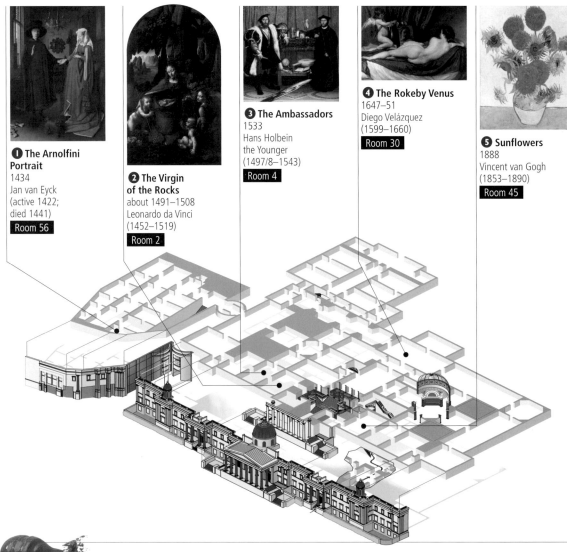

❶ The Arnolfini Portrait
1434
Jan van Eyck
(active 1422;
died 1441)
Room 56

❷ The Virgin of the Rocks
about 1491–1508
Leonardo da Vinci
(1452–1519)
Room 2

❸ The Ambassadors
1533
Hans Holbein the Younger
(1497/8–1543)
Room 4

❹ The Rokeby Venus
1647–51
Diego Velázquez
(1599–1660)
Room 30

❺ Sunflowers
1888
Vincent van Gogh
(1853–1890)
Room 45

The cutaway shows you which rooms you will visit on this tour, and where they can be found. The National Gallery was designed to showcase the best of western European painting, and it displays some of the world's most celebrated pictures. This tour introduces five masterpieces from different parts of the collection, including works by Leonardo da Vinci and Vincent van Gogh. Each one is a superb example of the particular kind of painting that these five famous artists practised – this is a tour of ultimate highlights. Look out for changes in the way that paint is applied, from the smooth, sharply focused surfaces of van Eyck to the rough textures of van Gogh.

Tour 1 – step 1

Start at the Sainsbury Wing Entrance and head to the second floor. Enter Room 51, turn left, then pass straight through Rooms 52, 53, 54 and 55, to reach Room 56.

Did you know?

The term 'masterpiece' comes from the final piece of work that apprentices made at the end of their long training period. If it was good enough, the artist or craftsman could set up as a 'master' in their own right.

The Arnolfini Portrait 1434

Jan van Eyck (active 1422; died 1441)
Oil on oak, 82.2 x 60 cm

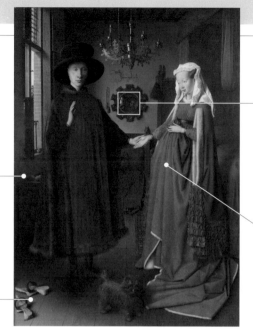

Oranges left casually on
a windowsill are a sign
of wealth: these were
precious, expensive fruits

Realistic mud-spattered
pattens, worn
over expensive shoes
to protect them outside

Tiny figures are reflected
in the mirror: is this the
image of the artist?

This bulge may look like a
pregnancy, but it was
actually a fashion
statement: lots of cloth
meant lots of money

What's so great about this painting?

The extraordinary amount of detail. We witness
a moment of carefully staged intimacy in an
interior described with unprecedented realism.

What is it about?

This probably shows Giovanni di Nicolao
Arnolfini and his wife. A wealthy Italian
merchant from Lucca, by 1434 Arnolfini was
living in Bruges. He commissioned the best artist
in the region to make a portrait that showed off
his social status and celebrated his marriage.
The interior is fictional, a stage that has been
set to include many signs of prosperity, such as
the bed hung with rich red fabric. The couple
wear their best fur-lined clothes, even though
the view through the window shows that it is
warm enough for cherries to be in fruit. They
hold hands to signal their union, and the dog
at their feet is a symbol of their fidelity. A single
flame burns overhead, possibly something
van Eyck has included to show that he can
paint both natural and artificial light.

What techniques does the artist use?

Van Eyck was an early pioneer of oil painting.
He used oil paints in thin glazes, building up
translucent layers and adding tiny details to
make surfaces look realistic.

Why has it been chosen for this tour?

The technique was considered groundbreaking
at the time, and artists from all over Europe
marvelled at the end result and tried to copy the
method. The format of a double portrait in an
interior was also new. This picture became
particularly famous because the artist's
elaborate signature in Latin (above the mirror)
led to the suggestion that the painting showed
the actual moment of marriage, and that the
artist had signed as a witness. However,
scholars now think that the inscription, which
translates as 'Jan van Eyck has been here',
is more likely to have been a general way of
acknowledging that these detailed likenesses
had been made from life.

Jan van Eyck

- born in Maaseick, in
 modern-day Belgium
 around 1394.
- initially trained
 as a manuscript
 illuminator.
- became official court
 painter to John III,
 Count of Holland,
 1422.
- moved to Bruges and
 became court painter
 to Philip the Good,
 Duke of Burgundy,
 1425.
- many patrons were
 members of an Italian
 colony in Bruges.
- advanced a powerful
 style of individual
 portrait painting.
- one of the first to
 unlock the potential
 of oil paint.
- died in Bruges, 1441.

Tour 1 – step 2

Return to the top of the Sainsbury Wing staircase, passing the lifts, to enter Room 9. Turn right to enter
Room 8, then left to go straight through Rooms 6 and 4, to reach Room 2.

The Virgin of the Rocks about 1491–1508

Leonardo da Vinci (1452–1519)
Oil on canvas, 189.5 x 120 cm

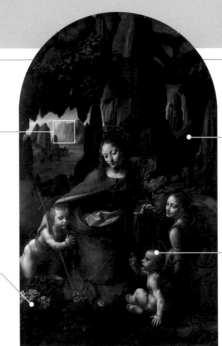

Misty blue landscape shows Leonardo's technique of 'aerial perspective', a way of suggesting distance through colour and haze

White flowers are Star of Bethlehem or heartsease, symbols of purity and atonement, studied with scientific precision by Leonardo

Setting of rocky cave symbolised sanctuary

Figures modelled using light and shade rather than outlines

Leonardo da Vinci

- born in Italy, 1452.
- apprenticed by 1476 to Andrea del Verrocchio, Florence.
- moved to Milan around 1482; worked for the Sforza court, focusing on military engineering.
- completed *The Last Supper* in the late 1490s in the refectory of S Maria delle Grazie, Milan.
- painted the portrait of Lisa del Giocondo, the so-called *Mona Lisa*, around 1503–6.
- 1516, entered service of King Francis I of France, for a series of architectural and engineering projects.
- died in France, 1519.

What's so great about this painting?

The sense of harmony and serenity suggested by its carefully balanced composition, and the way that strong sunlight and deep shadow have been used to create the effect of solid, rounded bodies.

What is it about?

This shows the infant Christ meeting his cousin Saint John the Baptist, watched over by the Virgin Mary and an angel. Christ is in the front of the painting, making a gesture of blessing, his mother's cloak and arms spread protectively around the scene. This was the central panel for an elaborate altarpiece ordered for the Church of San Francesco in Milan. It was, however, the second version that Leonardo painted. He disputed the terms of payment, and sold off the panel he and his associates originally made (now in the Louvre, Paris). This replacement was finally delivered by the temperamental artist, 25 years after the original commission.

What techniques does the artist use?

Leonardo used light and shadow to define three-dimensional objects, rather than painting firm outlines as his predecessors had done. He wrote that light and shade should blend 'without lines or borders in the manner of smoke', a technique known by the Italian word *sfumato*. Drawings under the painting's surface show that Leonardo experimented with a different design before completing this one.

Why has it been chosen for this tour?

Leonardo is probably the world's most famous artist, and the National Gallery is lucky to have one of his few paintings – he was involved in so many other sculptural, scientific and engineering projects that he did not finish many pictures. It achieves the ultimate High Renaissance aims of balance and harmony. Heads and hands are connected in a series of triangles, combining overall into a circular form that suggests completeness and eternity.

Tour 1 – step 3
Return to Room 4.

The Ambassadors 1533

Hans Holbein the Younger (1497/8–1543)
Oil on oak, 207 x 209.5 cm

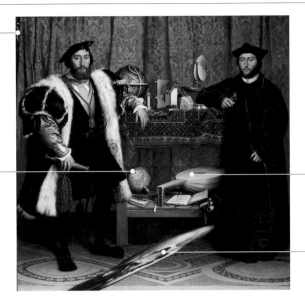

Crucifix – contrasts with the skull and offers Christian hope of life after death

Personalised globe, showing Polisy in France, where Dinteville had his château and this painting was destined to be hung

Broken lute string signals disharmony

Distorted skull, visible when you stand to the right

What's so great about this painting?

It looks very realistic, yet at the same time every object has been included for a symbolic reason, forming a sort of code for the viewer to decipher.

What is it about?

This powerful portrait commemorates friendship in a time of religious and political uncertainty. On the left is Jean de Dinteville, French ambassador to England in 1533. According to his diaries, he spent a miserable year in England, during which King Henry VIII divorced his first wife, causing a split from the Catholic Church and dividing Europe. Dinteville was cheered by a visit from his friend Georges de Selve, a young bishop. Holbein was commissioned to mark the occasion with this monumental portrait, displaying the learned interests as well as the luxury possessions of both men. The upper shelf contains instruments used to study the stars and measure time, while the lower shelf suggests their skills at earthly pursuits such as music, maths and geography.

What techniques does the artist use?

Holbein could make very accurate drawings of his sitters in just a few hours. Although this painting took months to finish, the sitters might only have 'sat' for Holbein once.

Why has it been chosen for this tour?

This painting is famous for its hidden symbols. The arithmetic book is open at a page on division (we can read 'Dividirt'), and the mathematical dividers were a symbol of good governance, needed at this point. The book beneath the lute shows two hymns used by both Protestants and Catholics – was this a plea for unity? The most hidden feature is in full view at the front of the painting. Stand at the right of the painting, close to the wall, and you'll see that the strange shape in the foreground is actually a skull, hidden by a distorted form of perspective known as anamorphosis. It is a reminder of death, a warning not to place too much faith in the luxury objects and learned accomplishments of this world.

Hans Holbein the Younger

- born in Germany around 1497/8.
- arrived in London in 1526.
- his arrival had a considerable impact on English cultural life as it effectively introduced Britain to the Renaissance painting of continental Europe.
- by 1536, Holbein established a reputation in England as a brilliant portraitist and had entered the service of King Henry VIII.
- died in London, 1543, apparently a victim of the plague.

Tour 1 – step 4

Enter Room 5 and head straight through Rooms 11 and 14, to Room 29. Turn right, through to the end of this room, to reach Room 30.

The Rokeby Venus 1647–51

Diego Velázquez (1599–1660)
Oil on canvas, 122.5 x 177 cm

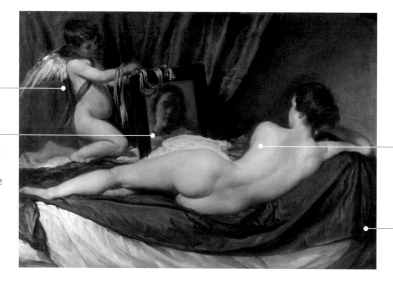

Cupid is identified by his wings and the quiver of arrows slung across his chest

Impossible mirror image – if we see this much of her face, she should be positioned where we are

Upper edge of her back was formed by one long, virtuoso brushstroke

Grey/blue cloth was originally a rich purple colour, now faded

Diego Velázquez
- born in 1599 in Spain.
- in 1623 became principal painter to King Philip IV, whom he painted about 40 times (including two portraits now in the National Gallery).
- visited Italy twice, acquiring paintings by Titian, Tintoretto and Veronese.
- distinctive loose handling of paint gave his artworks a vibrant, shimmering quality that was very influential.
- later paintings, such as 'The Rokeby Venus' (above), were greatly inspired by Italian models.
- died in Madrid, 1660.

What's so great about this painting?

The sensuous lines of the woman's body, and the ambiguous look on the goddess's face, reflected via a mirror image manipulated by the artist.

What is it about?

This is a celebration of female beauty, in the perfect form of the goddess Venus. She reclines on a bed, showing off her gorgeous back and buttocks, while apparently admiring her face in a mirror held by her son Cupid, the Roman god of love. However, the mirror has been tilted so that the goddess can look out at us, or rather we can try (and endlessly fail) to make eye contact with her through this blurred image. The picture was probably a private commission for the privileged playboy Marqués del Carpio, who no doubt kept it hidden from the disapproving eyes of the Spanish Inquisition. It may have been hung opposite a view of a reclining nude woman seen from the front, so the spectator could enjoy such bodies from every angle.

What techniques does the artist use?

Velázquez used real models for his mythological paintings. He suggested skin and fabric through a range of colours and brushstrokes rather than trying to paint every pore and fibre.

Why has it been chosen for this tour?

For its sheer beauty, and because it is a major highlight by Spain's most celebrated painter. Velázquez developed a form of naturalism that was based on observation: his earliest works include careful studies of kitchen pots and food. As his career developed, he used paint in increasingly loose brushstrokes to create effects that were believable at a distance. In this painting, he has also distorted Venus' body to achieve a particularly elegant ideal. Try putting your head on one side and imagine her standing up – her body is not properly proportioned, although she looks perfect from the intended viewpoint.

Tour 1 – step 5

Exit Room 30 via the Sunley Room, go through Central Hall and into the Portico Entrance. Turn left to reach Room 45.

Sunflowers 1888

Vincent van Gogh (1853–1890)
Oil on canvas, 92.1 x 73 cm

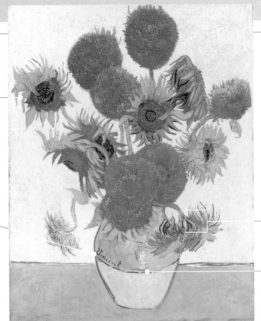

Dying petals may look tortured to us now, but for van Gogh they were simply interesting shapes in a colour that filled him with joy

Van Gogh gave himself a one-name signature like other great artists (Rembrandt, Raphael), though at times suffered from a crippling lack of confidence

Use of brush handle to score into the thick wet paint

Impasto (thick application of paint) to suggest highlight on ceramic pot

What's so great about this painting?

This is one of the world's most famous pictures. Van Gogh was captivated by the dramatic vitality of these short-lived blooms.

What is it about?

Some people imagine torment in the twisting petals of these sunflowers, but that is not what they meant to van Gogh when he painted them. He was preparing his Yellow House in Arles in the South of France for the arrival of his friend, the artist Paul Gauguin, and painted four canvases of sunflowers to decorate Gauguin's room. To van Gogh, these flowers represented optimism and the glorious colours of southern France. He wrote to his brother Theo: 'I am working at it every morning from sunrise on, for the flowers fade so quickly.' Sadly, the collaboration between the two artists was not as happy as either had imagined, although in creative terms it was very productive. Their arguments contributed to van Gogh's breakdown, and to Gauguin's departure.

This is the end of the Masterpieces tour.

What techniques does the artist use?

Van Gogh used very thick paint, applying it in textured strokes, putting fresh paint onto areas that were still wet. He also sometimes used the handle of the brush to score into the surface.

Why has it been chosen for this tour?

This is an iconic painting that everyone knows from postcards, but you see so much more when you stand in front of it. The vase has emphatic volume, and the flowers twist in all directions, creating a bold pattern against the flat background. Van Gogh has built up the forms of the flowers using an almost sculptural approach to paint, something that was considered to be daring in 1888 and is still very expressive for modern viewers.

Vincent van Gogh

- born in the Netherlands, 1853.
- worked as an art dealer in The Hague, London and Paris until 1876.
- in England, kept illustrations from *The Graphic* and the *Illustrated London News,* drawn to its stark imagery.
- mainly self-taught, developed his own distinct textural handling of the paint.
- suffered attacks of mental illness from 1888 and attended an asylum near Arles.
- spent the last period of his life north of Paris, committing suicide there in 1890.

Tour 2 Looking with children

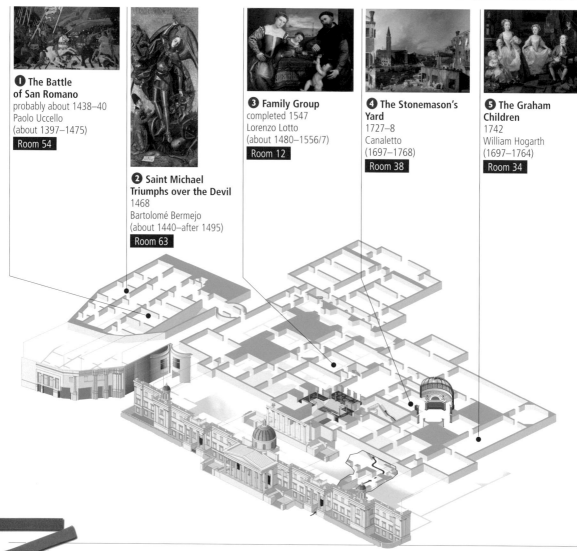

❶ The Battle of San Romano
probably about 1438–40
Paolo Uccello
(about 1397–1475)
Room 54

❷ Saint Michael Triumphs over the Devil
1468
Bartolomé Bermejo
(about 1440–after 1495)
Room 63

❸ Family Group
completed 1547
Lorenzo Lotto
(about 1480–1556/7)
Room 12

❹ The Stonemason's Yard
1727–8
Canaletto
(1697–1768)
Room 38

❺ The Graham Children
1742
William Hogarth
(1697–1764)
Room 34

The cutaway shows you which rooms you will visit on this tour, and where they can be found. This tour is for people visiting with children. Try working out what's going on in each picture – ask, 'what can we see?' Information is included in each tour entry, but it's just as much fun to let children imagine the answers: keep asking them 'what's happening?' and 'why do you think that's there?' Encourage every suggestion: you're all telling a story together, and everyone's ideas count. Try some drawing inspired by the paintings: the Gallery shops sell paper and pencils, or you could ask for scrap paper at the information desks.

Tour 2 – step 1
Start at the Sainsbury Wing Entrance and head to the second floor. Enter Room 51, to your left at the top of the stairs. Turn left, then head straight through Rooms 52 and 53, to reach Room 54.

Did you know?

Little boys used to wear dresses instead of trousers. Hundreds of years ago, all young children stayed 'in coats' (wearing a dress) until around the age of five, when boys started to wear trousers or knee breeches. Look out for a two-year-old boy 'in coats' in one of the paintings.

The Battle of San Romano probably about 1438–40

Paolo Uccello (about 1397–1475)
Egg tempera with walnut oil and linseed oil on poplar, 182 x 320 cm

The top of the panel was originally arch-shaped – it was cut down when the painting was removed from the home of a leading Florentine family, to be installed in the powerful Medici family's palace

Knights exiting at top of picture – where are they galloping off to?

How many legs can you count? Do they match the number of bodies?

Real gold and silver (now tarnished) used for harnesses and armour

What's so great about this painting?

Knights in shining armour go into battle – but who will win, and who has the best suit of armour? This painting combines Renaissance politics with an early use of perspective.

What is it about?

The picture shows the Battle of San Romano, fought between the rival Italian city states of Florence and Siena in 1432. The leader of the Florentines, Niccolò da Tolentino, is shown as the hero, rearing up on his white horse in the centre and commanding his troops with a baton. Although some of the knights look as if they are really hitting each other, this isn't what the battle actually looked like. The artist, Paolo Uccello, has made the action into a beautiful, complex pattern, rather like a woven tapestry (these were more valuable than paintings in the fifteenth century). Also, Tolentino was not so heroic. He nearly lost the battle, and was close to tears when extra Florentine troops found him and his men by accident and rescued them.

What techniques does the artist use?

Uccello followed tradition by mixing most of his colours using egg yolk, but he also experimented by adding some oil in parts. His biggest innovation was the early use of linear perspective: look how the broken lances and even a fallen knight have been placed in the foreground to point towards a 'vanishing point' in the rosebush hedge, creating the illusion of depth in the painting.

Why has it been chosen for this tour?

Because it can be the starting point for story-telling about knights and battles, horses and heroism. Who is the hero and how do you know? Are these real horses, or have they stepped off a carousel? Which of the decorated helmets do you like best? Try designing your own helmet, or hat. This armour is quite accurate – look for the hinges and buckles that connect the different sections. This fancy armour would have been kept for best, worn at jousting tournaments rather than used in battle.

Paolo Uccello

- born 1397 in Florence.
- apprenticed to the famous sculptor Lorenzo Ghiberti around 1412–16.
- as an artist, was fascinated with linear perspective, tending to draw natural forms as a series of geometrical shapes.
- the Gallery has two works by this rare artist; the other is *Saint George and the Dragon* (1470).
- active as a painter of frescos, panels and canvases in Florence.
- designed stained glass and mosaics in San Marco, Venice, 1425.
- died in Florence, 1475.

Tour 2 – step 2

Go to Room 53. Turn left and go straight through Room 59, to reach Room 63.

Saint Michael Triumphs over the Devil 1468

Bartolomé Bermejo (about 1440–after 1495)
Oil and gold on wood, 179.7 x 81.9 cm

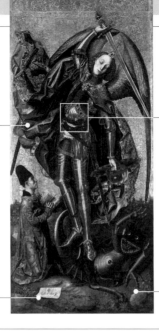

Cloak was probably laid out wet on the floor for the artist to study, which is why it looks so stiff

Reflection of the heavenly City of God, meant to inspire viewers as the ultimate destination

This paper shows the artist's signature as 'Bartolomeus Rubeus' or 'Red Bartholomew' – he probably had red hair

How many different animals inspired this devil?

Bartolomé Bermejo

- born in Córdoba, Spain, about 1440.
- greatly influenced by Netherlandish painting. Bermejo's oil-glaze technique suggests that he learned this in the Netherlands and then adapted it.
- painted exclusively for the Crown of Aragon, which controlled a large portion of present-day eastern Spain and southeast France.
- moved to Barcelona in 1485 and produced his masterpiece, *Pietà* (1490), for the Canon of the Cathedral, a work considered to mark Spain's entry into the Renaissance.
- died, probably in Barcelona, after 1495.

What's so great about this painting?

The fantastic devil with its horrible grin and a body made from many slimy animals. This picture shows good defeating evil. It is a Christian painting, but the same basic story occurs in most faiths and, of course, in general moral teaching, so you can relate your discussions and storytelling to whichever context feels most comfortable.

What is it about?

Saint Michael has swooped down on his multi-coloured wings to defeat evil in the form of a sharp-toothed demon. This powerful saint seems to be answering the prayers of the kneeling man, who is Antonio Juan, Lord of Tous near Valencia in Spain. He paid for this panel to be painted and installed at the centre of the altarpiece in the local church dedicated to this saint. Bermejo has shown Juan wearing a heavy chain and a sword, signs that he is a knight who has fought battles against Spain's enemies on Earth.

What techniques does the artist use?

The gold background, decorated with patterns stamped into it with a punch, was a traditional way to suggest heaven. The gold has worn through in some areas to reveal the red bole (clay) to which the gold was stuck and rubbed down. Oil paint was a relatively new technique, and has been skilfully used here to suggest reflective metal and glass.

Why has it been chosen for this tour?

Because we can all understand struggles between good and bad, and we can all imagine our own devil: what nasty things could form its body? What sort of being might help you fight it? Why might Antonio Juan be so much smaller than Saint Michael? What might Saint Michael's shield be made from? If you had wings, would they be inspired by a bird or a bat, or would you create something completely different?

Tour 2 – step 3

Enter Room 59, going straight through to Room 53. Turn left, to Room 52, through to Room 51. Turn right, pass the stairs and lifts to enter Room 9. Go through Rooms 10 and 11, to reach Room 12.

Family Group completed 1547

Lorenzo Lotto (about 1480–1556/7)
Oil on canvas, 104.5 x 138 cm

Landscape suggests a chilly outside world to contrast with the warmth of home and family

Children were often given coral to wear, as it was believed to have protective powers; larger pieces were used for teething

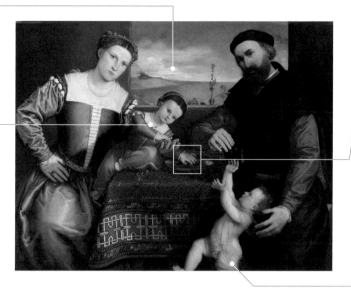

Cherries are used in symbolic games with both children

Naked child, so we can see he's a boy, destined to carry on the family name

What's so great about this painting?

The fact that it shows a real family playing together, which was very unusual for portraits at the time. The parents look very serious, though, so are their children meant to learn lessons from these games?

What is it about?

This probably shows the Venetian merchant Giovanni della Volta and his family. The artist, Lorenzo Lotto, knew them all very well, as he lodged with them for years. This painting is recorded in his accounts book, and may have been used to pay part of his rent. Lotto has been inspired by ideas from his many paintings of the Holy Family to present his friends as an ideal family, with the parents' bodies curving protectively around their children. They play with cherries, symbols of paradise, on a table covered with an expensive Turkish rug. The girl heaps handfuls into her mother's palm, celebrating her mother's fruitfulness and expressing the hope that she, too, will have children one day.

What techniques does the artist use?

Lotto has used oil paint, covered by thin, transparent glazes to build up layers of rich colour. Such brilliant reds and blues were often used by Venetian artists, as many precious pigments were imported directly into their city from the East.

Why has it been chosen for this tour?

Because it lets us compare our own families to this one from the 1540s. What games do you all play – are these similar? The father holds some juicy cherries just out of reach of his son: is he teasing him, or trying to teach him a lesson? Why do you think the little boy is almost naked? And how does the view through the window affect this portrait – would you rather be inside or outside? Can you see any signs of danger that might explain why the parents look a bit worried and move to shelter their children? Some things don't change much: parents still become tired and anxious, still play, and still hope for the best for their offspring.

Lorenzo Lotto

- born in Venice, about 1480.
- travelled widely, working in Treviso, Bergamo, Rome and the Marches, central Italy.
- worked primarily as a painter of altarpieces.
- received the commission to decorate the Vatican Palace in Rome around 1508–9, though no trace of his work remains.
- applied colours in smooth, meticulous brushstrokes with a distinct separation between different tones.
- died in 1556–7 in Loreto, central Italy.

Tour 2 – step 4

Exit Room 12, past the lift and stairwell, towards the Central Hall, carrying straight through to Room 39, to reach Room 38.

The Stonemason's Yard 1727–8

Canaletto (1697–1768)
Oil on canvas, 123.8 x 162.9 cm

This poster may refer to the election of a new parish priest – might he have bought this painting?

The Church now houses the Accademia art gallery, and a wooden bridge spans the Grand Canal

This little boy looks distressed – what has happened?

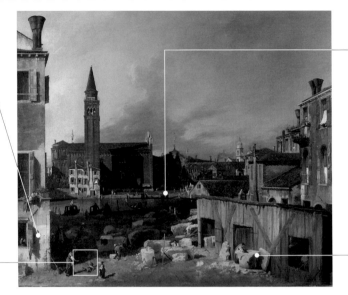

The well-head still exists in this square

Canaletto

- born in Venice, 1697.
- trained with his father and his brother, inspired by artist Giovanni Paolo Panini's paintings of the daily life of Rome and its people.
- from the 1720s, specialised in topographical views of the city.
- also worked as a printmaker, and published etchings.
- his paintings were particularly in demand by foreign visitors, especially the English.
- ran a large studio, with many assistants.
- made several visits to England.
- died in Venice, 1768.

What's so great about this painting?

The way it takes us behind the scenes in eighteenth-century Venice. Canaletto usually painted scenes of famous sights and glamorous festivals for tourists, but here we see more ordinary Venetian life.

What is it about?

This shows a temporary stonemason's yard that had been set up in the Campo San Vidal, to provide building material for the Church of San Vidal, which was being refurbished. The houses on the right and the sculpted well-head are there today, and you can still look across the Grand Canal to the church of Santa Maria della Carità. Its bell tower, however, fell down in 1744, demolishing the two white houses underneath. We see all kinds of ordinary life in this scene, from a mother settling a dispute between her children to gondoliers plying their trade and priests walking past washing lines. Did a local collector buy this, rather than one of Canaletto's more usual tourist clients?

What techniques does the artist use?

Canaletto made many sketches of Venice, but he rarely painted exactly what he saw. This is a carefully altered view, with buildings moved slightly so that together they form an attractive scene. Look how many roofs sit on the same horizontal line in the centre of the painting. He has also used repeated squares, triangles and arches to make patterns, adding buildings or windows to get the best effect.

Why has it been chosen for this tour?

Because there's so much detail to help us imagine what life in Venice was like at this time. Try to spot every person you can – who do you think they are, and what are they doing? The little boy in the foreground is so upset that he has had an accident; has his big sister done something to him? What tools are the stonemasons using, and how do you think they transported their blocks of Istrian stone through Venice?

Tour 2 – step 5
Carry on through Rooms 36 and 35, to reach Room 34.

The Graham Children 1742

William Hogarth (1697–1764)
Oil on canvas, 160.5 x 181 cm

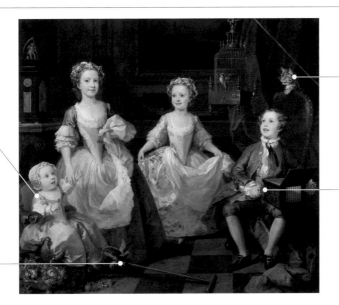

Thomas is 'in coats', wearing a dress, as boys under five usually did at this time

Mechanical baby carriage: the wings of the dove flapped as it was pulled along, also symbolic of the child's soul taking flight?

Unseen by the children, the cat is terrifying their pet bird

A carving of Orpheus playing music to charm the animals decorates this 'sérinette', an organ used to encourage caged birds to sing

What's so great about this painting?

This painting manages effortlessly to combine lively, believable portraits of children with serious symbols intended for their parents.

What is it about?

These are the children of the Royal Apothecary (pharmacist) Daniel Graham. They seem to be having fun playing together. Richard plays a mechanical organ to encourage their pet bird to sing; Anna holds her skirts up to twirl and dance. Their youngest brother Thomas reaches for the cherries that Henrietta holds out of reach. Yet we can see what they do not notice: the bird is in fact squawking with terror because of the cat that licks its lips and bares its claws. Their childhood innocence will pass – the clock with a Cupid holding Father Time's scythe points this out. This painting freezes time, so that the youngest boy is shown forever as an animated toddler. He had died by the time the painting was finished, so this portrait was a way for the family to remember him when he was full of life.

What techniques does the artist use?

Hogarth was largely self-taught as an oil painter, but despite his lack of formal training, he developed and published theories about what made something beautiful. He thought that 'serpentine' or S-shaped lines were particularly pleasing to the eye, and used them here in the girls' aprons.

Why has it been chosen for this tour?

The children are in charge – what would you do if there were no adults around? They are wearing their best party outfits: what would you wear? Would you have a basket of fruit to eat, or would there be other treats? Think about how the pets here compare to yours at home. If you had a portrait made of yourself with any brothers or sisters, how would you show yourselves?

This is the end of the Looking with children tour.

William Hogarth

- born in London, 1697.
- initially apprenticed as a goldsmith (about 1713), and worked as an engraver of prints.
- painted portraits but is probably best known for his satirical works and moralising narratives. Many, such as his 'Marriage-A-la-Mode' series – in the National Gallery Collection – were circulated as prints.
- by 1757, Hogarth was appointed Sergeant-Painter to King George II, earning several hundred pounds a year from fees for supervising decorative works.
- died in London, 1764.

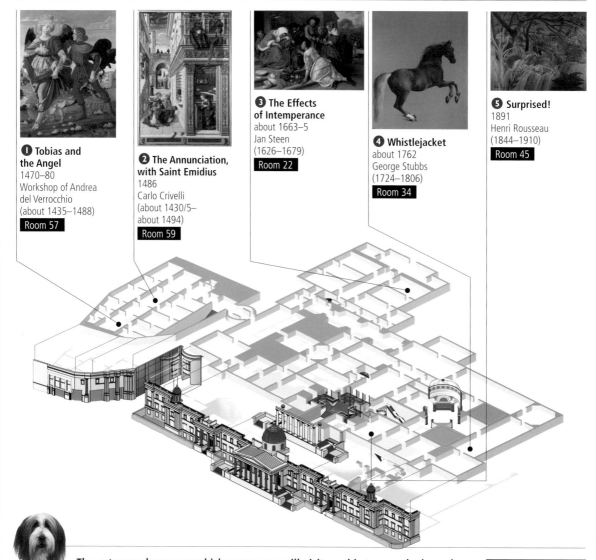

Tour 3 Animals

1 Tobias and the Angel
1470–80
Workshop of Andrea del Verrocchio
(about 1435–1488)
Room 57

2 The Annunciation, with Saint Emidius
1486
Carlo Crivelli
(about 1430/5–about 1494)
Room 59

3 The Effects of Intemperance
about 1663–5
Jan Steen
(1626–1679)
Room 22

4 Whistlejacket
about 1762
George Stubbs
(1724–1806)
Room 34

5 Surprised!
1891
Henri Rousseau
(1844–1910)
Room 45

The cutaway shows you which rooms you will visit on this tour, and where they can be found. This tour takes you in search of animals, from a disappearing dog and a fish with extraordinary powers to a tiger ready to pounce. Humans have depicted animals for as long as they have been making images. The characteristics attributed to different animals (faithful dogs, meek lambs) made them useful as symbols of that behaviour or quality. Certain birds and beasts became associated with particular gods, goddesses and Christian saints, making them instantly recognisable. Artists were also fascinated by wild animals: beautiful, unpredictable and savage.

Tour 3 – step 1
Start at the Sainsbury Wing Entrance. Go to the second floor and enter Room 51, to your left at the top of the stairs. Turn left, to go straight through Rooms 52, 53, 54 and 55. Turn right in Room 55, for Room 57.

Did you know?
Pelicans are symbols of sacrifice and nurture, because it was believed that they fed their young on their own blood. In fact, they press their long bills against their breasts to help bring up partly digested food for their chicks; without modern binoculars, it looked as if they were piercing their own flesh.

Tobias and the Angel 1470–80

Workshop of Andrea del Verrocchio (about 1435–1488)
Egg tempera on poplar, 83.6 x 66 cm

Box containing the fish's internal organs, which had miraculous powers

The dog may have been painted by Leonardo da Vinci – the brushstrokes look like his distinctive style

Highly decorated fabrics were fashionable in Florence at this time

Paper marked *ricordo* or 'memorandum' in Tobias's hand – this is the debt he must collect

What's so great about this painting?

The elegant lines and vibrant colours used to depict this well-dressed pair, its uplifting message about trust and friendship, and a disappearing dog that may have been painted by a young Leonardo da Vinci when he worked in Verrocchio's studio.

What is it about?

This story comes from the Bible (Book of Tobit, Apocrypha). The boy on the right is Tobias, sent by his blind father to collect a debt. On his journey, he was nearly eaten by a huge fish. A stranger (in fact the Archangel Raphael) urged Tobias to reach out and take the fish, as its innards would be of great help. Tobias trusted Raphael, and his faith was rewarded. He would use the fish's gall (bile) to cure his father's blindness, and its heart and liver to rid his future wife of a demon that had killed her seven previous husbands on their wedding night. Raphael was seen as a guardian angel protecting travellers, and was a popular subject in Florence.

What techniques does the artist use?

Verrocchio has used egg tempera, binding his colourful pigments with egg yolk and using bold areas of red and blue to create a strong visual impact. Like many of his Florentine contemporaries, he worked not only as a painter but also as a goldsmith and sculptor. This may explain the particular emphasis on elaborate shapes and decorative patterns here.

Why has it been chosen for this tour?

The fish is central to the story, and it identifies Tobias immediately. Verrocchio hasn't shown it as the monster described in the Bible; instead it is a carefully observed study of a market specimen. The crimson line on its belly shows it has been gutted, its organs safe in the box that Raphael holds. The dog, which trots along at the angel's feet, is also important. Trusting and faithful, it underlines the message that Tobias's behaviour was the right choice. This dog was created in thin layers of paint that have become partly transparent with age.

Andrea del Verrocchio

- born in Florence, 1435.
- trained as a sculptor, painter, draughtsman and goldsmith but was known above all for his sculpture. One of his most famous works is *David*, in the Bargello, Florence.
- greatly inspired by antique sculpture, which he re-interpreted in his work with increased naturalism and movement.
- ran a highly successful workshop, in which Leonardo da Vinci famously trained, which branched out into two studios: one in Florence and one in Venice.
- prestigious clients included the powerful Florentine Medici family.
- died in Venice, 1488.

Tour 3 – step 2

Enter Room 58, carrying on straight through, to reach Room 59.

The Annunciation, with Saint Emidius 1486

Carlo Crivelli (about 1430/5–about 1494)
Egg tempera and oil on canvas, 207 x 146.7 cm

A pigeon has brought news of the town's independence – this is being read on the bridge

Crivelli's trademark fruit – he showed off his painting skill by placing them so they seem to hang over the picture frame, tempting you to try to pick them up

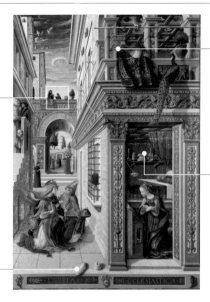

Caged domestic bird may refer to Mary's enclosed, virginal state

Mary's room is filled with objects that are both symbolic and practical, such as the jug of water that she can use but which also refers to her purity

Carlo Crivelli

- born in Venice
- sent to prison for adultery in 1457. This charge probably lead to a life of travelling to different courts, and to the development of his own individual style.
- trained as a painter with his father Jacopo, a local painter, though soon adopted the artistic style of the school of Squarcione at Padua, whose pupils included Andrea Mantegna.
- lived at Zara in Dalmatia in 1465. By 1468 had settled in the Marches, Italy Worked successfully here, becoming renowned for his delight in painted detail and decoration.
- knighted in 1490 by Ferdinand II of Naples.
- died in Ascoli, about 1494.

What's so great about this painting?

The precise use of perspective, and the way that the artist has imagined how people might have reacted if these miraculous events had happened in a house in their own town.

What is it about?

The Archangel Gabriel has come to visit the Virgin Mary, telling her she will give birth to the son of God. The Holy Spirit, in the form of a dove, is on its way towards her, gliding down a golden ray of light that comes from the heavens and passes through a conveniently placed hole in the wall of her elaborate palace. Onlookers in the street are astonished. Their interests are looked after by their patron saint, Emidius. He kneels by Gabriel, holding a model of Ascoli Piceno, the town for which this painting was made. Emidius's devotion had been recognised by the time this panel was installed as an altarpiece in 1486: the town had been granted a degree of self-government and the painting was commissioned to give thanks.

What techniques does the artist use?

Crivelli combined traditional egg tempera with newer oil techniques. He has also shown off his mastery of the relatively new tool of linear perspective, using dozens of precisely incised lines to zoom our eyes towards a vanishing point through the arch.

Why has it been chosen for this tour?

Birds play an important role in this painting. The Holy Ghost appears as a dove, and just below the disturbance in the clouds caused by his arrival, a carrier pigeon has flown in, bringing a second 'annunciation', that of the town's independence. There is also a peacock, a symbol of immortality. This bird's gorgeous tail meant that it could also signify richness, here glorifying the Virgin Mary. The 'eyes' on its feathers were interpreted as all-seeing eyes of powerful figures. When they appear in mythological paintings, they allow the goddess Juno to see everything; here, they remind us that God sees all.

Tour 3 – step 3

Return to the staircase, passing the stairs and lifts to enter Room 9. Turn left and go straight ahead into Room 15, straight through to Room 18, down to the end and turn right into Room 22.

The Effects of Intemperance about 1663–5

Jan Steen (1626–1679)
Oil on wood, 76 x 106.5 cm

Basket containing the crutch and clapper of the beggar and the birch of judicial punishment – poverty and crime could result if the parents' behaviour doesn't improve

Here, an older man (the father of the family?) behaves just as foolishly, drinking and flirting with the young girl

Cheese, bread and fruit lie forgotten on the step, the glistening grapes an enticement to eat them before they are fermented

Parrot mimicking its owners, drinking wine. Has the girl who offers it a glass also begun to imitate the mother?

What's so great about this painting?

It uses popular proverbs and visual jokes to make a moral point about how people should behave. This artist's humorous pictures became so famous in the Netherlands that even now, a boisterous and ramshackle family is called a 'Jan Steen household'.

What is it about?

This illustrates the Dutch saying that 'wine is a mocker' – it makes fools of us all. The mother of this family has fallen asleep, and the pewter flagon tipped over on its side suggests that over-indulgence is the reason why. If the clay pipe doesn't burn her skirt, the small coal brazier to the left will surely set it on fire. Her children gleefully take advantage of this lack of supervision, wasting food, flowers and more wine on animals. One little boy even picks his mother's pocket. Dutch viewers might have smiled at such chaos, but also understood that it represented the real possibility of moral and social breakdown.

What techniques does the artist use?

Steen uses oil paint in broad, fluid strokes that may have been influenced by nine years spent in Haarlem, where Frans Hals was famed for such techniques. The delicately painted still life deliberately contrasts with the main characters' coarse features: they may have fine things, but they are unattractive, due to the way they act.

Why has it been chosen for this tour?

Animals are central to the communication of the painting's moral message. The clever cat takes the chance to eat a valuable meat pie, helped by the unsupervised children. A pig illustrates a popular saying about foolish behaviour, as it happily munches on roses thrown before it (just as in English we mock those who cast pearls before swine). The parrot plays the most important role: it has learned to mimic the humans and drink wine. Will the children do the same? Viewers are encouraged to watch and learn, and urged to decide not to imitate this foolish behaviour.

Jan Steen

- born in Leiden, the Netherlands, 1626.
- was a prolific painter of genre pictures.
- travelled around the Netherlands to work, but struggled to make a profitable living.
- set up a brewery with his father, but this appears to have been unsuccessful. Steen went on to open a tavern.
- his work was admired for its fine characterisation, strong brushwork and rich colours.
- died in 1679.

Tour 3 – step 4

Return to Room 29 and turn left to enter Room 30. Carry on straight through Room 32, to enter Room 34.

Whistlejacket about 1762

George Stubbs (1724–1806)
Oil on canvas, 292 x 246.4 cm

Bare background was deliberate. It may have been inspired by classical sculptures; it also makes Whistlejacket's body look more three-dimensional

Did the horse's owner plan to show King George III on Whistlejacket's back, then change his mind for political reasons? There is no firm evidence, although some contemporaries suggested this

We see the whites of Whistlejacket's eyes, reminding us of his nervous disposition and wild ancestry

The horse may have been given its name from a medicinal drink of gin and treacle called a Whistlejacket, which had a rich brown colour

George Stubbs

- born in 1724, Liverpool, the son of a leather worker.
- largely self-taught as a painter; dissected horses and detailed his study of their anatomy.
- famous for his pictures of horses, painted with remarkable accuracy. Early clients for his equestrian paintings included many of the founders of the Jockey Club.
- also became known as a printmaker and for his paintings in enamel on Wedgwood earthenware plaques.
- died in 1806.

What's so great about this painting?

The fact that it's so realistic, and life-sized – it looks as if this horse could jump out of the picture frame and gallop off at any moment.

What is it about?

This is a portrait of Whistlejacket, a famous eighteenth-century racehorse. He made his name at York Races in 1759, when he beat Brutus to win the huge stake of 2,000 guineas for his owner, the 2nd Marquess of Rockingham. He is shown rearing up, in a pose which suggests barely tamed wildness, with no rider or reins to control him. Whistlejacket did have a reputation for being highly strung, but Stubbs also wanted to communicate a sense of the 'sublime', the awe-inspiring thrill of the natural world. We are given a glimpse of horseshoes, but any mastery man has over this beautiful animal is a fragile one at best.

What techniques does the artist use?

Stubbs used oil paint to achieve the picture's realistic effects, along with his intimate knowledge of horse anatomy. Helped by his life partner Mary Spencer, he spent years involved in the laborious business of dissecting horses. They suspended each carcass from the ceiling, and replaced its blood with warm tallow, which hardened and prevented the horse's veins from collapsing. Stubbs then gradually stripped the layers of muscle away, recording his findings in detailed drawings that would help vets as much as artists.

Why has it been chosen for this tour?

This portrait was probably commissioned because Whistlejacket was a perfect specimen of a thoroughbred horse, descended from one of the three Arabian horses first imported into Britain for racehorse breeding. Stubbs knew exactly which features to emphasise: his small tapering head, large nostrils, curved ears and powerful body.

Tour 3 – step 5
Return to Room 36, turning left to head straight through Rooms 40 and 44. Turn right to reach Room 45.

Surprised! 1891

Henri Rousseau (1844–1910)
Oil on canvas, 129.8 x 161.9 cm

The painting's entire surface is covered with semi-transparent grey-and-white glazed stripes, to suggest rain

Jungle based on domestic pot plants and specimens from the Botanic Gardens in Paris – this is a rubber plant

Lightning shows the wildness of the storm

The tiger is based on a range of sources, including a domestic cat

What's so great about this painting?

This combination of the naïve and childlike with a sense of genuine menace, conveyed by an elaborate pattern of shapes and colours.

What is it about?

Rousseau has imagined a tiger, ready to pounce on its prey, in the middle of a violent storm. We don't know whether the title was meant to refer to the tiger itself, startled as lightning strikes, or to the object of its fixed gaze (an animal, or perhaps human hunters about to get a taste of their own medicine). An untutored 'Sunday' painter, Rousseau left his job working in a Parisian office to be a full-time artist. This was the first of the jungle pictures for which he became famous, tapping into a trend for exotic, 'oriental' themes and a curiosity about unknown, uncivilised lands and their savage animal life. His focus on shapes and patterns rather than realism can be seen as a move towards abstract art.

This is the end of the Animals tour.

What techniques does the artist use?

Rousseau admitted he had never 'travelled further than the glass houses of Paris's Jardin des Plantes'. He took as source material everything from stuffed animals in museums to prints, scientific illustrations and a pastel drawing of a tiger fighting a lion, by Eugène Delacroix. Having created a fantasy jungle from a collage of domestic pot plants, he used a pantograph (mechanical enlarger) to add the tiger. This is perhaps why the animal seems to float on the vegetation at its feet. The densely patterned composition may have been inspired by medieval tapestries and Persian miniatures.

Why has it been chosen for this tour?

This is the most popular animal in the Gallery. It isn't the most realistic painting of a wild beast ever made, seeming to be part domestic cat, part stuffed animal and part oriental print. However, Rousseau conveys something of the tiger's untamed nature, perhaps through the thrashing branches overhead.

Henri Rousseau

- born in 1844 in Laval.
- the most celebrated of the 'Naïve artists' – received no formal training as a painter and painted from his imagination and from books and prints.
- served in the French Army as a young man.
- was nicknamed 'Le Douanier', referring to his day-job at a municipal toll-collecting office in Paris.
- took an early retirement in 1893 to concentrate on his painting and found support among young Parisian Avant-garde artists, such as Vollard and Picasso.
- died in 1910.

Tour 4 Impressionism and beyond

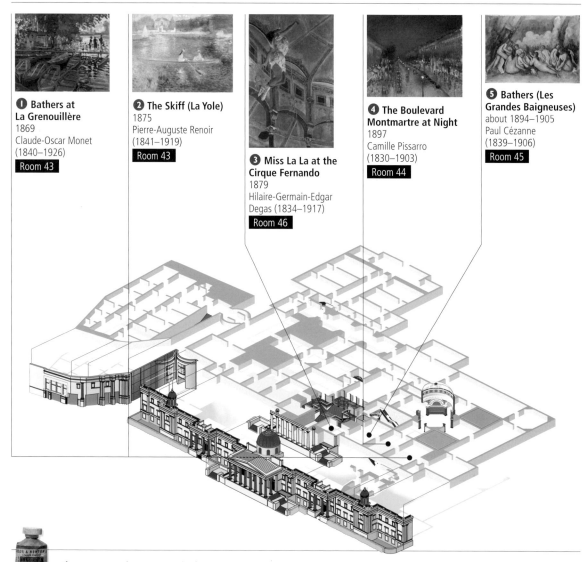

1 Bathers at
La Grenouillère
1869
Claude-Oscar Monet
(1840–1926)
`Room 43`

2 The Skiff (La Yole)
1875
Pierre-Auguste Renoir
(1841–1919)
`Room 43`

3 Miss La La at the
Cirque Fernando
1879
Hilaire-Germain-Edgar
Degas (1834–1917)
`Room 46`

4 The Boulevard
Montmartre at Night
1897
Camille Pissarro
(1830–1903)
`Room 44`

5 Bathers (Les
Grandes Baigneuses)
about 1894–1905
Paul Cézanne
(1839–1906)
`Room 45`

The cutaway shows you which rooms you will visit on this tour, and where they can be found. The Impressionists were a loosely connected group of artists working in and around Paris from the 1860s onwards, particularly active in the 1870s. They were never formally organised, instead coming together over certain shared interests: painting out of doors, depicting modern life rather than historical themes, and trying to capture the essence of a scene through rapid, expressive brushstrokes. Often rejected from the official art show in Paris (the 'Salon'), they displayed their work in independent exhibitions. Their techniques were radical at the time, and opened up possibilities for early twentieth-century painters.

Tour 4 – step 1
Starting at the Portico Entrance, go through to the Central Hall. Turn right, into Room 39, straight through Rooms 39, 38 and 36. Turn right into Room 40, straight through to Room 44. Turn right into Room 43.

Did you know?
The term 'Impressionist' was originally intended as an insult. When the critic Louis Leroy saw Monet's painting *Impression: Sunrise* in 1874, he used the word sarcastically in a scathing review, adding that 'wallpaper in its embryonic state is more finished than that seascape'.

Bathers at La Grenouillère 1869

Room 43

Claude-Oscar Monet (1840–1926)
Oil on canvas, 73 x 92 cm

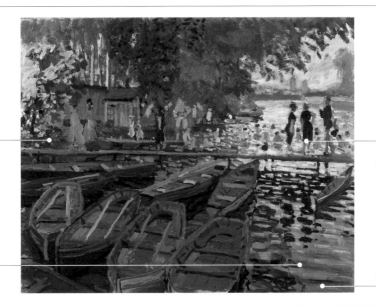

Women dressed up in their brightest and best outfits, who have come to see and be seen

Broad, choppy strokes suggest water, their angular edges made possible by new metal ferrules on brushes: these clamped the bristles together into a flat, square shape

Just a few brushstrokes create this woman's pose, the hand on her hip suggesting her feisty, flirtatious character

Monet's signature, added later, perhaps a sign that he hoped to sell this work

What's so great about this painting?

The way that Monet can suggest everything from light on water to someone's personality with just a few strokes of paint. You can almost hear the shouts from the bathers as they splash about in the cool River Seine.

What is it about?

Monet set up his easel at the drinking and bathing spot of La Grenouillère, the 'frogpond'. Here, women of easy virtue (known as 'frogs') would gather to have fun with visitors who made the short train journey from Paris. The two women silhouetted on the wooden jetty are flirting openly with the fully dressed man: no respectable woman would have been seen out of the water in her swimming costume. The group of heads behind the trio may be a swimming lesson; later, participants could cross the jetty to a floating restaurant. Monet lived nearby during the summer of 1869, painting outdoor scenes like this with his friend Renoir, surviving with his family on little money.

Tour 4 – step 2
Remain in Room 43.

What techniques does the artist use?

Monet has used oil paint in rapidly applied strokes, making the picture appear informal and spontaneous. He did begin this work outside at La Grenouillère, though X-rays have shown it wasn't done in one sitting. He turned his canvas upside down, started again and, later, probably back in the studio, repainted the position of some of the boats. Getting the right 'impression' could require a considerable amount of work.

Why has it been chosen for this tour?

It's a key early Impressionist work, capturing an outdoor scene from contemporary life in suggestive, sketchy strokes. Monet did not intend this as a finished work: it was initially a sketch for a larger painting (now lost) that he sent to the Salon of 1870. He would sometimes later retouch sketches like this and exhibit or sell them as finished. This was partly an act of rebellion against official standards that he felt judged his work harshly, and partly a practical move to earn more money.

Claude-Oscar Monet

- born in 1840.
- introduced to painting *en plein-air* ('from nature') around 1856 by Eugène Boudin.
- entered the studio of Charles Gleyre, in Paris, in 1864, meeting Renoir, Sisley and Bazille.
- moved to London 1870–1 to escape the Franco-Prussian War.
- lived 1871–8 at Argenteuil, which was to draw many other Impressionist painters.
- co-organised the first Impressionist exhibition in 1874.
- settled in 1886 at Giverny, where he painted his famous waterlilies.
- died 1926, Giverny.

The Skiff (La Yole) 1875

Pierre-Auguste Renoir (1841–1919)

Oil on canvas, 71 x 92 cm

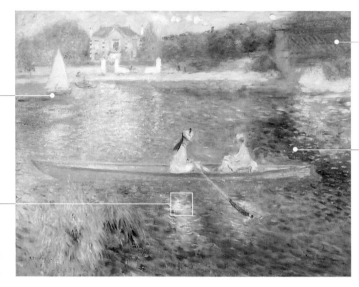

Use of contrasting orange and blue colours to achieve vibrant effect

Wet paint applied on top of wet paint, usually a sign of rapid work done on the spot

Location could be Chatou, close to Asnières – the railway bridge may be the same one as in Seurat's *Bathers at Asnières* (see Tour 5, p. 62)

Wet paint dragged over dry paint – a sign that the artist has reworked the picture in the studio, after the initial paint application had dried

Pierre-Auguste Renoir

- born in Limoges, France, in 1841, but raised in Paris.
- entered the studio of Charles Gleyre in 1861, meeting Bazille, Monet and Sisley.
- exhibited at the first Impressionist exhibition of 1874.
- developed a reputation as a portraitist of popular society figures.
- began travelling around Europe and North Africa in the 1880s. Influenced by Raphael and the frescos in the Vatican, his style became more linear and classical.
- died at Cagny-sur-Mer in France, 1919.

What's so great about this painting?

The way that it evokes the shimmering heat of a summer's day, using strong contrasting colours and bright highlights to make the surface of the painting appear to sparkle before our eyes.

What is it about?

The skiff referred to in the title is the shallow boat in the centre of the canvas, used by two middle-class women as they spend their leisure time rowing and reading. Renoir frequently painted day trippers on the River Seine: when asked where his studio was, he would point to the river and say 'here it is!' He worked in the open air using soft metal tubes of oil paint, a mid-nineteenth-century innovation that made painting outside the studio much more practical. His real subjects here could be said to be water, reflections, air, light and atmosphere, all shifting elements that are difficult to suggest in a single painted 'moment'.

What techniques does the artist use?

Renoir restricted his palette to lead white and just seven intense synthetic pigments, most of which were recently developed bright colours. He used them unblended, sometimes straight from the tube. Exploring optical theories proposed by the French chemist Chevreul, he achieved dazzling effects by placing contrasting colours (such as orange and blue) directly side by side.

Why has it been chosen for this tour?

It shows Renoir undertaking a key Impressionist challenge, that of capturing atmospheric effects in paint. To do so, he combined cutting-edge theory with experimental techniques, applying thick crusts of paint in some parts yet letting his barely primed canvas show through in others, adding to the light, airy effect of the scene. He reworked parts of the picture later in the studio: his 'formless spontaneity' was carefully considered.

Tour 4 – step 3

Enter Room 44, carrying on straight through to Room 45, to reach Room 46.

Miss La La at the Cirque Fernando 1879

Hilaire-Germain-Edgar Degas (1834–1917)
Oil on canvas, 117.2 x 77.5 cm

Her body is carefully positioned so that her arms and legs echo the lines of the roof and the rope; woman and building are treated as interlocking compositional elements

Lines look like creases in stockings, but she performed with bare legs; these lines also appear on her arms, probably caused by Degas's habit of scrubbing and working them over repeatedly

X-rays show that Degas struggled to achieve the correct perspective in the roof; the painter Walter Sickert noted that he had to hire a professional draughtsman to help him

Rapid brushstrokes suggest speed and movement as Miss La La flies through the air

What's so great about this painting?

The daring viewpoint: we seem to be hovering in mid air, gazing up at the dizzying sight of this circus performer as she shoots towards the roof, hanging by her teeth alone.

What is it about?

Miss La La was a black wire-walker, trapeze artist and strong woman who was famous across Europe. The finale of her act saw her hang upside down from a trapeze and hold a cannon with her teeth while it was fired. Degas sketched her in Paris at the Cirque Fernando, a permanent urban spectacle close to his home. He did not, however, focus on her as an individual: we don't see her face, and only her hair seems to suggest her ethnicity. Degas was more interested in the overall effect of Miss La La's body as it flew through the air, both echoing and contrasting with the architecture. He was fascinated by female bodies captured in movement or twisted into difficult poses, from ballet dancers to women drying themselves.

What techniques does the artist use?

Unlike some of his Impressionist friends, Degas never aimed to make spontaneous paintings in a single sitting. Nor did he paint outside, grumbling that all artists should be kept indoors with the 'threat of a whiff of grapeshot'. Instead, he made charcoal and pastel sketches on the spot, which he then combined into an imaginary scene back in the studio. Miss La La is deliberately set off-centre: Degas was influenced by Japanese prints, which often placed their main subjects to one side and cropped them in dramatic ways.

Why has it been chosen for this tour?

It shows how the shared aims of the Impressionists could also be achieved by an approach very different to the rapid, suggestive brushstrokes of Monet and Renoir. This is modern life at its most exciting, but painted as part of a painstaking process of construction and refinement.

Hilaire-Germain-Edgar Degas

- born in Paris in 1834.
- intended to study law, but instead chose to train as an artist with a pupil of Ingres. This training helped give his art a strong sense of classicism and line.
- his wealthy background allowed him to follow his own artistic interests. Was drawn to scenes of contemporary life – dancers, entertainers and women at their toilette.
- often worked in pastel, charcoal and pencil, as well as painting, and was a brilliant draughtsman.
- died in Paris, 1917.

Tour 4 – step 4

Return to Room 45 and head straight through, to reach Room 44.

The Boulevard Montmartre at Night 1897

Camille Pissarro (1830–1903)
Oil on canvas, 53.3 x 64.8 cm

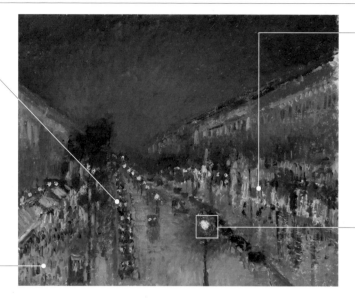

Carriages lined up, waiting for the show at the Moulin Rouge (just round the corner) to finish

Almost abstract marks suggest throngs of people on the side of the street, sheltering under trees and shop awnings

Contrasting yellow light of carriage lamps and orange glow of gas lights in shop windows

New electric street lights – Pissarro focused on their distinctive white globes and blue aura

Camille Pissarro
- born in the Danish Virgin Islands in 1830, and educated in Paris.
- largely self-taught but was influenced by many artists, including Daubigny, Corot and Courbet. Met Monet and Cézanne in the early 1860s.
- like Monet, fled to London in 1870–1 to escape the Franco-Prussian War. Became inspired by Turner and Constable, and painted views of London.
- was interested in the human and industrial aspects of landscape.
- died in 1903 and was buried in the famous Père Lachaise Cemetery, Paris.

What's so great about this painting?

The blurred quality of the surface, which makes it look like a wet scene viewed through a rain-drenched window. Both gas and electric lighting were modern developments, fitting subjects for such a progressive artist.

What is it about?

Thirty years after he had been part of the main burst of Impressionist activity, Pissarro returned to some of his original concerns in a new series of street scenes. His dealer, Durand-Ruel, suggested the idea, with a series showing the same view in different light or weather conditions. Pissarro lodged in the Grand Hôtel de Russie, on a corner that allowed him to observe this wide boulevard round the clock. Of fourteen versions of this view, this is the only night scene. Pissarro used all of his expertise to capture the effect of brightly-lit shop windows and street lamps. Evening strolls involving window shopping were a new leisure activity, apparently even in the pouring rain.

Tour 4 – step 5
Return to Room 45.

What techniques does the artist use?

Pissarro has employed a wide range of brushstrokes and means of applying his oil paint. Some of the smaller lights have been suggested simply by dabs from an uncapped tube of oil paint. Energetic, short strokes give form to the sky so that it radiates out from the horizon, subtly changing colour to suggest the glow of light pollution, seen by Pissarro as exciting.

Why has it been chosen for this tour?

Because it shows that Impressionist artists were still producing innovative work at the turn of the last century. You can also see how these sorts of pictures may have inspired more abstract painters in the next generation. Pissarro wrote in 1897: 'I am delighted to be able to paint those Parisian streets that people have come to call ugly, but which are so silvery, so luminous and vital… this is completely modern!'

Bathers (Les Grandes Baigneuses) about 1894–1905

Paul Cézanne (1839–1906)
Oil on canvas, 127.2 x 196.1 cm

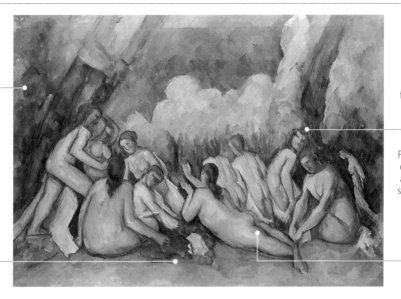

Forms suggested by flat, geometric patches of colour

Mask-like faces prevent the viewer from reading emotions and narrative into the painting

Figure reduced to basic cylindrical shape. She's also been viewed from slightly different angles – several sketchy outlines create her shape, which is why she seems to have three buttocks

Is this a dog? Cézanne leaves it as an ambiguous form

What's so great about this painting?

Cézanne used the classical theme of bathers as the starting point for an exploration of the world as a series of increasingly abstract shapes and masses. When it was exhibited in 1907, it inspired Picasso just as he and others began to develop Cubism.

What is it about?

After long hours of study in the Louvre museum, Cézanne was familiar with Old Master paintings of bathers, a favourite subject for artists and patrons that embodied the idea of man and nature in harmony in 'Arcadia', an idyllic mythical retreat. However, Cézanne's figures are not individualised, and they play no role in a literary story. Their faces are like masks, so it's difficult for us to work out their emotions. They are bunched tightly together, yet don't seem to interact. Both figures and landscapes are reduced to essential shapes, combined to form patterns of light and colour. The painting is fundamentally about these patterns.

This is the end of the Impressionism and beyond tour.

What techniques does the artist use?

Cézanne used sketches made from models, as well as drawings of statues done in museums. He also frequently painted the landscape around his home town, Aix-en-Provence. He used his imagination to create monumental forms, experimenting with flat, geometric planes of colour as a way of representing trees, hillsides and sky. The space in which the figures are placed here is deliberately confusing. We can never feel we have quite grasped it, so we have to keep on looking.

Why has it been chosen for this tour?

Because it shows the different directions taken by the Impressionists. Cézanne exhibited at their first show, but broke away, spending the rest of his career finding a new approach to painting. Many critics found his work unattractive, his figures rough and ungainly. Only later did it become clear how important Cézanne was in the development of modern art.

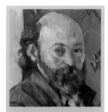

Paul Cézanne

- born in Provence in 1839.
- practised with Pissarro in the 1870s and participated in the first and third Impressionist exhibitions.
- associated with the Impressionists, but always had other aims. Said that his ambition was to 'make of Impressionism something solid and durable like the art of museums'.
- worked mainly in Aix in the 1890s.
- had his first one-man show in 1895, and exhibited widely in his later years.
- died in Aix, 1906.

Tour 5 Colour and technique

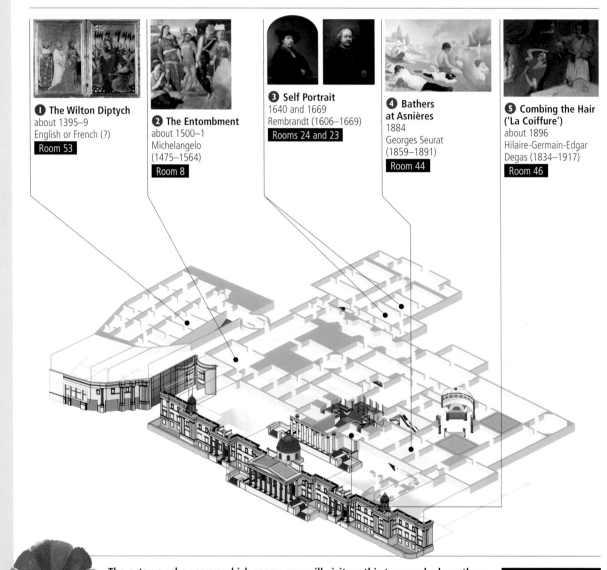

1 **The Wilton Diptych**
about 1395–9
English or French (?)
`Room 53`

2 **The Entombment**
about 1500–1
Michelangelo
(1475–1564)
`Room 8`

3 **Self Portrait**
1640 and 1669
Rembrandt (1606–1669)
`Rooms 24 and 23`

4 **Bathers at Asnières**
1884
Georges Seurat
(1859–1891)
`Room 44`

5 **Combing the Hair ('La Coiffure')**
about 1896
Hilaire-Germain-Edgar
Degas (1834–1917)
`Room 46`

The cutaway shows you which rooms you will visit on this tour, and where they can be found. This tour explores colour and technique. What did different colours mean, and how were they achieved? The tour includes a fourteenth-century puzzle – a painting that combines techniques normally found in completely different parts of Europe. An unfinished painting by Michelangelo offers a glimpse into his unusual working method, while two self portraits by Rembrandt allow us to see how his approach to paint changed during his career. Pictures by Seurat and Degas show the development of a new systematic technique, and the dramatic use of colour.

Tour 5 – step 1

Start at the Sainsbury Wing Entrance. Go to the second floor and enter Room 51, to your left at the top of the stairs. Turn left, going straight through Room 52, to reach Room 53.

Did you know?

Ultramarine, the rich blue colour used in many early paintings, was actually more expensive than gold. It was made from lapis lazuli, a semi-precious stone imported from Afghanistan. The long journey it made to western Europe gave it its name, which is Latin for 'beyond the sea'.

The Wilton Diptych about 1395–9

English or French (?)
Egg on oak, 53 x 37 cm

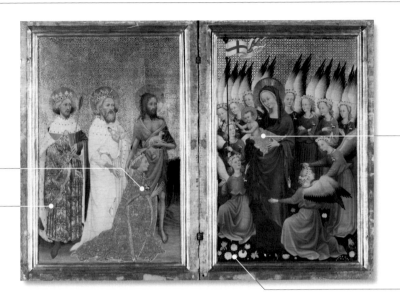

Jewel-encrusted surfaces created with blobs of thick lead white paint, and chalk covered with coloured glaze

Patterned fabrics created using *sgraffito* – the gold surface was painted over, then the design was formed by scratching off the paint

Folds on Christ's robes formed by 'stippling', punching tiny dents into the gold

Colours can change over time: the peach roses were originally white, symbolising Mary's purity. The pink roses were originally red, a sign of Christ's courage and suffering

What's so great about this painting?
The intense ultramarine blue of the robes worn by the Virgin Mary and angels, the colour of heaven; and the beautiful patterns of the angels' wings. Opening this folding painting up must have been like looking into a jewel box.

What is it about?
This is a diptych, a painting made from two panels joined so that they open like a book. The outside is decorated with the coat of arms and symbols of King Richard II of England, including his white hart badge. Inside, Richard kneels in prayer, presented to the Virgin, Christ and angels by his patron saints. Those in heaven show their approval: Christ leans forward with a gesture of blessing, and the angels demonstrate support by wearing simpler versions of the white hart badge. A banner that refers both to Christ's resurrection and the English flag of Saint George is passed towards Richard, a much-needed sign of divine confidence in a king who in reality was weak and ineffective.

What techniques does the artist use?
The pieces of oak that make up the diptych were first sealed with glue made from animal skins, which then had strips of parchment stuck on top. This was covered with layers of smooth chalk, which formed the basis for egg tempera paint: ground, coloured pigment bound together with egg yolk. Thin sheets of gold were stuck onto a layer of red bole (clay), rubbed down with a piece of amber, and decorated with patterns lightly punched into the surface.

Why has it been chosen for this tour?
Technical clues can help pinpoint the origin of unknown artists. The oak panels and chalk ground suggest northern European painting, but the gilding follows Italian practices and the angels' folded arms are found in Sienese painting. The Virgin's face and hands look like French illuminated manuscripts, but showing Saint John the Baptist wearing an entire camel skin was an exclusively English tradition. Did a group of artists work on this piece?

Unknown artist
- the unknown artist is believed to be English or French due to the subject represented and because the panels are made of north European oak.
- the diptych was painted as a portable altarpiece for the private devotion of King Richard II (1377–1399).
- the white hart was Richard's personal device, and the collars worn by Richard and the angels were the device of Charles VI, King of France, which Richard probably took over. The diptych is thought to have been made in the last five years of Richard's reign, when he was seeking reconciliation with France.
- it is called *The Wilton Diptych* because, by 1718, it was in the collection at Wilton House, the seat of the Earls of Pembroke.

Tour 5 – step 2
Return to the top of the Sainsbury Wing staircase, pass the lifts and head straight through to Room 9. Turn right to enter Room 8.

The Entombment about 1500–1

Michelangelo (1475–1564)
Oil on wood, 161.7 x 149.9 cm

Figure could be male or female, possibly Saint John the Evangelist. Ideals of male beauty can seem quite feminine to modern eyes; however, Michelangelo often painted rather masculine women

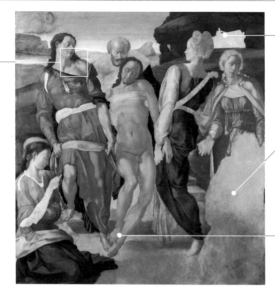

Paint removed to create tomb opening

This bare patch would have contained the Virgin Mary – Michelangelo seems not even to have sketched her in when he left the panel

Christ appears to float, even though his friends struggle to hold his weight, a sign that he will be resurrected

Michelangelo
- born 1475 in Caprese, central Italy.
- preferred to work as a sculptor. His most famous work, *David*, typifies his obsession with creating the idealised male nude.
- his cartoon *Battle of Cascina* (1504–7), known only through copies, had a lasting impact on generations of artists.
- his frescos for the Sistine Chapel ceiling (1508–12) are his most celebrated painted works.
- was in great demand as an architect, and also wrote sonnets and madrigals.
- died in Rome, 1564.

What's so great about this painting?
It's a rare unfinished panel painting by the Renaissance artist Michelangelo – most of his painted work was fresco, applied directly onto wet plaster walls; many still decorate buildings in Italy. It shows his enduring fascination with twisting muscular bodies held in tension.

What is it about?
This picture shows the moment when Christ, taken down from the cross, is being moved to a tomb by his grieving family and friends. There is some dispute about who all of the figures are, but the older man behind Christ is probably Joseph of Arimathea, a wealthy disciple who donated his own tomb for the burial. The figure in red helping to support Christ may be Saint John the Evangelist, and kneeling at his feet is Mary Magdalene, looking at something in her hand. A drawing shows that Michelangelo had planned to depict her contemplating the crown of thorns that had been removed from Christ's head.

What techniques does the artist use?
Michelangelo used oil paint, but didn't work over the whole panel, building up successive layers. Instead, his work as a sculptor and fresco painter influenced his technique in oils. We can see that whole figures were carefully painted in one at a time: fresco demands this approach, as you just apply wet plaster to the area you can paint in one session, and the joins between sections show least if they follow the outlines of a figure or object. It's also clear that Michelangelo sometimes painted in the same way that he made sculpture, his greatest artistic passion. He has created the shape of two figures opening up the tomb by scraping away the paint applied to represent rock, removing material as he did when carving marble.

Why has it been chosen for this tour?
This painting was left unfinished in Rome when Michelangelo returned to Florence, so allows us a glimpse of the artist's unusual working process.

Tour 5 – step 3
Go to Room 6, heading straight through to Room 4. Turn left into Room 5, and straight through Rooms 11, 14, 29 and 28, carrying on straight through to Room 25. Turn left to reach Rooms 24 and 23.

Self Portrait 1640 and 1669
Rembrandt (1606–1669)
Oil on canvas, 102 x 80 cm and 86 x 70.5 cm

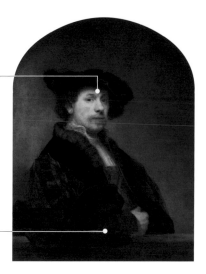

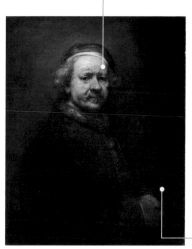

Smooth paint to create precise, skilful illusion

Arm on ledge is a deliberate reference to a celebrated portrait by Titian, (see Tour 10, p. 91)

Textured paint gives a more suggestive effect of older skin, grief and exhaustion

X-rays show his hands originally held a paint brush: did Rembrandt decide to show himself as a man rather than as an artist?

What's so great about these paintings?
They show us one of the most famous Dutch artists at different points in his life, as a proud and successful 34 year old and at a weary 63, a few months before his death.

What are they about?
In the first self portrait, Rembrandt meets our gaze with confidence, turning his own shrewd scrutiny on us. By 1640, he had made a good marriage and established a thriving art business. He is dressed in an elaborate costume from the previous century, adopting a pose designed to remind viewers of famous portraits by the Italian masters Raphael and Titian: Rembrandt positions himself as the next great artist. In the second self portrait, he still makes eye contact, but it's as if the intervening years have been etched on his face. His wife, his beloved son, and his long-term partner had all died, and he had been declared insolvent. However, he had clearly not lost his extraordinary ability to express emotion through paint.

What techniques does the artist use?
Rembrandt used oil paint in different ways at various points in his career. His earlier work is more detailed, carefully painted to create the illusion of cloth and skin. The later self portrait shows how experimental he became as he aged, applying thick, textured paint in loose, suggestive strokes. He used a palette knife as well as a brush, to plaster, cut and scrape paint.

Why have they been chosen for this tour?
Because they allow us to see how Rembrandt's technique changed over time. They also demonstrate what could be achieved with a very limited range of colours. This was perhaps a self-imposed challenge that Rembrandt's contemporaries would have understood and respected: Rembrandt could create paintings of great beauty using just earth pigments, lead white and bone black.

Rembrandt
- born in Leiden in the Netherlands, 1606.
- concentrated on portraits, biblical and mythological subjects, genre scenes, still life and landscapes.
- popularised a new kind of painting, the *tronie* or portrait head, usually in costume.
- his most famous portrait commission is popularly known as *The Night Watch* (1642).
- recognised as the greatest Dutch painter and one of the most important artists in the tradition of western European art.
- died in Amsterdam, 1669.

Tour 5 – step 4
Return to Room 29, turning left to go through Rooms 30 and 32. Turn right to reach Room 37, heading straight through Rooms 36 and 40, to reach Room 44.

Bathers at Asnières 1884

Georges Seurat (1859–1891)
Oil on canvas, 201 x 300 cm

Train steaming across the bridge, bringing day trippers from Paris

The landscape has been carefully planned as a series of triangles, from the sloping river bank to triangular trees which echo sails

Curved backs are repeated across the canvas, setting up a pattern

Area reworked to include dots of contrasting blue and orange

Georges Seurat

- born in Paris in 1859; entered the Ecole des Beaux-Arts in 1877.
- inspired by Ingres, Delacroix and the scientific theoreticians of colour; developed the approach to painting called 'pointillism'.
- began his first important project, the *Bathers at Asnières*, in 1883, and shortly afterwards painted a companion piece, *A Sunday Afternoon on the Island of La Grande Jatte*.
- began painting the borders and frames of his pictures using pointillism in 1887.
- died suddenly in Paris, aged just 31, in 1891.

What's so great about this painting?

It represents a radical attempt at a scientific method of painting, from its geometric composition to the separate touches of colour that Seurat would develop into the dots that formed his 'Pointillist' technique.

What is it about?

It's a modern take on the classical theme of bathers, set in the Parisian suburb of Asnières. Working men and boys enjoy their day off, although they don't talk and there's no sign of pleasure. Was Seurat making a point about the alienation of modern life? In the background, the factories of Clichy replace the more usual mountains. The men are also ignored by the wealthier couple being rowed across the river to the more elegant island of La Grande Jatte: the lady has turned her round white parasol in their direction, to ensure that she doesn't see naked male flesh by accident. Each figure is a vital form in Seurat's carefully composed design, as shapes and lines echo each other.

Tour 5 – step 5

Enter Room 45, and go through to Room 46.

What techniques does the artist use?

Seurat began by making conté crayon drawings of groups of figures, studying light and shade. He moved on to small painted studies, and gradually planned the full-scale canvas. Here, he has applied oil paint in small strokes, placing different colours side by side and on top of one another. Grass is not just green: on the bank next to the boy in the red hat, Seurat has used viridian green, cadmium yellow, cobalt blue, French ultramarine (a greyer blue), mauves and purples created by blue pigments mixed with red lake, as well as pure red, orange and pink. He was fascinated by chemist Chevreul's observations of how colours acted on each other when placed close together, and used his theories to achieve more vibrant results.

Why has it been chosen for this tour?

Seurat developed a new systematic approach to painting, and this picture shows him working it out. He returned to this canvas to add dots of contrasting colours in key areas.

Combing the Hair ('La Coiffure') about 1896

Hilaire-Germain-Edgar Degas (1834–1917)
Oil on canvas, 114.3 x 146.7 cm

Long black lines sketch in the main forms – Degas changed the angle of this arm, and the previous line shows through

Small areas of cool grey used to heighten the effect of the warm reds

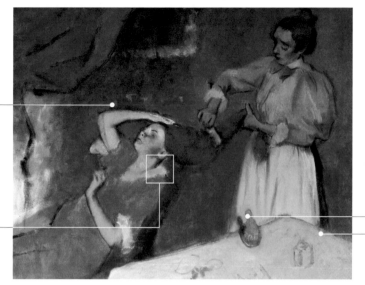

Small touches of yellow really stand out

Bare canvas left to create areas of white cloth

What's so great about this painting?
What Degas manages to do with one colour. This painting suggests many different ideas; red is a central part of communicating all of them.

What is it about?
A maid brushes the long, red hair of her mistress. But her dress and the room are red, too, creating an extraordinary effect. The painting seems to generate an oppressive heat. The colour also suggests pain, underlined by the way that the mistress holds the roots of her hair against the maid's firm tug. Is she pregnant, exhausted in the hot weather? The relationship between the women is ambiguous: in some ways, the maid is the more powerful at this moment. There could even be a touch of eroticism about this act, heightened again by the sensuous reds. Degas returned to the theme of women combing each others' hair repeatedly, perhaps inspired by the Japanese prints that he loved. This is an intimate gesture: these two women are connected by the mane of hair.

This is the end of the Colour and technique tour.

What techniques does the artist use?
Degas used models, drawing them repeatedly in different ways in pastel, in an attempt to get closer to the essence of a subject or motif. He painted in a similarly obsessive and exploratory way, trying out ideas and going over outlines in thick black paint as he refined shapes. Here, he applied oil paint in a sketchy way: this picture isn't signed, so he may not have considered it finished. The effect of the absorbent coarse-weave canvas also became a creative factor.

Why has it been chosen for this tour?
In this painting, Degas pushed the boundaries of what you could communicate with different tones and shades of red. Areas of cool grey and white serve to make the hot orange-reds jump out even more; placing different reds side by side makes them appear to pulsate. Degas took the mundane act of hair combing and, through his experimental approach to colour and technique, transformed it into something mysterious and provocative.

Hilaire-Germain-Edgar Degas

- born in Paris in 1834.
- intended to study law, but instead chose to train as an artist with a pupil of Ingres. This training helped give his art a strong sense of classicism and line.
- his wealthy background allowed him to follow his own artistic interests. Was drawn to scenes of contemporary life – dancers, entertainers and women at their toilette.
- often worked in pastel, charcoal and pencil, as well as painting, and was a brilliant draftsman.
- died in Paris, 1917.

Tour 6 Costume

❶ The Doge Leonardo Loredan
1501–4
Giovanni Bellini
(active about 1459; died 1516)
`Room 62`

❷ Saint George and the Dragon
about 1560
Jacopo Tintoretto
(1518–1594)
`Room 9`

❸ Lady Elizabeth Thimbelby and her Sister
about 1637
Anthony van Dyck
(1599–1641)
`Room 31`

❹ Mr and Mrs Andrews
about 1750
Thomas Gainsborough
(1727–1788)
`Room 35`

❺ Madame Moitessier
1856
Jean-Auguste-Dominique Ingres
(1780–1867)
`Room 41`

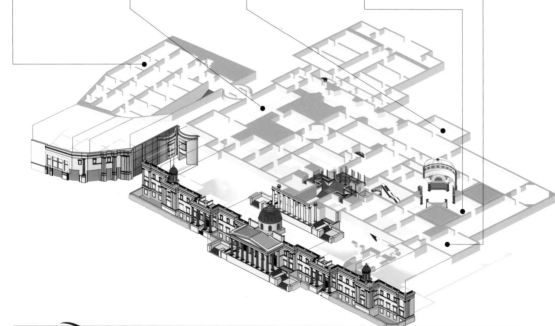

The cutaway shows you which rooms you will visit on this tour, and where they can be found. Costume plays a vital role in many paintings. In portraits, it usually communicates important information about status: it's a way of displaying rank or wealth that could include a range of subtle distinctions that the sitter's peers could read at a glance. Clothes were also a way to show that you followed fashion; now, it helps to reveal when paintings might have been made. Costume could also be symbolic. Sometimes it appears to be completely impractical, included simply for its colour or shape, another means of expression and a showcase for the artist's skills.

Tour 6 – step 1
Start at the Sainsbury Wing Entrance. Go to the second floor and enter Room 51, moving straight through to Room 61. Turn left to enter Room 62.

Did you know?

In many European countries, there used to be laws governing what kinds of clothes different people could wear. Sumptuary laws were used to stop excessive expenditure on luxury goods, including clothes. They also discouraged the middle classes from daring to dress like the nobility.

The Doge Leonardo Loredan 1501–4

Giovanni Bellini (active about 1459; died 1516)
Oil on poplar, 61.6 x 45.1 cm

Corno – horned cap that signals that Loredan is the Venetian ruler

Campanoni – buttons that were also bells

Oil paint, unusual for this early date, is textured to create the effect of brocade

Bellini's signature is written in Latin, as if it's on a piece of paper we could pull off

What's so great about this painting?

His face, which appears uncannily three-dimensional against the blue background.

What is it about?

This depiction of Doge Leonardo Loredan was probably made soon after his election in 1501. His pose was inspired by sculpted portrait busts of ancient Roman leaders, giving him an aura of power and prestige. Look closely though at his face: each half suggests a different character. The left is stern and steely while the right seems softer and more thoughtful, or as a man of religious faith. The right side may have been intended to emphasise his age, as a sign of modesty. He was 65 when elected to lead the Venetian Republic, and it was wise to show that he understood that his power would be limited by his life span. This differed from other Italian states that were ruled by hereditary princes. Loredan appears as a virtuous Venetian leader, bathed in a golden glow that suggests his sun is setting. In fact, he would reign for twenty years.

What techniques does the artist use?

Oil paint was a new medium for Bellini, but he managed to achieve an astonishing degree of naturalism with it. He roughed up the paint on the robes to suggest the texture of the fabric.

Why has it been chosen for this tour?

Venetians would have known immediately who was depicted in this portrait because of Loredan's official robes. His mantle was made from several entire loom widths of gold and white silk damask. Its pomegranate pattern is upside down on the front, but would have been the right way up on the back, visible when he took part in ceremonial processions. Loredan also wears the Doge's cap, the horned *corno*, under which we can see the *camaura*, an undercap with string ties. The buttons down the front of his robes were small gold bells, known as *campanoni*. Under Venetian sumptuary law at this time, only the Doge, his family and distinguished citizens who had been awarded the *stola d'oro* were allowed to wear gold.

Giovanni Bellini

- born in Venice.
- probably taught by his father Jacopo who, with Giovanni and his brother Gentile, ran a workshop in Venice.
- the workshop – which perhaps included the young Giorgione and Titian – specialised in altarpieces, devotional pictures and portraits.
- greatly inspired by the Byzantine and Gothic heritage of Venice and by the inventive work of his brother-in-law Andrea Mantegna.
- gradually abandoned egg tempera in favour of oil, encouraging this technical revolution in Italy.
- died in Venice, 1516.

Tour 6 – step 2

Return to the top of the Sainsbury Wing staircase, passing the lifts, to reach Room 9.

Saint George and the Dragon about 1560

Jacopo Tintoretto (1518–1594)
Oil on canvas, 157.5 x 100.3 cm

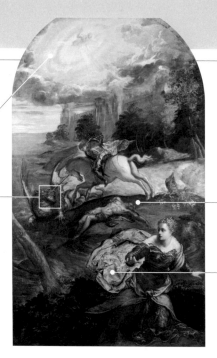

God the Father orchestrating this act of salvation

Dragon, symbolic of the Devil, here defeated by Saint George

One of the Dragon's earlier victims is laid out in a crucified position, emphasising Christian context

Expressive drapery, used for dramatic effect and to create colour connections: look for other uses of this rose pink

Jacopo Tintoretto
- born in Venice in 1518 as Jacopo Robusti, later taking the name 'Tintoretto'.
- possibly studied in Titian's workshop.
- known for his *prestezza* (rapid, abbreviated painting technique).
- his dramatic works typically feature active figure grouping, shown in dynamic, twisting or foreshortened poses.
- painted his earliest known version of *The Last Supper* in 1547.
- his patronage grew after the death of Titian, and he became recognised as Venice's finest painter.
- died in Venice, 1594.

What's so great about this painting?

It's a dramatic painting that offers an unusual view of a familiar story, Saint George killing the dragon. The princess who has just been saved runs straight at the viewer, rose-coloured cloth streaming out behind her.

What is it about?

This story was told through popular books such as *The Golden Legend*, a thirteenth-century collection of saints' lives. A knight, Saint George rescued a princess and saved an entire city from a dragon once the inhabitants had promised to convert to Christianity. Usually, paintings focus on Saint George, but here the princess is the dominant initial figure. Her body forms a V-shape with the tree trunk, framing the central action. The low viewpoint adds to the sense of drama and, as we look up, we see the source of Saint George's power, God himself. Reforming church authorities encouraged artists to focus on the divine aspect of the story rather than on the saint's heroic feat.

What techniques does the artist use?

Tintoretto painted rapidly in oil, using sketchy, loose brushwork. He developed a form of shorthand for background details such as the landscape, sky and town walls that was sometimes interpreted as carelessness by his contemporaries.

Why has it been chosen for this tour?

Because, although the princess's robes are a key element in this painting, they are invented and certainly the pink cloth would be useless as a garment. It is there for dramatic impact, adding movement and energy, directing the eye back towards Saint George. The blue and pink draperies are then found again on the corpse and on our hero. Tintoretto means 'little dyer': the artist's father was a fabric dyer, so the artist spent his childhood among lengths of coloured fabric billowing in the wind as it dried.

Tour 6 – step 3

Enter Room 10, passing straight through Rooms 11 and 12, to reach the Central Hall. Turn left to enter the Sunley Room and carry on straight through Room 30, to reach Room 31.

Lady Elizabeth Thimbelby and her Sister about 1637

Anthony van Dyck (1599–1641)
Oil on canvas, 132.1 x 149 cm

Room 31

Stormy skies may refer to the scandal caused by Dorothy's marriage

Delicate gold patterning painted onto Elizabeth's veil

Curtain used to frame the composition, a device often employed by van Dyck

A pearl necklace, as worn by Dorothy, was another reference to purity and marriage

What's so great about this painting?

The beautiful coloured silks worn by these women. Van Dyck's skill at representing costume was central to his status as Europe's most sought-after portrait artist, creating an aura of sensuous luxury that would soon appear dangerously excessive during the English Civil War.

What is it about?

Lady Elizabeth Thimbelby and Dorothy Savage, Viscountess Andover, were sisters. This portrait of them was commissioned at the time of Dorothy's marriage in 1637. Her sister appears in this portrait rather than her husband: this was a gesture of solidarity. Dorothy had converted to Catholicism at the time of her marriage, eloping without the blessing of her parents and causing a scandal. The presence of Cupid here suggests that this was a love match. He gives Dorothy a rose, symbol of Venus (goddess of love) but also the attribute of Saint Dorothea of Cappadocia, the Catholic patron saint of brides. Elizabeth stands by her sister, helping her to weather the storm.

What techniques does the artist use?

Layers of oil glazes worked up into a smooth finish, so that skin appears to have a satin sheen that almost rivals the fabric.

Why has it been chosen for this tour?

These costumes are more than simply superb examples of van Dyck's skill at rendering cloth. Cupid's pink drapery underlines how often non-functional material is included to add colour and balance. The women's costumes are particularly interesting because they combine realism with symbolism. The sisters wear fashionable dresses, although the usual lace collars have been removed. However, Dorothy's gown is deliberately saffron coloured, a dark yellow that to contemporaries recalled the robes worn by ancient Roman brides. Elizabeth touches the veil around her shoulder, a pose taken from antique statues that indicated a woman's chastity. Their costumes communicated clear messages about marriage and virtue, and were a definite public relations move.

Anthony van Dyck

- born in Antwerp, 1599.
- trained locally before entering the studio of Peter Paul Rubens. Was also profoundly influenced by the work of Italian artists, above all, Titian.
- was a successful etcher and published *The Iconography*, a book of portrait prints of eminent contemporaries'.
- acquired tremendous fame as a portrait painter in the southern Netherlands, London, Genoa, Rome and Palermo.
- moved to London in 1632 to become court painter to Charles I.
- died in London, 1641.

Tour 6 – step 4

Return through Room 30 and the Sunley Room to the Central Hall. Turn left and go straight through Rooms 39, 38 and 36, to reach Room 35.

Mr and Mrs Andrews about 1750

Thomas Gainsborough (1727–1788)
Oil on canvas, 69.8 x 119.4 cm

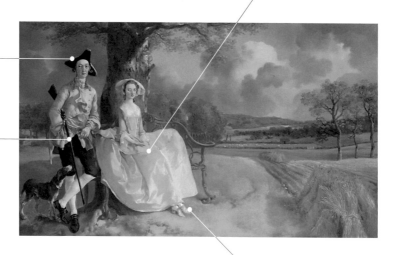

Tricorne hat, a male fashion from France

Male accessories – gun and gun-powder pouch showed he was a landowner

Bare unfinished patch on Mrs Andrews's lap – intended for a pheasant her husband had shot? Vague suggestion of tail feathers

Slippers suggest this wasn't painted from life outside – these are indoor shoes that would be ruined by mud

Thomas Gainsborough

- born in Suffolk, 1727.
- studied art in London, returning to Suffolk in 1748. Here he painted *Cornard Wood*, an important early work depicting rural life, which also affirmed a life-long interest in landscape.
- moved to Bath in 1759, to concentrate on well-paid portrait commissions.
- was among the first to take up soft-ground etching and aquatint – new printmaking techniques.
- was a foundation member of the Royal Academy in 1768.
- died in London, 1788.

What's so great about this painting?
It's the quintessential portrait of English landed gentry, unusual in that over half the canvas is devoted to a realistic depiction of the land they owned.

What is it about?
Robert Andrews and Frances Carter were wed in 1748. Their union had been planned for years by their fathers, as it brought together the neighbouring plots of land they inherited. The tree still exists on the family farm, Auberies, in Suffolk. Mr Andrews adopts a pose of studied relaxation, copied from an etiquette book that advised on how to appear as a gentleman at ease. Displayed around him are his possessions: his wife, his dog and his land. His gun marks him out as a wealthy landowner: only those holding property worth £100 or more were allowed to hunt game. The oak tree and sheaves of corn were realistic touches that also symbolised the couple's hope for a large family. Their apparent lack of intimacy was 'polite' behaviour.

Tour 6 – step 5
Enter Room 34, turning right to enter Room 41.

What techniques does the artist use?
Gainsborough painted with oil and may only have recorded his sitters' faces from life. At this early stage in his career, he often used wooden lay figures to recreate poses in the studio, which could explain why the bodies of his subjects seem rather stiff and awkward.

Why has it been chosen for this tour?
It shows how casual costume could also be vital for social display. Mr Andrews wears his linen frock coat half-unbuttoned and deliberately dishevelled, as if he scorns any need to dress up for a portrait. His stockings cling to his calves, his pose designed to show off his finely turned leg. Mrs Andrews is dressed in a fashionably rustic style, wearing a 'round-ear' cap under her 'bergère' hat, whose brim has been rolled in imitation of a shepherdess or milkmaid. Her pink satin slippers and pale blue bodice and skirt confirm that she does no such work in reality. Her hoop skirt is supported by a frame (panier) that spreads over the entire bench.

Madame Moitessier 1856

Jean-Auguste-Dominique Ingres (1780–1867)
Oil on canvas, 120 x 92.1 cm

Ingres was obsessed with Madame Moitessier's arms, relishing their fleshiness: she asked for them to be slimmed down

Collection of interesting objects to show that she's cultured, including a Japanese Imari vase and silk hand screen to protect her complexion from the fire

Mirror reflecting at an impossible angle, to show a different view of the sitter's beauty

Fringing shows that the pattern on this fabric was expensive and woven, not printed – an example of high-quality French fashion fabrics

What's so great about this painting?

It's strange but fascinating. Why is she holding her hand up to her ear like this, and is this a portrait of the woman or of her dress?

What is it about?

Ingres was asked to paint Madame Moitessier following her marriage to a wealthy banker. More interested in mythological paintings, he was reluctant, but relented when he saw her beauty. He spent years trying to perfect a pose taken from an ancient wall painting unearthed in Herculaneum, showing the goddess of Arcadia. Madame Moitessier holds her hand to her ear in imitation of this ancient work. The flowers on her dress signify fertility and abundance; they extend onto the painting's frame, which was probably also designed by Ingres. During the 12 years that he worked on the portrait, his sitter had several children, and grew so tired of waiting that the artist had to complete a simpler version of her portrait (now in the National Gallery of Art, Washington DC).

This is the end of the Costume tour.

What techniques does the artist use?

Ingres worked slowly in oil paint, achieving a flawless smooth finish on areas of bare skin that contrasts with the rougher technique used for the dress. This suggests perhaps that the sitter's body is as perfect as a marble sculpture.

Why has it been chosen for this tour?

Because the portrait took so long to complete, Madame Moitessier's gown changed several times as the portrait progressed. The mid 1850s were a time of great change in French fashion, and this last dress shows these developments. The new Empress Eugénie had been asked by her husband, Napoleon III, to wear brocades from Lyons to stimulate business for the silk-weaving industry. Eugénie was also fascinated by the doomed Queen Marie-Antoinette, executed during the French Revolution. This led to a revival of bright rococo patterns. Madame Moitessier's dress combines the fashionable floral fabric with a crinoline, a stiffened petticoat that was only introduced in 1855.

Jean-Auguste-Dominique Ingres

- born 1780 in southwest France.
- won a scholarship to Rome in 1801; took this up in 1806; became especially interested in the works of Raphael.
- moved to Paris, 1824.
- held up as an example of the Academic tradition in painting.
- made a successful career as a portrait painter, but considered himself a history painter.
- held directorship of the French Academy in Rome, 1835–40.
- returned to France in 1841, painting into his 80s.
- died in Paris, 1867.

Tour 7 Myths and legends

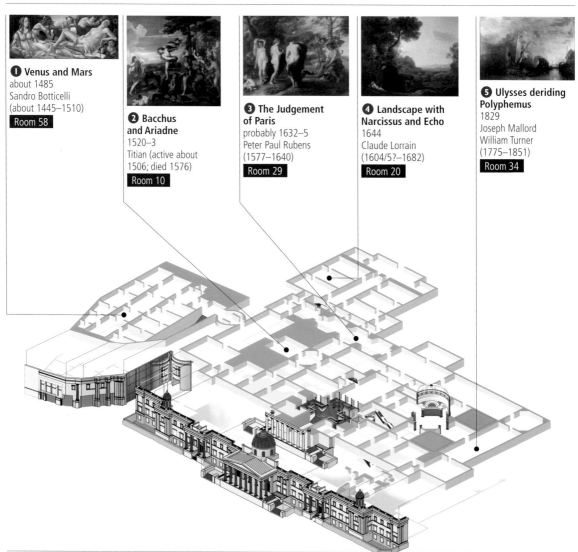

1 Venus and Mars
about 1485
Sandro Botticelli
(about 1445–1510)
Room 58

2 Bacchus and Ariadne
1520–3
Titian (active about 1506; died 1576)
Room 10

3 The Judgement of Paris
probably 1632–5
Peter Paul Rubens
(1577–1640)
Room 29

4 Landscape with Narcissus and Echo
1644
Claude Lorrain
(1604/5?–1682)
Room 20

5 Ulysses deriding Polyphemus
1829
Joseph Mallord William Turner
(1775–1851)
Room 34

The cutaway shows you which rooms you will visit on this tour, and where they can be found. Ancient Greek and Roman authors developed some of the most popular tales of love, loss, struggle and victory in works that would become famous again during the Renaissance. Painters relished the chance to show gods, monsters and mortals engaged in dramatic and moving narratives. Their clients also seem to have enjoyed the nudity that was acceptable for this kind of subject matter. Later artists explored different ways of expressing the emotional content of myths, through landscape and colour.

Tour 7 – step 1
Start at the Sainsbury Wing Entrance. Go to the second floor and enter Room 51, to your left at the top of the stairs. Head straight through to Room 60 and turn left to go through Room 59. Enter Room 58.

Did you know?
Many myths explained how the stars came to exist. One told that the Milky Way was created when the god Jupiter put his illegitimate son Hercules to his wife's breast while she slept. He sucked so hard she awoke and pulled away. Milk shot into the sky and became stars (see Tintoretto's example on p. 23, or in Room 9).

Venus and Mars about 1485

Sandro Botticelli (about 1445–1510)
Tempera and oil on poplar, 69.2 x 173.4 cm

Armour made for Mars by
Vulcan, Venus' husband

Wasps nesting in tree
trunk could be a reference
to the patron – may have

been commissioned by the
Vespucci family (*vespe*
means wasp in Italian)

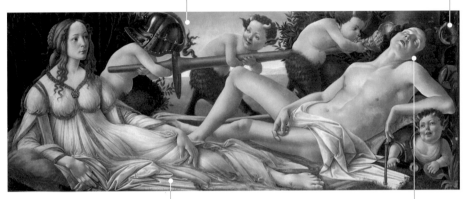

What happened to Venus'
lower leg? Botticelli
may have covered up an

anatomical error with
the beautiful folds of
fabric on Venus' dress

Accurate perspective
creates a naturalistic
view of Mars' face

What's so great about this painting?

The way that we know straight away what has happened between this couple. She wants to talk, but he has fallen asleep: human behaviour hasn't changed much over the last 500 years.

What is it about?

This panel shows an adulterous liaison between Venus, goddess of love and beauty, and Mars, god of war. He lies exhausted after their love-making, feet tangled in silken sheets, and so soundly asleep that he fails to notice the satyrs (half humans, half goats) playing with his armour. Even the loud noise of a conch shell being blown in his ear fails to wake him. This was a comic touch used in theatre at the time, so we are meant to laugh. Venus looks over with an ambiguous expression: is she anxious that they will be discovered, or becoming aware of just how powerful she is? Love has conquered war; the female has completely disarmed the male.

What techniques does the artist use?

Botticelli might have trained as a goldsmith, which may be why lines and patterns are central to his work, as we see from the gold decorations on Venus' robes and their carefully arranged folds. He was also increasingly interested in naturalism, and used a mixture of egg tempera and oil paint to try to make Mars' face and body look rounded and realistic.

Why has it been chosen for this tour?

It shows that myths were relevant to contemporary society. This panel's shape suggests it decorated a *spalliera*, the backboard of a large chest usually given as a marriage gift. Venus' hair and face look Florentine, as does Mars' armour: the couple who received this were meant to consider themselves in light of this story. It may reflect ideas about female qualities needing to balance male aggression: a good woman was seen by some as a civilising force. Myths provided the framework for this kind of social debate.

Sandro Botticelli

- born about 1445 in Florence as Sandro di Mariano Filipepi, nicknamed 'Botticelli' ('a small wine cask').
- became a pupil of the Renaissance painter Filippo Lippi.
- was popular for his graceful Madonnas, altarpieces, and life-size mythological paintings.
- from 1478 to 1490 painted his famous mythologies *Primavera* and *The Birth of Venus* (both now in the Uffizi, Florence).
- was commissioned in 1481–2 to paint the walls of the Sistine Chapel with scenes from the life of Christ.
- died in Florence, 1510.

Tour 7 – step 2

Return to the top of the Sainsbury Wing staircase, passing the lifts to enter Room 9. Carry on straight through to Room 10.

Bacchus and Ariadne 1520–3

Titian (active about 1506; died 1576)
Oil on canvas, 1/6.5 x 191 cm

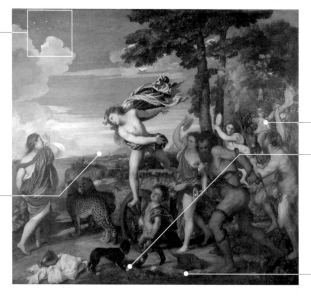

Stars formed when Ariadne's crown was thrown into the sky

Diagonal divide across composition to suggest the meeting of heaven (the god Bacchus) and Earth (mortal Ariadne)

Drunken Silenus, shown – as usual – asleep after his over-indulgence

A dog, perhaps a pet of the patron, barks at the child satyr, who is too drunk to take notice

Animals torn apart in frenzied revelling

Titian

- born Tiziano Veccellio in Pieve di Cadore, near Venice, between 1485 and 1490.
- brought as a child to Venice, where he was eventually apprenticed to the Bellini brothers, and finally became associated with Giorgione.
- worked for Francis I of France, the Emperor Charles V and his son Philip II of Spain, as well as the leading families of Venice.
- developed a technique of painting directly on to the canvas without the use of preparatory drawings, resulting in a freer painting style.
- died in Venice, 1576.

What's so great about this painting?

The extraordinary colours, which were a speciality of Venetian painting, as well as the sheer romance of the story.

What is it about?

Classical authors Ovid, Catullus and Philostratus all described this story. The woman in blue is the Cretan princess Ariadne. She has tearfully been waving after the ship taking her lover Theseus away. Suddenly, she is startled by a tremendous noise: Bacchus, god of wine, comes through the forest accompanied by his drunken followers. He sees Ariadne and falls head over heels in love with her. Leaping from his chariot, he swears that he will be 'a more faithful love'. Titian's decision to show Bacchus in mid air was a bold move, creating a dynamic central focus for the painting. Bacchus literally offers Ariadne the stars. Taking the crown from her head, he throws it into the sky, where it becomes the constellation known as Ariadne.

What techniques does the artist use?

Titian reworked this complex composition as he was painting it, redesigning some figures (most notably Ariadne) completely on the canvas. He took a long time to finish the painting, keeping the patron waiting.

Why has it been chosen for this tour?

It's a classic love story, but it's also an example of mythological painting as part of an intellectual project. Duke Alfonso d'Este of Ferrara commissioned a series of works on similar themes to decorate a particular room in his palace. He approached the best artists of the day, and dictated which classical texts they should study. He even sent out canvases of the correct size. Titian included specific details from Ovid and Catullus, so he has clearly studied his literature. The man wrestling with snakes could also be a reference to classical art, specifically the ancient sculpture known as the Laocoön (see p. 17), which depicts a man in agony as he is killed by snakes.

Tour 7 – step 3
Make your way to Room 11, turning left to enter Room 14. Carry straight on through to Room 29.

The Judgement of Paris probably 1632–5

Peter Paul Rubens (1577–1640)
Oil on oak, 144.8 x 193.7 cm

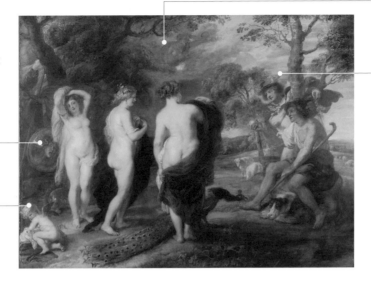

Minerva's shield, with the image of the screaming Gorgon Medusa. One look from her can turn you to stone, but even this fearsome creature is apparently horrified by the implications of the decision Paris takes

Cupid, up to mischief – love will be at the centre of the tragedy ahead

The Fury Alecto, sign of trouble ahead

Mercury, the winged messenger who brought Paris to the place of judgement

What's so great about this painting?

It's a prime example of Rubens's sensuously painted fleshy nudes, based on his young wife's body and presented here as gorgeous goddesses. It depicts a story full of life lessons, showing that all is never fair in love and war.

What is it about?

This is a beauty contest; Roman author Lucian told the tale. Paris was the son of King Priam of Troy. It was prophesied that he would bring ruin to the city, so he was abandoned; shepherds found and raised him as one of their own. Years later, he was asked to judge who was the fairest of all the goddesses. He asked them to disrobe, to help him decide. Desperate to win, Juno (with her peacock) offered him power and wealth. Minerva (with her shield and owl) offered wisdom and skill in war. But Venus won, with the promise of the world's most beautiful woman, Helen of Troy. Paris holds out Venus' prize, a golden apple. His later abduction of Helen would start the disastrous Trojan wars.

What techniques does the artist use?

Rubens painted fluently in oils, using colour and expressive brushstrokes to mould forms rather than hard-edged lines. He deliberately positioned his naked female figures so that we see different views of their bodies, showing off his skill at painting the same range of angles you'd see in a sculpture. Scientific investigation has revealed that changes were made to this painting. Rubens initially showed Paris as still undecided, asking the goddesses to undress. One of the painting's early owners may have asked another artist to resolve the picture's ambiguity, after Rubens's death.

Why has it been chosen for this tour?

It represents an important type of mythological story, one which seeks to explain some of life's big emotions and difficult situations (desire, jealousy, bribery and war). The goddesses who didn't win were furious, and the Trojan wars were their doing – mere mortals didn't stand a chance.

Peter Paul Rubens

- born in Siegen, Germany, 1577, but trained in his parents' native city, Antwerp.
- was well educated in classical art and literature.
- became painter to the courts of Europe, travelling to Italy from 1600 to 1608.
- produced magnificent cycles of allegorical painting glorifying his princely patrons, as well as altarpieces, history and mythological scenes, portraits and landscapes.
- his numerous pupils and assistants included Anthony van Dyck.
- died in Antwerp, 1640.

Tour 7 – step 4

Enter Room 28 and go straight through to Room 25. Turn left to enter Room 24, carrying on straight through Room 18, to Room 19. Turn right into Room 20.

Landscape with Narcissus and Echo 1644

Claude Lorrain (1604/5?–1682)
Oil on canvas, 94.6 x 118.7 cm

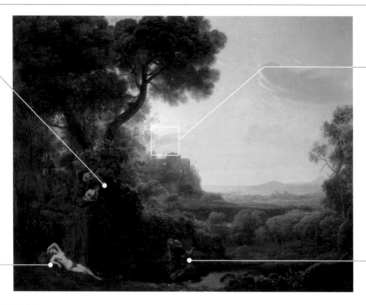

Is one of these nymphs Echo, calling out in vain to try to attract Narcissus?

This water nymph was originally wearing drapery, but was repainted naked in the eighteenth century, probably to make it more arousing

Sun forms a focal point, and casts a golden light on the scene

Narcissus, mesmerised by his own reflection

Claude Lorrain
- born as Claude Gellée in the Duchy of Lorraine.
- moved to Rome around 1617, where he worked as a domestic helper, then as a studio assistant, for the landscape artist Agostino Tassi.
- was influenced by northern painters such as Elsheimer, as well as Bolognese artists Annibale Carracci and Domenichino, who evolved his balanced classical landscapes.
- influenced eighteenth- and nineteenth- century artists, including Constable and Turner.
- died in Rome, 1682.

What's so great about this painting?
The landscape, which has a dreamy, magical quality. It's very serene, and feels like a cool green oasis for the eyes.

What is it about?
This is a story of unrequited love told by the Roman poet Ovid in *The Metamorphoses*. Narcissus was an unusually beautiful youth, destined to live happily as long as he never 'knew himself'. The nymph Echo was smitten, but could not communicate properly with him. The goddess Juno had restricted Echo's voice so she could only repeat something said to her. Narcissus didn't understand her advances, and ignored her. He had rejected so many lovers that they appealed to the gods for revenge. The goddess Nemesis arranged for him to fall in love with himself, so he would know the suffering of unrequited love. But it went much further – when Narcissus finally saw his reflection in a pool of water, he was so entranced he could not leave, eventually dying where he knelt.

What techniques does the artist use?
Claude constructed idealised landscapes in oil paint, combining views he had observed around Rome into a perfectly balanced scene. He used large trees at the edges of the painting to direct the eye inwards and backwards, and often made a golden sun the focal point of his composition.

Why has it been chosen for this tour?
Because Claude uses landscape as the main means of expressing the emotional content of this myth. The figures themselves are small scale and not that well painted; they serve simply to identify the scene. It is the setting which communicates both a sense of mesmerising beauty and the wistful melancholy of doomed love. Like Narcissus, we stand before an entrancing vision that we can never fully enter, never quite possess.

Tour 7 – step 5
Return to Room 29, heading straight through Rooms 30 and 32, to reach Room 33. Turn right to enter Room 34.

Ulysses deriding Polyphemus 1829

Joseph Mallord William Turner (1775–1851)
Oil on canvas, 132.5 x 203 cm

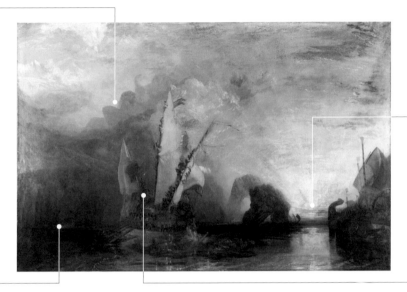

Polyphemus is formed from clouds – curving lines suggest his shoulder, head and fist holding a rock

Apollo's mythical horse-drawn chariot pulls this sun out of the sea. The horses were based on the Elgin Marbles, which Turner had just seen

Red glow in the cave reflects a belief that Polyphemus lived on Sicily, under the volcano Mount Etna. Erasmus Darwin had also suggested volcanos were formed by sea water rushing into caverns

Ulysses is a tiny figure, punching the air in victory

What's so great about this painting?

The technicolour sunrise, which astonished viewers when it was first exhibited, praised as 'a singularly overpowering display' and at the same time criticised as 'colouring run mad'.

What is it about?

The narrative comes from Book IX of the Greek poet Homer's *Odyssey*. The hero Ulysses is trying to get back to his home in Ithaca after many years away fighting in the Trojan wars. This is the latest in a series of problems encountered on the journey. He and his companions have been held captive by a one-eyed giant, the cyclops Polyphemus. They have escaped after getting him drunk and blinding his eye. Ulysses taunts him from his ship as they sail off, and Polyphemus throws rocks at them in vain. The cyclops would, however, call on greater powers: he complained to his father Neptune, god of earthquakes and water, who then caused Ulysses even more delay and difficulty on his way home.

This is the end of the Myths and legends tour.

What techniques does the artist use?

Turner explored ideas for this scene in sketches made over a twenty-year period. Some elements were based on Italian views, but more came from his imagination. He used a brilliant range of oil colours to paint his dazzling sky, dragging on thick strokes of paint with both brush and palette knife.

Why has it been chosen for this tour?

Here, it is colour within the landscape that communicates Ulysses' sense of intense triumph at his escape. Turner wanted desperately to prove to his critics that landscape painting, which had a low status at the time, was just as capable of inspiring the mind and spirit as traditional large-figure history painting. Pursuing an interest in theories concerning the origin of myths – that giants were imagined in the shapes of mountains and clouds – he used a mythological story as the platform for his campaign, with spectacular results.

Joseph Mallord William Turner

- born 1775 in London.
- entered the Royal Academy Schools aged just 15. Was elected associate of the RA in 1802.
- first travelled on the continent in 1802, and took regular drawing trips abroad.
- was particularly influenced by the landscape of Switzerland and Italy.
- his use of brilliant colours led to him becoming known as 'the painter of light'.
- bequeathed much of his artwork to the nation, the great majority of which is now at Tate Britain.
- died in London, 1851.

Tour 8 Life of Christ

① The Adoration of the Kings
1510–15
Jan Gossaert
(active 1503; died 1532)
Room 14

② The Baptism of Christ
1450s
Piero della Francesca
(about 1415/20–1492)
Room 66

③ Jesus opens the Eyes of a Man born Blind
1311
Duccio
(active 1278; died 1318/19)
Room 51

④ The Mond Crucifixion
about 1502–3
Raphael
(1483–1520)
Room 8

⑤ The Supper at Emmaus
1601
Caravaggio
(1571–1610)
Room 32

The cutaway shows you which rooms you will visit on this tour, and where they can be found. Christian paintings are at the heart of the National Gallery's collection. Religious themes were virtually the only focus for medieval European painters, and the Catholic Church and its supporters remained major artistic patrons long after that. Christianity is centred on the life and teachings of Jesus of Nazareth (Christ), as told by the New Testament. Followers believe that he was the son of God, a man who lived, died and was resurrected 2,000 years ago in order to save humankind from sin. Paintings of his life were, and for many Christians still are, a crucial part of religious devotion.

Tour 8 – step 1

Start at the Portico Entrance, carrying on straight through to the Central Hall. Turn left, heading straight through Room 12. Turn right in Room 11, to reach Room 14.

Did you know?
When you see a picture of Christ holding his right hand out with his palm facing outwards and the two smaller fingers bending in, he's making a gesture of blessing. See Duccio's *Jesus opens the Eyes of a Man born Blind*, p. 79, for an example.

The Adoration of the Kings 1510–15

Jan Gossaert (active 1503; died 1532)
Oil on wood, 177.2 x 161.8 cm

Ox and ass are present because this is supposed to be a stable. They also represent contrasting reactions to Christ's birth: the ox is attentive, but the ass ignores this important event, focusing instead on filling its belly

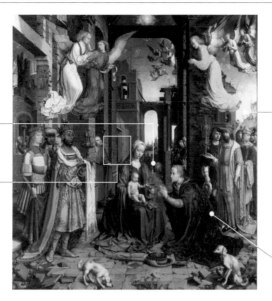

King Herod's soldiers are already within sight, so the family will have to escape soon to keep Jesus safe

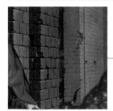

Could this hidden man be a self portrait of the artist?

This may well be a portrait of Joannes de Broeder, the new Abbott of Saint Adrian's Grammont, who probably paid for this painting. The Christ child graciously accepts his gift of gold

What's so great about this painting?

The colours, sense of depth, amount of detail, and the way that it shows northern and southern European artistic elements combining in creative fusion.

What is it about?

Christ has been born in a stable in Bethlehem. Paintings rarely show him as a newborn; here, he is already able to sit up and interact with people who followed an intensely bright star which led them to his birthplace. His father Joseph (in red) hangs back, not quite sure yet if he believes that his virgin wife has given birth to the son of God. Jesus himself is far more assured. He calmly receives gifts from three kings or wise men, who have arrived with their extensive retinue to show that earthly rulers bow down to Christ. Caspar kneels, offering gold coins; Balthazar (the black king on the left) carries an elaborate container of scented myrrh; and Melchior waits with another precious object filled with frankincense.

What techniques does the artist use?

Gossaert was a Netherlandish artist who travelled to Italy around the time he made this painting, which combines precise oil techniques with Italian symmetry and architecture.

Why has it been chosen for this tour?

Depictions of the infant Christ were very popular. Christ's innocence and vulnerability were often emphasised, as here through his nakedness. The aim was to inspire protective feelings, encouraging viewers to consider the boy's future suffering. The serious expressions of his mother Mary and the angels above suggest his sombre destiny. The kings' gifts underline the symbolism: myrrh was used to embalm dead bodies, while the chalice of gold coins recalls the cup used for the wine that represents Christ's blood during Holy Communion, a key Christian ritual. Yet the message is positive. The grand architecture of this 'stable' has started to crumble, as the old order falls apart. Above all, this child represents a new start.

Jan Gossaert
- active in Antwerp, was a painter and engraver of portraits and religious or mythological subjects.
- entered the service of Philip of Burgundy in 1507/8, afterwards Bishop of Utrecht.
- travelled to Rome in 1508 where he studied the polished works of the followers of Leonardo da Vinci; the trip introduced the fashion of travelling to Italy; it became popular for Netherlandish painters to visit the peninsula.
- later patrons included Adolf of Burgundy, the Countess of Nassau, Margaret of Austria and Christian II of Denmark.
- died in Antwerp, 1532.

Tour 8 – step 2
Return to Room 11. Turn right, straight through Rooms 10 and 9. Pass the staircase to enter Room 51. Head straight through to Room 61. Turn left, straight through Rooms 62, 63, 64 and 65, to Room 66.

The Baptism of Christ 1450s

Piero della Francesca (about 1415/20–1492)
Egg on poplar, 167 x 116 cm

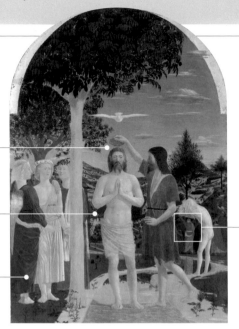

Fine gold lines represent divine light

City may be Borgo Sansepolcro, Piero della Francesca's home town

Angels seem to have been inspired by classical sculptures

Not everyone present is supportive of this act. These figures in priests' robes point out the dove of the Holy Spirit, and look worried. Christ would soon begin his own ministry, becoming a challenging and radical figure

Piero della Francesca
- born in Tuscany, about 1415–20.
- greatly experimented with painting techniques such as painting frescos with an oil-based medium (as opposed to pigment and water).
- wrote treatises on arithmetic, algebra, geometry and perspective, and resolved problems set by the ancient Greek mathematician Euclid.
- painted serene, solid figures influenced by the sculpture of Donatello as well as classical statuary.
- died in Sansepolcro, 1492.

What's so great about this painting?
It's so calm, serene and still. You almost hold your breath waiting for the water to pour down the sides of Christ's face.

What is it about?
The Gospels of Matthew, Mark and Luke all described this event. Saint John the Baptist had been preaching by the River Jordan, urging people to repent and be baptised so that their sins would be forgiven. He said that someone far greater than he would arrive soon. Jesus stepped forward and was baptised by having water poured over him. The heavens opened and the Holy Spirit descended in the form of a dove, and God said that Jesus was his son. His baptism is depicted here as a moment of great solemnity, while on either side practical preparations bring the scene back down to Earth. Three angels wait patiently to dry Christ with a pink cloth, while the next man to be baptised pulls his tunic over his head in a highly naturalistic gesture.

Tour 8 – step 3
Return to Room 51.

What techniques does the artist use?
Piero used egg tempera – finely ground pigment bound together with sticky egg yolk – in delicate strokes to depict carefully observed details such as the folds of cloth on the man undressing. He divided the composition precisely, placing Christ, the Holy Spirit and other elements at significant, evenly spaced points. This creates a sense of balance and harmony throughout the painting. He also used linear perspective to suggest depth – a line of triangular trees recedes into the distance.

Why has it been chosen for this tour?
Baptism is a key sacrament for most Christians, so Christ's own baptism was a particularly important act. The pouring of water represents a ritual cleansing, and marks the moment that a person becomes part of the Church. Piero's decision to set this scene within a recognisable local landscape suggests that viewers were meant to identify with it, perhaps recalling their own baptism.

Jesus opens the Eyes of a Man born Blind 1311

Room 51

Duccio (active 1278; died 1318/19)
Tempera on poplar, 43.5 x 45 cm

Early attempt to create the illusion of depth, before linear perspective had been fully understood

Figure wearing same clothes appears twice, to show the story's progression and link to the next panel of the altarpiece

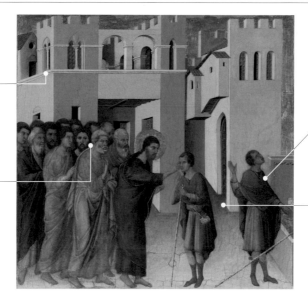

Light and shade used to model the faces and make them look rounded, an early example of this key development in naturalistic painting

Incised guidelines extend beyond the edges of buildings in places

What's so great about this painting?

It's by one of the earliest pioneers of Renaissance painting, who has really tried to make the people and their setting look believable. It also tells the story of this miracle with great clarity, showing the same figure twice in 'before' and 'after' poses.

What is it about?

Duccio painted a scene described in the Gospel of Saint John. Jesus smeared a blind man's eyes with mud and spittle, and when the man washed them, his sight was restored. The disciples crane forward to see the moment of miraculous touch. We continue gazing in the same direction and see the same blind man, now looking up in wonder and casting aside his stick. This is one of more than thirty small panels, known as the Maestà, that formed Duccio's huge altarpiece for Siena Cathedral. Originally, the healed man would have been gazing up at Christ in the next panel.

What techniques does the artist use?

Several artists from Duccio's workshop may have collaborated on this panel, as was the custom in the early fourteenth century. An architectural specialist used a ruler and metal stylus to incise the straight lines of the buildings, giving the painters (who used egg tempera) firm guidelines. Gold leaf was applied to the background to form the earth and sky. This was traditional, but must also have helped to unify the visual effect of the many different small panels once they were placed together in the altarpiece.

Why has it been chosen for this tour?

It shows one of the moments from Christ's ministry, the important work he undertook as a young adult. These were often acts of charity, kindness and healing. Miracles like this one proved to his followers that God's love was all powerful and mysterious. Witnesses couldn't understand how it worked, but they saw that if you had faith, anything was possible.

Duccio

- birthdate is unknown but is estimated at before 1278.
- Duccio's work was largely influenced by Byzantine paintings, particularly of the Madonna and Child.
- most famous for his large, double-sided Maestà altarpiece for Siena Cathedral, installed in 1311.
- also worked on a smaller scale, painting small devotional pictures.
- ran a large workshop and his pictures of the Madonna and Child became some of the most widely imitated works in all of Italy.
- died in his native Siena in about 1318/19.

Tour 8 – step 4

Return to the top of the staircase in the Sainsbury Wing, passing the lifts to reach Room 9. Turn right to enter Room 8.

The Mond Crucifixion about 1502–3

Raphael (1483–1520)
Oil on poplar, 283.3 x 167.3 cm

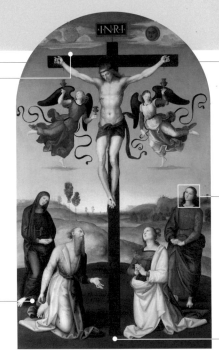

Sun represents the New Testament of the Bible, shining light on the moon, which stands for the Old Testament. This suggests that Christianity illuminates and supersedes earlier religious history

Saint Jerome holds the rock he used to beat his breast and rid himself of the erotic dreams – which he believed were demonic temptations – he experienced while living as a penitent hermit in the desert

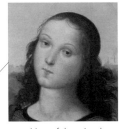

Most of the saints have similar idealised faces, with rosebud lips, a feature Raphael learned from his teacher Perugino

Raphael's signature – now hard to see – scratched through paint to reveal silver leaf

Raphael

- son of a painter, was born Raphael Sanzio in Urbino, Italy, 1483.
- worked for Popes Julius II and Leo X, and many private patrons, as a painter of frescos, portraits and altarpieces; was also an architect and designer of tapestries.
- ran a large workshop in Rome.
- painted the Vatican rooms with carefully balanced, complex compositions.
- left the 'Stanze' unfinished at his death in 1520, to be completed by his followers.

What's so great about this painting?

The way that this sad scene has been transformed into an image that encourages viewers to meditate upon Christ's suffering. There is calm and beauty here as well as pain.

What is it about?

Christ's radical preaching and ministry brought him into conflict with local religious groups and the Roman authorities. His insistence that he was the son of God was in the end the pretext for his trial and execution: for non-Christians, this was blasphemy. Here, he dies on the cross, surrounded by mourners: his mother in blue, his close disciple Saint John the Evangelist in red and green, and Mary Magdalene, a female disciple believed during the Renaissance to have been a reformed prostitute. The bare-chested figure is Saint Jerome, who lived four centuries after the crucifixion took place. He has been included because he was the patron saint of the chapel for which this painting was made. See Tour 9, p. 83 for a different depiction of this saint.

What techniques does the artist use?

Raphael painted in oil, but he wasn't trying to make his scene look realistic. The unnatural degree of symmetry makes it clear that this is not meant to be a record of what the crucifixion might have looked like. Instead, it is an idealised scene, whose balance, vivid colours and decorative shapes facilitate contemplation.

Why has it been chosen for this tour?

Painted and sculpted representations of the crucifixion are still an important focal point of prayer for many Christians. Here, Saint Jerome showed visitors to the chapel how to kneel and gaze up at the perfect but fatally wounded body on the cross. Angels trailing decorative ribbons delicately hover nearby; it's only when you look closer that you realise they are collecting Christ's blood in their chalices. The parallel with communion wine would have been obvious. It was as if Christ's blood was passed straight down to the priest at the altar to share with the communicants.

Tour 8 – step 5

Return to Room 9, turning right, into Room 10. Go straight through Rooms 11 and 12, to the Central Hall. Turn left into the Sunley Room, go straight through to Room 30. Turn right to reach Room 32.

The Supper at Emmaus 1601

Caravaggio (1571–1610)
Oil and tempera on canvas, 141 x 196.2 cm

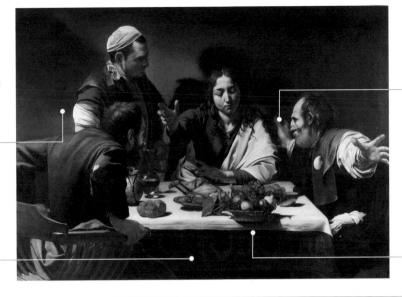

Colour moves our eyes around the composition. Caravaggio has strategically placed patches of white, green and red to keep us looking. These are also the symbolic colours of faith, hope and charity

Space left at front beckons the viewer – we are included in the action

This hand is far too large, but it serves its purpose of drawing the eye immediately in towards Christ

The basket of fruit is a skilfully painted still life, poised on the edge of the table and ready to drop into the viewer's space – it adds to the sense of three dimensionality

What's so great about this painting?

It's so dramatic, a frozen moment of complete shock on the part of two of the figures. Their bodies seem to protrude from the painting, projecting into the viewer's space.

What is it about?

As described by the Gospel of Saint Luke, after Christ's death, two of his disciples are walking towards Emmaus, talking dejectedly about the loss of their leader. A stranger joins them and shares a meal at a local inn. It is only when he blesses the bread and wine that they realise he is in fact Christ, risen from the dead. Here, the inn-keeper isn't certain what's happening, but the two disciples are stunned – they haven't seen this gesture of blessing since the final meal they shared with Christ. Unusually, Christ is shown without a beard in this painting. Caravaggio may have done this so that the viewer could also experience an initial misrecognition of him, just as the disciples have done.

This is the end of the Life of Christ tour.

What techniques does the artist use?

Caravaggio developed an earthy form of realism in his artworks, painting in oils directly from live models who came from the streets. He used strong contrasts of light and dark to add drama to compositions already full of movement. Some of Caravaggio's patrons were uneasy with the powerful impact of these works. However, others praised the way the artist was revitalising religious imagery and making it something to which people from all levels of society could relate.

Why has it been chosen for this tour?

Christ's resurrection is the good news that he told his disciples to share with others. To Christians, it means that after earthly life, there is eternal life in Heaven with God. Caravaggio's painting was designed to demonstrate vividly that there can be life after death.

Caravaggio

- born in Caravaggio, northern Italy, 1571.
- established himself early on as a painter of portraits, still life and genre scenes. Would become one of the most influential religious painters of his time.
- moved to Rome in 1592/3 and began painting his first public commissions.
- his dramatic style of painting was widely imitated by other artists.
- in 1606, killed a man in a duel and fled to Naples, then Malta and Sicily.
- returned to Rome and died of fever, 1610.

Tour 9 Landscape

1 Saint Jerome in a Rocky Landscape
probably 1515–24
Attributed to the workshop of Joachim Patinir (active 1515; died not later than 1524)
Room 14

2 The Avenue at Middelharnis
1689
Meindert Hobbema (1638–1709)
Room 21

3 A View of Het Steen
probably 1636
Peter Paul Rubens (1577–1640)
Room 29

4 The Hay Wain
1821
John Constable (1776–1837)
Room 34

5 The Thames below Westminster
about 1871
Claude-Oscar Monet (1840–1926)
Room 43

The cutaway shows you which rooms you will visit on this tour, and where they can be found. Having appeared initially as the backgrounds of religious and mythological paintings during the Renaissance, land and water only really became subjects in their own right in the seventeenth century. They were considered to be of trivial status, not challenging for either artist or viewer. Yet the evidence from great landscape painters tells a different story. Their work can express ideas of faith, or create a sense of national identity. Because of its marginal status, landscape painting has also been the site of bold technical experiments.

Tour 9 – step 1
Start at the Portico Entrance, carrying on straight through to the Central Hall. Turn left, heading straight through Room 12. Turn right in Room 11, to reach Room 14.

Did you know?
Many landscape painters suggest distance by painting the front of their scene in brown tones, the centre in greens, and the parts of the landscape that are furthest away in blues. Look out for this basic colour scheme – you'll notice it in the work of many different artists.

Saint Jerome in a Rocky Landscape probably 1515–24

Room 14

Attributed to the workshop of Joachim Patinir (active 1515; died not later than 1524)

Oil on oak, 36.2 x 34.3 cm

High viewpoint used, to give sense of sweeping panorama and vastness of God's creation

Pilgrim making the difficult climb up to the monastery

The lion became Saint Jerome's attribute. The saint is usually shown in paintings with the lion, which reminds us of Jerome's bravery and faith

Tiny figures showing thieving merchants apologising – by recovering the stolen ass, the lion proved that the monks could trust him

What's so great about this painting?

The fact that so much of this early panel depicts landscape, an imaginary scene where light accentuates the soaring rocky pinnacles and the cave in the foreground.

What is it about?

Although landscape dominates this work, it is actually a painting of Saint Jerome, who lived in the fourth century. He spent years as a hermit in the wilderness, represented here by inhospitable rocky terrain. Jerome sits by his cave in the foreground, removing a thorn from a lion's paw; his fearlessness and kindness earned him the lion's everlasting loyalty. In the centre of the scene, a later moment from their lives is played out. The lion was charged with guarding the ass used by the monks in Saint Jerome's monastery to collect firewood. The ass was stolen by some merchants while the lion was asleep; however, the lion later recognised the ass in the merchants' train and raised the alarm. The thieves kneel to beg forgiveness from the abbot.

What techniques does the artist use?

This invented landscape was probably based on close-up studies of stones and moss. Several members of Patinir's workshop seem to have contributed to this picture: painting was a business, and at this point, successful artists operated large and productive workshops.

Why has it been chosen for this tour?

Strictly speaking, this is a religious picture, but it's clear that Patinir was very interested in painting panoramic views. The landscape is, however, also a central part of how this painting communicates ideas about Saint Jerome. The rocky terrain is an effective way of expressing the difficult path that he chose in life. Originally, the painting was wider at the left-hand side, and similar paintings from this period suggest this part would have contained flat, fertile land that offered an easy life, as a contrast to the inhospitable mountains inhabited by Jerome.

Joachim Patinir

- born in Dinant or Bouvignes, about 1480.
- became a master in the Antwerp Guild of Saint Luke in 1515.
- presumed to have run a workshop in Antwerp with several apprentices in 1520s.
- was the first Netherlandish landscape painter; also the originator of the panoramic *Weltlandschaft*, imaginary compilations of scenic features and dramatic vistas.
- produced few paintings; only five paintings signed by Patinir exist, and just twenty works can be attributed to him.
- died in Antwerp, before 5 October 1524.

Tour 9 – step 2

Go to Room 29, carrying on straight through to Rooms 28 and 25. Turn left and enter Room 24, going straight through Room 18, to Room 19. Turn right, straight through Room 20, to reach Room 21.

The Avenue at Middelharnis 1689

Meindert Hobbema (1638–1709)
Oil on canvas, 103.5 x 141 cm

Lines of trees converge on people – literally and symbolically they are at the centre of the landscape

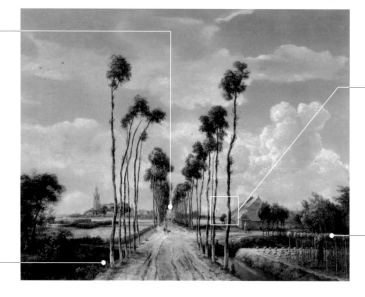

Masts and dock-side equipment – Middelharnis was a port, so its citizens were making productive use of the sea as well as the land

Two trees in the foreground were painted out – they probably would have divided the composition up too much at the front

Man pruning to show careful cultivation of this fertile land

Meindert Hobbema

- born Meindert Lubbertsz in Amsterdam in 1638, later adopting the surname Hobbema.
- apprenticed to Jacob van Ruisdael around 1660.
- specialised in wooded landscapes with sun-lit clearings.
- particularly adept at painting the varied effects of light, often filtering through cloud or through leaves.
- in 1668 appointed to the prestigious post of being one of the city's wine-gaugers, and was less active as a painter.
- died 1709.

What's so great about this painting?

The way that these trees zoom us right into the painting, making the ordinary, domesticated Dutch countryside into a dramatic landscape.

What is it about?

This avenue of poplars leads towards the village of Middelharnis. It's a carefully observed view of a landscape where man and nature work in harmony. Hobbema has drawn a deliberate contrast between the wilder trees and bushes at the front on the left and the careful human cultivation of plants behind them and on the other side of the road. Drainage channels remind us how much of the Netherlands was reclaimed from the sea, a tribute to Dutch ingenuity and engineering. We see people both working and taking their leisure in this land that they have made into something prosperous and special. The prominent church steeple reminds viewers though that all of this is fundamentally God's creation: they have simply made the most of what He has given them.

What techniques does the artist use?

Hobbema used single-point perspective, centring his composition on the converging lines of the trees. This view still largely exists, so the painting is topographical, based on a recognisable landscape. However, Hobbema has edited it to achieve exactly the effect he wanted. There were originally two more trees in the foreground, which he then painted out.

Why has it been chosen for this tour?

Landscape painting was particularly important in the Netherlands in the seventeenth century. The Dutch Republic was formed in 1609, after bitter wars of independence against Spain that lasted decades – though it only achieved legal recognition in 1648. Its citizens were rightly proud of their country, and celebrated it in realistic landscape paintings. Pictures like this helped to form a Dutch sense of national identity, both when the wars were still raging, and later when the Netherlands reaped the prosperity that peace brought.

Tour 9 – step 3

Enter Room 18 and go straight through to Room 22. Turn left, through Room 23 to Room 24, turning left to enter Room 25. Head straight through to Room 28, to enter Room 29.

A View of Het Steen probably 1636

Peter Paul Rubens (1577–1640)
Oil on oak, 131.2 x 229.2 cm

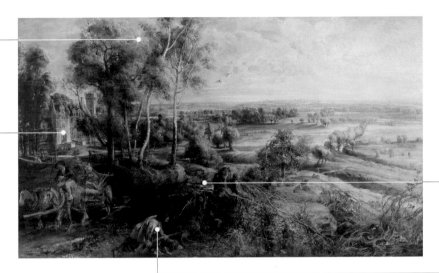

Strategically placed clump of trees, designed to direct the eye into the painting

Fifteenth-century manor house; figures may be Rubens and his much younger second wife, and a wet nurse with one of their children

Sketchy white highlights to suggest water

Hunter and his dog, ready to bag some game

What's so great about this painting?

The sheer exuberance of this view. This was a private painting that Rubens made of his own land, purely for his own pleasure.

What is it about?

This shows Het Steen, the country estate near Antwerp that Rubens bought in 1635 for his retirement after a long career as a painter and diplomat. He loved spending time here with his second wife and young family, and spent hours walking his lands. Rubens has shown far more than he actually owned, but the panoramic view suggests his pride at finally being a wealthy man of property. This is also good land, which supports game, including plump partridges, and a dairy herd. Two servants take a cart full of produce off to market, while the lord and lady of the house simply admire the view. Wild birds take to the air, underlining a sense of freedom. The sun is rising: a new era (perhaps that of Rubens's retirement) is dawning.

What techniques does the artist use?

Rubens initially conceived this very personal painting as a much smaller work, centred on the view of the house. His panel was formed of three small planks, probably off-cuts: he was frugal when painting for himself. As his ideas for the picture grew, so did the panel. Eventually, 17 different pieces of oak were joined together to make the support. Rubens used oil paint in relatively free, expressive brushstrokes, creating forms with colour and light rather than by drawing firm outlines.

Why has it been chosen for this tour?

Because it's a very expressive landscape. Rubens read poems such as Virgil's *Georgics*, which described feelings of intoxication with the majesty of nature. He wanted to communicate his sensations of wonder and optimism at Het Steen. This painting also influenced the next landscape on this tour. John Constable used to admire it at breakfast when he worked at the house of his patron, Sir George Beaumont.

Peter Paul Rubens

- born in Siegen, Germany, in 1577 but trained in Antwerp.
- well educated in classical art and literature, Rubens became painter to the courts of Europe.
- produced magnificent cycles of allegorical painting glorifying his princely patrons as well as altarpieces, history and mythological scenes, portraits and landscapes.
- designed tapestries, book illustrations and pageant decorations.
- numerous pupils and assistants included Anthony van Dyck.
- died 1640.

Tour 9 – step 4
Go to Room 30, carrying on straight through Room 32, to enter Room 33. Turn right to reach Room 34.

The Hay Wain 1821

John Constable (1776–1837)
Oil on canvas, 130.2 x 185.4 cm

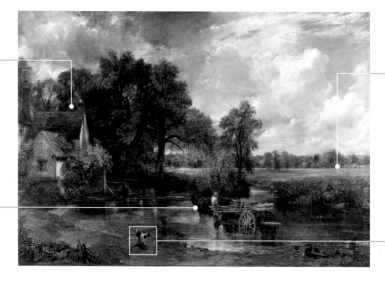

Willy Lott's cottage, used by Constable in several paintings

Small touches of paint represent the hay makers – Constable rarely showed the difficulty of agricultural labour up close

The dog balances the composition. A barrel was included but painted out; it is now partly visible as paint has become transparent

Red touches on harnesses draw the eye to the centre

John Constable

- born in East Bergholt, Suffolk, 1776.
- was influenced by Gainsborough and Dutch landscape painters, such as Jacob van Ruisdael.
- in 1824, received a gold medal at the Paris Salon for *The Hay Wain*. However, his status in England was not marked until he was elected member of the RA in 1829. Lectured on landscape painting, but only achieved modest fame.
- his status as one of Britain's finest-ever painters grew only after his death in 1837.

What's so great about this painting?

It's one of the most famous pictures of the English countryside. Many people love it because it's an idyllic scene. This was, however, a radical painting when it was first made, a deliberate challenge to ideas advanced by the Royal Academy.

What is it about?

A horse-drawn cart, known as a hay wain, is crossing the River Stour in Suffolk. It may have stopped to cool the metal rims of the wheels, or to give the horses a break. The cart is journeying to and from the hay makers shown as dots in the field on the right. A woman collects water for a nearby cottage, and a boy casts his fishing line. Constable has consciously created an idealised version of his native landscape. Life in rural Suffolk was far from perfect for agricultural workers. Unemployment and poverty led to protests and rick-burnings, of which Constable was aware. This is a harmonious view of how things were, and perhaps could be again.

What techniques does the artist use?

Constable painted sketches outside, later combining them into finished works in his studio. He made adjustments so that topographical sketches became idealised versions of recognisable scenes. He applied flicks and dabs of oil paint, as in the sparkling highlights on the water; these effects were considered rough and unfinished at the time.

Why has it been chosen for this tour?

Partly because it's such an iconic English landscape, but also because it was provocative in 1821. Constable challenged ideas about landscape painting's low status by producing a series of these large views, each carefully constructed from sketches. His aim was to capture nature's essence rather than a specific landscape, and to show it could be intellectually and artistically fulfilling. His technique also upset some critics. It was only in France that this painting was really admired, influencing artists who in turn would inspire the Impressionists.

Tour 9 – step 5
Make your way to Room 41, turning left into Room 43.

The Thames below Westminster about 1871

Claude-Oscar Monet (1840–1926)
Oil on canvas, 47 x 72.5 cm

Room 43

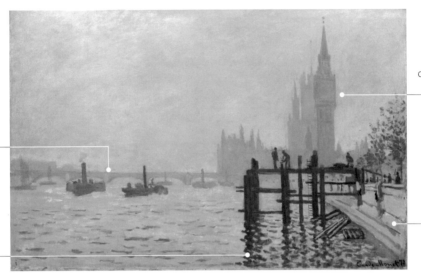

Westminster Bridge serves as the horizon

Almost abstract focus on dark lines of the jetty, and how they break up when reflected in the water

Important landmarks are not the main focus – this landscape is about trying to capture atmospheric effects in paint

Victoria Embankment had recently replaced the old river bank, providing a smart promenade for strolling crowds

What's so great about this painting?

It is so evocative of the Thames, even though we are no longer in the age of steam boats. Monet has captured brilliantly the effect of the Houses of Parliament looming out of the hazy background.

What is it about?

This painting gives an impression of the river on a day when fog shrouded much of the view. Monet loved how the light shone through the particles in the air, declaring that 'without fog, London would not be a beautiful city'. He came to Britain in 1870 to escape the Franco-Prussian War. In London, he found much to excite his interest in painting modern life and his quest to capture atmospheric effects. Based in a room at the Savoy Hotel, Monet spent hours observing the tugs and barges that puffed up and down the Thames. He also watched the crowds who came to enjoy their leisure time by the river, strolling along the newly constructed Victoria Embankment, the promenade on the right.

This is the end of the Landscape tour.

What techniques does the artist use?

Monet painted in the open air whenever possible. In this case, he sat on a balcony leading off from his room. Short, choppy strokes suggest reflections on the water, while the buildings behind disappear into veils of carefully calculated grey.

Why has it been chosen for this tour?

It shows how far landscape had progressed by the late nineteenth century. Monet felt no need to link this to a religious or mythological story, or to make any kind of proud statement about national heritage. Celebrated buildings are simply the excuse for him to study London's air, the way that muted light bounces softly off each structure's surface. He takes a recognisable view that includes the famous clock tower of Big Ben, but focuses primarily on the way its verticals interact with the geometric grid of the rough wooden pier in front. Landscape here is the springboard for Monet's creative agenda and groundbreaking technique.

Claude-Oscar Monet

- born in 1840.
- introduced to painting *en plein-air* ('from nature') around 1856 by Eugène Boudin.
- entered the studio of Charles Gleyre, in Paris, in 1864, where he met Renoir, Sisley and Bazille.
- moved to London 1870–1 to escape Franco-Prussian War.
- lived 1871–8 at Argenteuil, which was to draw many other Impressionist painters.
- co-organised the first Impressionist exhibition in 1874.
- settled in 1886 at Giverny, where he painted his famous waterlilies.
- died in Giverny, 1926.

Tour 10 Frames

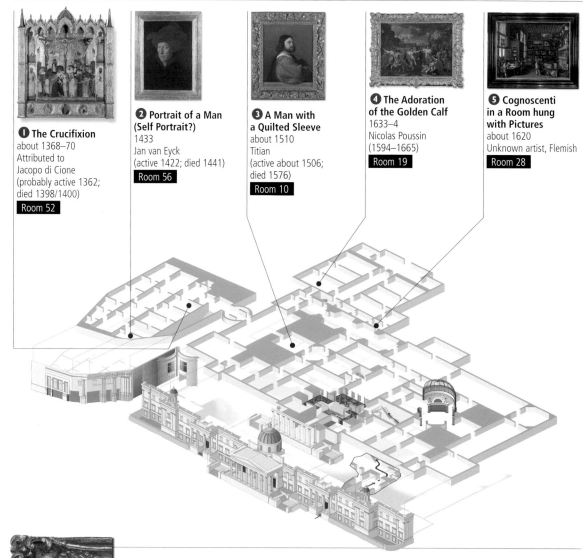

❶ The Crucifixion
about 1368–70
Attributed to
Jacopo di Cione
(probably active 1362;
died 1398/1400)
Room 52

**❷ Portrait of a Man
(Self Portrait?)**
1433
Jan van Eyck
(active 1422; died 1441)
Room 56

**❸ A Man with
a Quilted Sleeve**
about 1510
Titian
(active about 1506;
died 1576)
Room 10

**❹ The Adoration
of the Golden Calf**
1633–4
Nicolas Poussin
(1594–1665)
Room 19

**❺ Cognoscenti
in a Room hung
with Pictures**
about 1620
Unknown artist, Flemish
Room 28

The cutaway shows you which rooms you will visit on this tour, and where they can be found. Frames can make an enormous difference to our experience of a painting. They can draw your eye in, build a bridge between the painting and the wall, and emphasise particular colours or parts of the composition. In the Early Renaissance, frames were usually in place by the time the artist started to paint, so he would design the picture with the frame in mind. Today, relatively few paintings are in their original frames. However, to retain authenticity, museums often try to find suitable second-hand frames from the same period.

Tour 10 – step 1

Start at the Sainsbury Wing Entrance. Head to the second floor, to Room 51 (to your left at the top of the stairs). Enter, turn left, then head straight through Room 52, to reach Room 53.

Did you know?

When you see a big gold frame on a light, airy Impressionist painting, it can look odd – but it could well be the artist's original choice. They wanted their pictures to stand out on the wall in crowded public exhibitions, so often preferred to use wide, decorative gold frames.

The Crucifixion about 1368–70

Attributed to Jacopo di Cione (probably active 1362; died 1398/1400)
Tempera on poplar, 154 x 138.5 cm

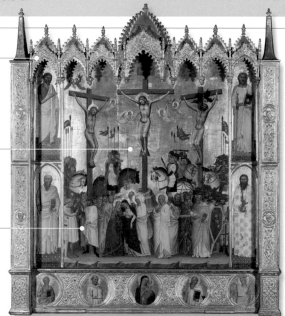

The top of the frame is three-dimensional; the interior of the canopies is painted to look like heavenly skies

Man holds up a stick to offer Christ a sponge soaked in vinegar, to quench his thirst

Soldiers cast lots to win Christ's clothing

The lower part of the altarpiece is called the *predella*. This one has been decorated using *pastiglia*, a raised pattern formed by dribbling thick gesso (plaster), like icing a cake. Glass beads have then been stuck on, to make the frame look like a precious metalwork object

What's so great about this painting?
This small altarpiece is nearly 650 years old, and is still in one piece. It gives a sense of what altarpieces looked like, with lots of different painted panels set into a sculpted frame that's like a miniature golden Gothic building.

What is it about?
The main panel shows Christ's slow and painful execution. He hangs on the central cross; his friends and family gather beneath to mourn him. Mary Magdalene (in red) supports Christ's mother (in a blue cloak) as she swoons with grief. Ideas of the afterlife are explained by the contrasting fates of the two thieves who were crucified with Christ. Angels take the soul of the 'good thief' to heaven, while demons hold burning coals over the 'bad thief'. Set into the frame (clockwise from top left) are Saints John the Baptist, James the Greater, Bartholomew, and Paul, probably important local saints or the name saints of the altarpiece's patrons.

What techniques does the artist use?
The frame was nailed and glued to the poplar panel before painting took place, then the object was covered with layers of gesso (white plaster), bole (sticky clay), gold leaf and egg tempera paint. At least two artists from Jacopo's workshop contributed to this piece, a practice common in Florence at this time.

Why has it been chosen for this tour?
Because from this altarpiece's initial design, the frame has played a central role in the way it honours Christ, adding considerably to its glory and splendour. The frame is designed like a reliquary or shrine, a precious object housing something sacred. It is architectural, including a roof: the upper section of the frame is a series of canopies designed to protect the holy image from dust. Inside, each one is decorated with a starry sky. This frame was probably retained because it is an integral part of this small work. Larger altarpieces were often cut up when their frames were no longer in fashion.

Jacopo di Cione
- probably active in Florence by 1362.
- worked alongside three of his brothers, who were also painters.
- headed a large workshop that painted altarpieces and frescos, and collaborated with other artists, especially Niccolò di Pietro Gerini.
- in 1370–1 his workshop produced the polyptych for the high altar of the church of San Pier Maggiore – one of the largest created in fourteenth-century Florence.
- worked in Florence Cathedral between 1378 and 1380.
- died in Florence sometime between 1398 and 1400.

Tour 10 – step 2
Enter Room 53, passing straight through Rooms 54 and 55, to reach Room 56.

Portrait of a Man (Self Portrait?) 1433

Jan van Eyck (active 1422; died 1441)
Oil on wood, 26 x 19 cm

Inscription: 'AK IXH XAN'
('Als ich can' or 'As I can' /
'As Eyck can')

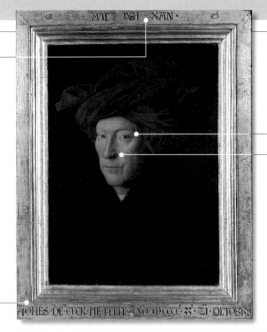

Skilfully painted eyes
– tiny veins painted into
wet under layer so they
have run slightly. Pure
white spots create
glistening highlights

Nose is further in profile
than the position of his
eyes would suggest –
a trick used to increase
the sense of likeness,
as the nose is such a
distinctive feature
of the face

Lower inscription is the
artist's signature – it
translates as 'Jan van
Eyck made me
in the year 1433
on 21 October'

Jan van Eyck

- born in Maaseick, in modern-day Belgium.
- initially trained as a manuscript illuminator.
- became official court painter to John III, Count of Holland, 1422.
- moved to Bruges and became court painter to Philip the Good, Duke of Burgundy, 1425.
- many patrons were members of an Italian colony in Bruges.
- advanced a powerful style of individual portrait painting.
- one of the first to unlock the potential of oil paint.
- died in Bruges, 1441.

What's so great about this painting?
The way that it seems to be based so closely on a person who existed. He looks out with a penetrating gaze, and it's as if you're in the presence of a man who lived centuries ago.

What is it about?
This is a portrait of a man in a fur-lined robe, wearing a red *chaperon*, a head-dress constructed from scarves wrapped around a roll of padding. This might be a self portrait by the artist, Jan van Eyck. He seems to have scrutinised each eye separately; it could be that he has studied every one of his features in turn in a mirror. However, he frequently distorted his portraits in a similar way, as it was believed that this gave them a more lively and expressive air. Here, the distinctive nose is placed too far into profile, so we can see its shape more easily. The inscription on the top of the original frame – 'As I can' or 'As Eyck can' – could be another clue. It's his personal motto, placed where the sitter's name would usually be.

What techniques does the artist use?
Van Eyck pioneered oil painting techniques, using thin glazes and tiny strokes of paint to realistically suggest skin, stubble and cloth.

Why has it been chosen for this tour?
Netherlandish paintings from this period often had integral frames, where the surface to be painted was chiselled out of a thick panel, leaving a raised surround. This one is unusual: the long edges (mouldings) are part of the main panel, but the short ones have been added, possibly a solution to the problem of chiselling neat edges across the grain of the wood to achieve a sharp finish at the corners. It also meant he could plane the surface to be painted very flat before putting the upper and lower mouldings in place. Frames often carried texts: prayers or, as here, personal mottos and the signature of the artist. Van Eyck's inscriptions were painted to imitate chiselled letters, and were fragile; this painting and its frame may originally have been protected by a box or cover.

Tour 10 – step 3
Return to the top of the staircase in the Sainsbury Wing, passing the stairs and lift, to enter Room 9. Carry on straight through this room to reach Room 10.

A Man with a Quilted Sleeve about 1510

Titian (active about 1506; died 1576)
Oil on canvas, 81.2 x 66.3 cm

THE NATIONAL GALLERY

NATIONAL GALLERY COMPANY LTD
St Vincent House, 30 Orange Street
London WC2H 7HH

Tel 0207 747 5958
www.nationalgallery.co.uk
VAT no. 480730549

THE NATIONAL GALLERY

NATIONAL GALLERY COMPANY LTD
St Vincent House, 30 Orange Street
London WC2H 7HH

Tel 0207 747 5958
www.nationalgallery.co.uk
VAT no. 480730549

We will offer a refund or exchange on any item
purchased from the National Gallery shops
provided it is returned, with its receipt, within 28
days of purchase and in saleable condition.

Unless proved faulty, we cannot accept the return
of certain items for hygiene reasons, including
earrings, or perishable goods, or items which

Frame slopes outwards towards the wall, connecting the painting and the surface on which it is hung

This frame design was influenced by the increasing number of picture galleries in European palaces – artists and patrons began to think about how paintings would look on display

What techniques does the artist use?

Titian painted in oil, sometimes without drawing in outlines first. He built up forms using glazes of colour, adding highlights in thicker strokes.

Why has it been chosen for this tour?

It has a detachable frame. These became popular in Italy during the sixteenth century, probably because canvas was increasingly used as a support. It could be rolled up for easy transportation, but only if the frame could also be removed. This is an example of the most common type of detachable frame in Italy, the *cassetta* or 'small box' frame. It consists of a *frieze* (a long piece of carved ornamentation), with clearly defined inner and outer mouldings. This one was made in the early seventeenth century in France, and is a reverse-pattern frame. This means that the sight edge, that nearest the painting, is the most prominent feature of the frame. The rest slopes away, to form a visual connection between the painting and the wall on which it hangs.

[...]s 14, 29, 28 and 25. Turn left into Room 24,
[...]

Titian

- born Tiziano Veccellio in Pieve di Cadore, near Venice.
- brought as a child to Venice; eventually apprenticed to the Bellini brothers, and finally became associated with Giorgione.
- worked for Francis I of France, the Emperor Charles V and his son Philip II of Spain, as well as the leading families of Venice.
- developed a technique of painting directly on to the canvas without the use of preparatory drawings, resulting in a freer painting style.
- died in Venice, 1576.

The Adoration of the Golden Calf 1633–4

Nicolas Poussin (1594–1665)
Oil on canvas, 153.4 x 211.8 cm

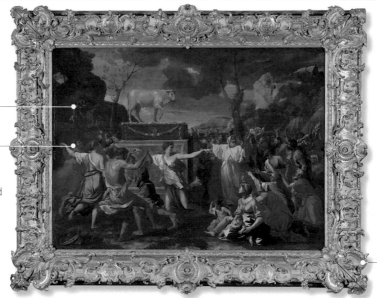

Moses breaking the tablets of the Ten Commandments in his anger

Dancers use a similar pose, studied from different angles. The woman with outstretched arm was adapted from an earlier painting by Poussin, *Bacchanalian Revel before a Term of Pan*, also in the National Gallery

Carved gilt frame simulates bronze – sand has been mixed with the gesso (plaster) undercoat to give the effect of metal that has been hammered with tiny points

Fine details such as grooved surfaces of feathers and leaves have been cut into the gesso (plaster) undercoat rather than into the wood itself

Nicolas Poussin

- born in 1594 in Normandy.
- travelled to Rome in 1624; stayed there for most of his life.
- was influenced by sixteenth-century Venetian art, especially that of Titian.
- tried to recreate ancient myth and history in his works.
- was popular with learned, aristocratic patrons, and had a high reputation in France and Italy.
- is hailed as introducing classic grandeur and rational composition to French painting.
- died in Rome, 1665.

What's so great about this painting?

The intricate dancing figures, frozen like a group of sculptures. The way this painting uses its composition to tell its story.

What is it about?

This is an Old Testament story from the Bible (Exodus). Moses climbed Mount Sinai to receive the tablets containing the Ten Commandments, laws for life, from God. In his absence, the Israelites reverted to their former religious practices and, with the help of Moses's brother Aaron (in white), built a golden statue of a calf that they worshipped with song and dance. When Moses returned, he was furious, breaking the tablets and demanding that his followers either choose God or death. Poussin deliberately makes Moses a smaller figure at the left, which we only notice after we have been distracted by the beautiful dancing figures and the false idol of the golden calf. Like the Israelites, we too have momentarily missed the point.

What techniques does the artist use?

Poussin researched his subjects carefully, reading relevant texts, and drawing from sculptures and other paintings. He then gradually refined his composition, making wax models of figures that he placed in a stage set, lit from one angle and then drew, studying the shadows. Every colour and expressive gesture was carefully planned.

Why has it been chosen for this tour?

It's in a spectacular carved oak frame that dates from about 1710, when it was in a Parisian collection. The frame is far more ornate than anything Poussin would have chosen: he favoured plain mouldings with dull gilding. This frame was no doubt added to help the painting match the ornate gilded furniture around it in the eighteenth-century interior, and as a way of honouring what was already a very famous painting. Now, the frame almost threatens to upstage the picture, and certainly stands out more than it might have done in 1710.

Tour 10 – step 5
Return to Room 18, continuing straight through, to enter Room 24. From here, go to Room 25. Turn right and enter Room 28.

Cognoscenti in a Room hung with Pictures about 1620

Unknown artist, Flemish
Oil on oak, 95.9 x 123.5 cm

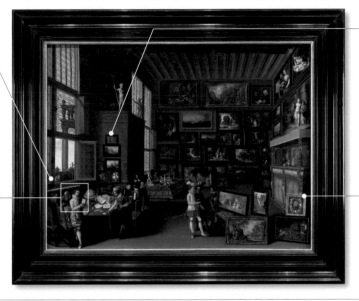

A church interior
by Hendrick
van Steenwyck
the Younger

Monkey mocking this
earnest pursuit of
earthly knowledge

Man holding painting of
snails and insects in a frame
that had a closing shutter

*Virgin and Child in a
Flower Garland*,
by Jan Brueghel
the Elder

What's so great about this painting?

The glimpse it gives into what was collected
in Antwerp around 1620, and the sense of
how different galleries looked in the past.

What is it about?

This is an imaginary private gallery, stuffed with
a wide range of objects designed to represent
the best of art on offer in Antwerp at the time.
Various richly dressed men are engrossed in
studying them: these are the *cognoscenti* or
connoisseurs. They are surrounded by paintings,
but also have at their disposal prints, coins
and medals, sculpture, a fine red Persian rug,
Chinese porcelain, and a range of scientific and
astrological instruments. However, the pleasure
they all take in collecting art and scholarly study
is countered here by the monkey on the
windowsill. He is a symbol of the foolishness
of man's endeavours, mocking this thirst for
earthly knowledge. These men should instead
be devoting time to religious contemplation,
and preparing for eternal life.

This is the end of the Frames tour.

What techniques does the artist use?

Probably made by one artist who painted
interiors, and by another who painted figures,
the pictures and objects are painted with
convincing detail: some are recognisable today.

Why has it been chosen for this tour?

It gives a sense of how densely galleries used
to be hung, although they were perhaps never
quite as crammed as in this imaginary scene.
Pictures were, though, frequently taken down
for close examination, and propped up as we
see here. We are also shown the sorts of frame
preferred in the Netherlands at this time:
relatively plain *cassetta* (small box) frames. Even
the most decorative examples are not entirely
gilded. The man looking out from the lower left
corner holds a painting showing snails and
insects, covered with a shutter fitted to the
frame. This protective function would also have
allowed the owner to pull back the shutter
quickly and startle an unsuspecting viewer with
the realistic depiction of life-sized bugs inside.

Unknown artist

- the painting is one
 of a large number
 of scenes showing
 collectors and visitors
 in real or largely
 imaginary settings
 that were produced
 in Flanders in the
 seventeenth century.
- the large print on the
 table is *Ceres mocked
 by Peasants* by Goudt
 after Elsheimer; in the
 open folio are prints
 by Dürer and Lucas
 van Leyden. The
 paintings on the wall
 are almost all by
 Antwerp artists of
 the sixteenth and
 seventeenth centuries
 and include works in
 the style of Joachim
 Beuckelaer, Joos de
 Momper, Jan Brueghel
 the Elder and Frans
 Francken.

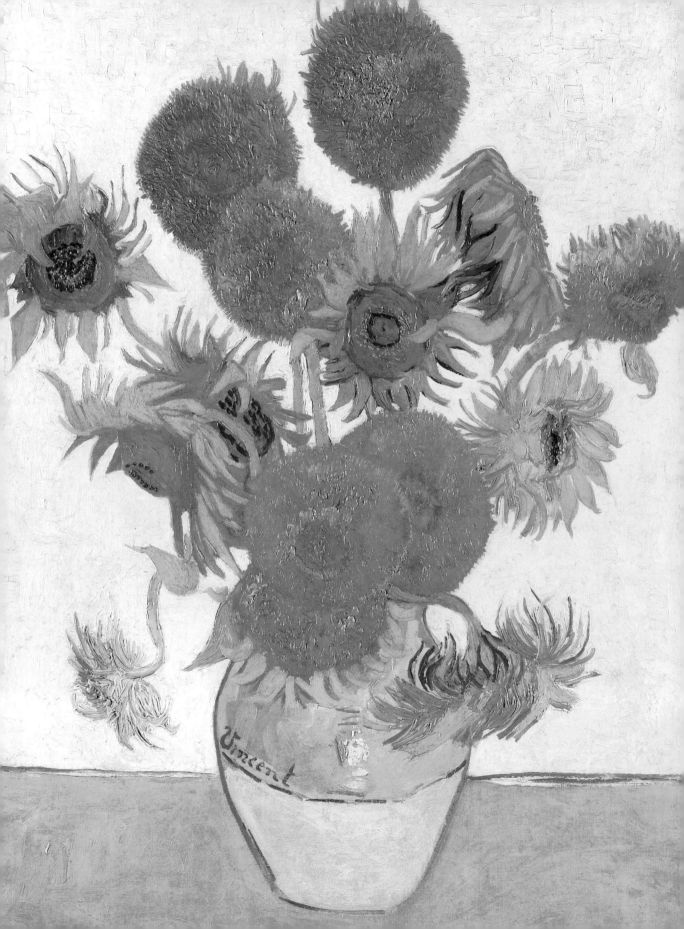

4

More about your Gallery

The building's beginnings

The Gallery's founders wanted the collection to be centrally located, so that wealthy west Londoners and poorer people from east London could visit, as well as those from the rest of the country and abroad. In 1824, the first display was held at the townhouse of the late John Julius Angerstein (pictured) at Pall Mall, close to Trafalgar Square. While it was still rather like visiting a private collection, it was open to everyone.

Right: The front elevation of the National Gallery as it is today, seen from Trafalgar Square.

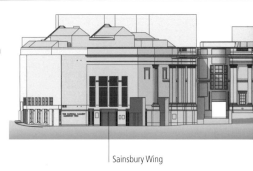

Sainsbury Wing

Location, location

With increasing criticism of the Pall Mall building and a growing collection, architect William Wilkins was commissioned to design a building to house both the National Gallery and the Royal Academy of Arts. After much debate in 1831, Trafalgar Square was chosen as a central place for both local visitors and those from further afield. There would be no admission charge, and children were to be allowed, so that families could also visit.

The first years of the Gallery

Once the Gallery had opened in 1838, its collection was shown in just five rooms on the main floor of the west wing (Rooms 2, 4, 6, 7 and 8). The galleries were top-lit with large lanterns, which meant that the Gallery could only open during daylight hours (it took until 1935 for the entire building to be fitted with electrical lighting).

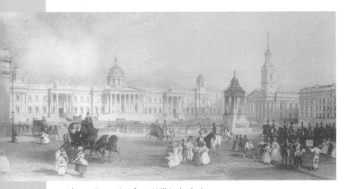

Above: Engraving from Wilkins's design, *The National Gallery – Charing Cross*, about 1837.

A temple of art?

Wilkins was greatly influenced by classical temples he had seen in Greece and Italy. However, he was forced to compromise on his initial design. His building had to be moved back fifty feet, so that the church of St Martin-in-the-Fields could still be seen from Pall Mall, and his desire for an imposing central flight of stairs up to the portico on the front was quashed, in place of two smaller staircases at either side. Despite initially negative press, by the 1980s, Wilkins's building had become such a familiar and popular icon that Prince Charles called it a 'much-loved friend' when radically different architectural additions were proposed.

Recycling of architecture

The estimate for Wilkins's first design was £43,425. By 1833 this figure had grown to £66,000, much to the outrage of public finance controllers. The project was soon scaled down, with a saving of £4,000 made by using second-hand materials. Wilkins was told to use columns from the recently demolished Carlton House (the previous residence of George IV), as well as sculpture left over from Marble Arch. Believing that the Carlton House columns were inadequate for the central portico, he in fact used only the bases and the capitals of some of the columns – which now flank the openings to the building's rear. The leftover Marble Arch statuary – designed by Flaxman and executed by Rossi – was placed in the front window niches.

Above: Front of Carlton House, 1820.

> The first duty of government is to see that people have food, fuel, and clothes. The second, that they have means of moral and intellectual education.
>
> John Ruskin, 1876

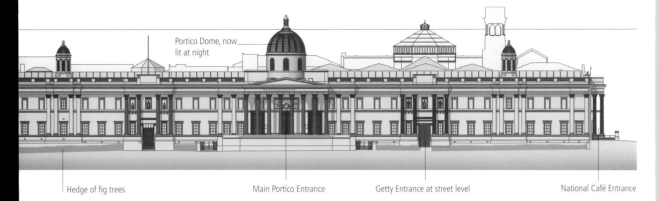

Portico Dome, now lit at night

Hedge of fig trees Main Portico Entrance Getty Entrance at street level National Café Entrance

The collection itself

But where did the paintings for this venture come from? Gallery supporters had to start the collection on their own. The Royal Collection had not been taken over by the state, as had been the case at Paris's Louvre during the French Revolution. In response, philanthropist Sir George Beaumont offered a solution that aimed both to provide paintings and to encourage the Government to commit funds to the project. He promised to donate his own substantial art collection to the Gallery, if the state would buy Angerstein's collection and provide a building to house the work. Beaumont's collection included Claude Lorrain's *Narcissus and Echo* and Rubens's *A View of Het Steen*. The Reverend Holwell Carr made a similar offer to donate works, including Paolo Veronese's *The Rape of Europa*. The Government agreed to help if funds became available and, when Austria unexpectedly repaid a war debt in 1824, the project became viable. The Government proceeded to buy Angerstein's collection of 38 Old Master paintings, including Sebastiano del Piombo's *The Raising of Lazarus*. This was the Gallery's first official painting, which was given the reference number 'NG1'. The National Gallery was now officially in existence.

Below: Williams Wilkins's original building plan, July 1836.

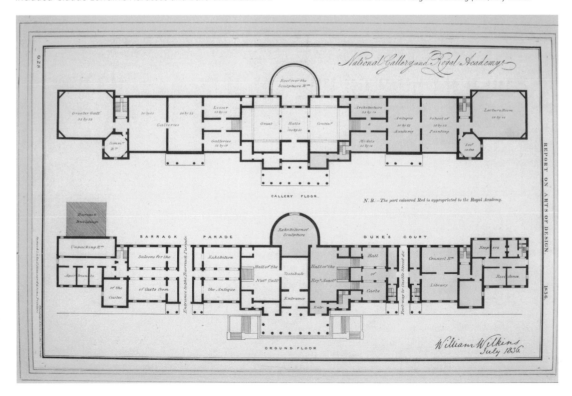

The expansion of the National Gallery

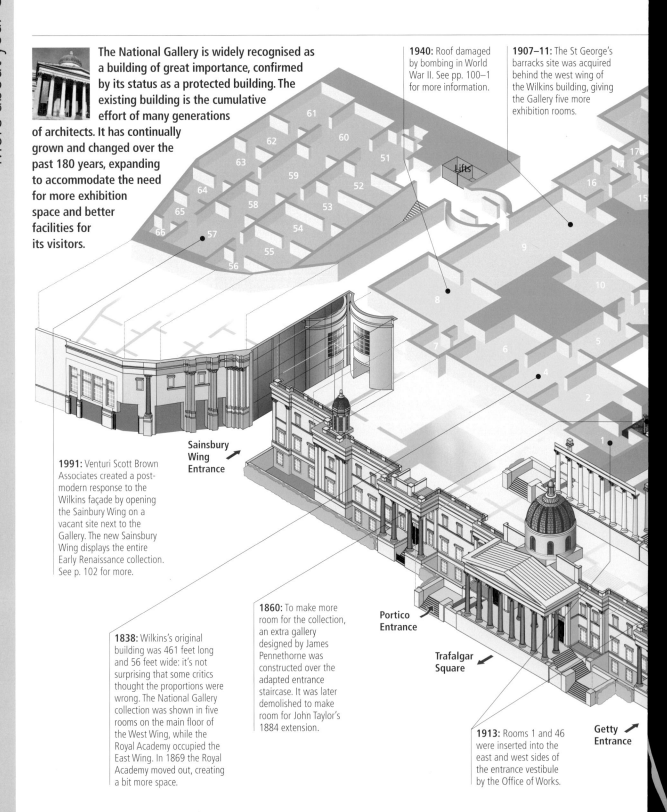

The National Gallery is widely recognised as a building of great importance, confirmed by its status as a protected building. The existing building is the cumulative effort of many generations of architects. It has continually grown and changed over the past 180 years, expanding to accommodate the need for more exhibition space and better facilities for its visitors.

1940: Roof damaged by bombing in World War II. See pp. 100–1 for more information.

1907–11: The St George's barracks site was acquired behind the west wing of the Wilkins building, giving the Gallery five more exhibition rooms.

1991: Venturi Scott Brown Associates created a post-modern response to the Wilkins façade by opening the Sainbury Wing on a vacant site next to the Gallery. The new Sainsbury Wing displays the entire Early Renaissance collection. See p. 102 for more.

Sainsbury Wing Entrance

1838: Wilkins's original building was 461 feet long and 56 feet wide: it's not surprising that some critics thought the proportions were wrong. The National Gallery collection was shown in five rooms on the main floor of the West Wing, while the Royal Academy occupied the East Wing. In 1869 the Royal Academy moved out, creating a bit more space.

1860: To make more room for the collection, an extra gallery designed by James Pennethorne was constructed over the adapted entrance staircase. It was later demolished to make room for John Taylor's 1884 extension.

Portico Entrance

Trafalgar Square

1913: Rooms 1 and 46 were inserted into the east and west sides of the entrance vestibule by the Office of Works.

Getty Entrance

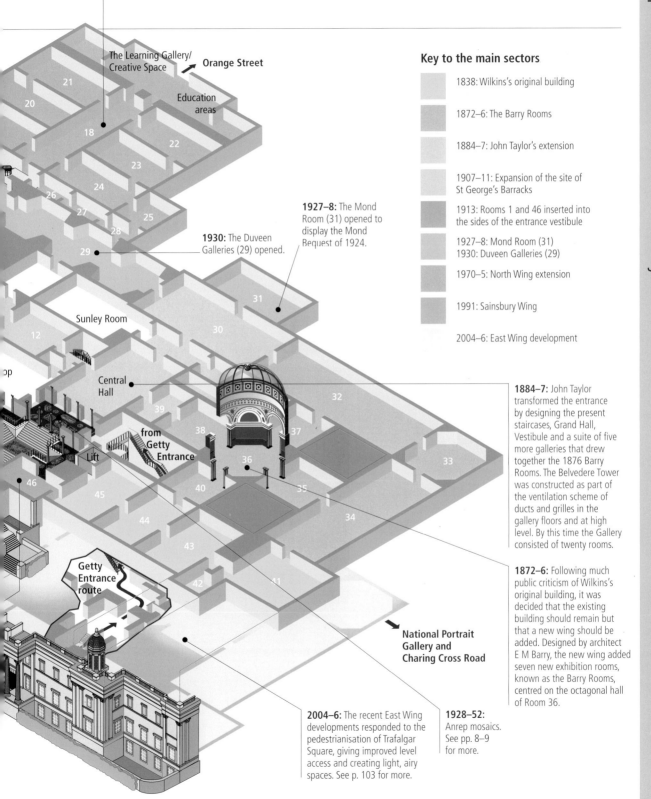

1970–5: Government body the Property Services Agency designed the North Wing, an unloved modernist extension, which increased gallery space by 25 per cent.

The Learning Gallery/ Creative Space

Orange Street

Education areas

21
20
18
22
23
24
26
27
25
28
29

1927–8: The Mond Room (31) opened to display the Mond Bequest of 1924.

1930: The Duveen Galleries (29) opened.

31
30

Sunley Room
12

Central Hall

from Getty Entrance

39
38
37
36
40
35
34
32
33

Lift

46
45
44
43
42
41

Getty Entrance route

National Portrait Gallery and Charing Cross Road

Key to the main sectors

1838: Wilkins's original building

1872–6: The Barry Rooms

1884–7: John Taylor's extension

1907–11: Expansion of the site of St George's Barracks

1913: Rooms 1 and 46 inserted into the sides of the entrance vestibule

1927–8: Mond Room (31)
1930: Duveen Galleries (29)

1970–5: North Wing extension

1991: Sainsbury Wing

2004–6: East Wing development

1884–7: John Taylor transformed the entrance by designing the present staircases, Grand Hall, Vestibule and a suite of five more galleries that drew together the 1876 Barry Rooms. The Belvedere Tower was constructed as part of the ventilation scheme of ducts and grilles in the gallery floors and at high level. By this time the Gallery consisted of twenty rooms.

1872–6: Following much public criticism of Wilkins's original building, it was decided that the existing building should remain but that a new wing should be added. Designed by architect E M Barry, the new wing added seven new exhibition rooms, known as the Barry Rooms, centred on the octagonal hall of Room 36.

2004–6: The recent East Wing developments responded to the pedestrianisation of Trafalgar Square, giving improved level access and creating light, airy spaces. See p. 103 for more.

1928–52: Anrep mosaics. See pp. 8–9 for more.

World War II

On 23 August 1939, as concerns about imminent war intensified, the National Gallery closed its doors to the public, not knowing when they would open again. Few realised that the Gallery would soon be providing a much-needed cultural boost for people caught up in the drudgery and fear of wartime London.

The evacuation of paintings

The secret destination of most of the paintings was Wales, but 100 of the smaller pictures were to go to Gloucestershire. The last shipment left Trafalgar Square the day before war was declared. After the fall of France, the pictures were further dispersed and transport to Canada was considered, but Churchill immediately vetoed the plan, stating: 'Hide them in cellars or in caves, but not one picture shall leave this island.'

Ian Rawlins, the Gallery's scientific adviser, was asked to find alternative accommodation – the result was Manod Quarry, a slate mine in the mountains above the Welsh village of Ffestiniog. Preparations to house the pictures at Manod took almost a year and transportation was carried out by the London Midland Scottish Railway and the Great Western Railway.

The lunchtime concerts

With the National Gallery closed and many of the capital's cinemas, theatres and concert halls also shut due to the heavy bombing, concert pianist Myra Hess approached Gallery Director Kenneth Clark with the idea of staging

Below: A capacity crowd at one of the lunchtime concerts.

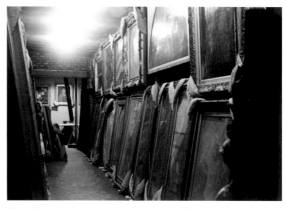

Above: Evacuated paintings stored underground in Wales during the War.

lunchtime concerts of classical music in the empty Gallery. The first concert was held at 1pm on 10 October 1939 and admission cost one shilling. These ran uninterrupted for six and a half years until 10 April 1946. In all, 1,698 concerts were given.

The lunchtime canteens

The success of the lunchtime concerts spawned another innovation: a canteen to provide lunch for the concert-goers. This was the idea of keen concert supporter Lady Irene Gater who, with a team of women volunteers, produced light meals, biscuits, cakes, tea and coffee at modest prices for those attending the concerts.

The canteen was opened in 1940 to also cater for civil servants and war workers, and was in operation until the end of July 1945, raising £45,000 for wartime charities.

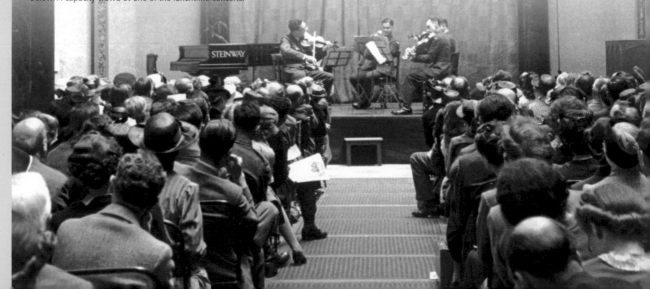

Bomb damage at Trafalgar Square

The first bombs of the Blitz fell on the City of Westminster just before 11pm on 30 August 1940. The National Gallery was hit for the first time on the night of 12 October, by a 250-kilo bomb that destroyed Room XXVI (now Room 10). It was very lucky not to suffer worse damage: during the same raid seven people were killed and thirty-three people were injured when a bomb hit Trafalgar Square.

A second bomb fell in one of the Gallery's small courtyards five days later on 17 October 1940, but it did not explode immediately. It eventually went off – destroying the Old Board Room and damaging the Library – on 22 October, while the Royal Engineers Bomb Disposal Squad was at lunch. Further bombs fell on the National Gallery on 7 and 15 November 1940 but – despite the damage to the building – no one was hurt, and the pictures had already been safely stored outside the capital.

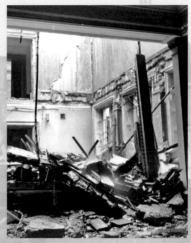

Left: Damage caused by the bomb that hit Room XXVI (now Room 10) in 1940.

> ❝ Hide them in cellars or in caves, but not one picture shall leave this island. ❞
> Sir Winston Churchill

Exhibitions and war artists

In December 1939, upon art dealer Lillian Browse's suggestion, National Gallery Director Kenneth Clark proposed to the Trustees that the Gallery should host a loan exhibition of recent British painting. The idea was accepted and the first temporary exhibition, *British Painting since Whistler*, opened to the public in March 1940. When it closed at the end of August it had attracted over 40,000 visitors. The Gallery staged a further 19 temporary exhibitions and alongside these it also

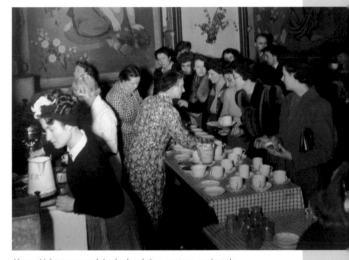

Above: Volunteers work in the lunchtime canteen against the backdrop of paintings by British war artist Duncan Grant.

ran a single, constantly renewing exhibition – the work of Britain's war artists. The War Artists Scheme had been initiated by Kenneth Clark in the early days of the War, and he was appointed chair of the War Artists Advisory Committee. Its aim was to acquire for the nation pictures recording all aspects of the War, both at home and abroad. Some of the most famous works were by artists such as Henry Moore, Graham Sutherland, John Piper and Paul Nash.

By the end of the War, the Committee had built up a collection of 5,500 works, which were distributed among museums in Britain and the Commonwealth. The majority of works and the records of the War Artists Advisory are today held at the Imperial War Museum – for further information, visit: www.iwm.org.uk/collections.

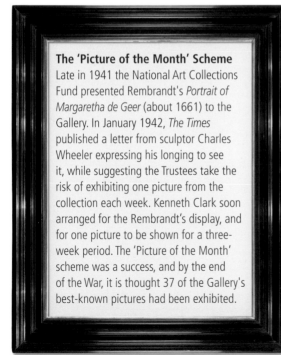

The 'Picture of the Month' Scheme

Late in 1941 the National Art Collections Fund presented Rembrandt's *Portrait of Margaretha de Geer* (about 1661) to the Gallery. In January 1942, *The Times* published a letter from sculptor Charles Wheeler expressing his longing to see it, while suggesting the Trustees take the risk of exhibiting one picture from the collection each week. Kenneth Clark soon arranged for the Rembrandt's display, and for one picture to be shown for a three-week period. The 'Picture of the Month' scheme was a success, and by the end of the War, it is thought 37 of the Gallery's best-known pictures had been exhibited.

Modern developments

The National Gallery is constantly changing. Its collection expands as new works are acquired, loaned or bequeathed to the nation. The Gallery also keeps pace with the changing needs both of the collection and its visitors. Paintings require constant scientific and conservation care, just as visitors need spaces for orientation, relaxation and refreshment. The latest developments help to make the collection more accessible than ever.

During 1985, a detailed design brief for the building was drawn up and the following year Robert Venturi of Venturi Scott Brown Associates in Philadelphia, USA, was selected as the architect. Construction began in 1988, and the Sainsbury Wing was opened to the public by the Queen in July 1991.

The Sainsbury Wing's exterior takes elements from Wilkins's classical façade and uses them as a series of references. Some critics appreciated Venturi's design; others were disappointed by such a 'classical blancmange' when there had been an opportunity to make outstanding new architecture. Inside, the design – inspired by Florentine churches, reflecting the Gallery collection's historical bias towards Italian painting – creates a contemporary yet sympathetic setting for some 250 paintings. Humidity and lighting is controlled by a computer system, keeping the temperature at 20 degrees celsius and humidity at 55%Rh.

Above: Renaissance pieces hang in Room 59 of the Sainsbury Wing.
Left: The cool, elegant architectural style of the Sainsbury Wing Entrance.

The Sainsbury Wing

In April 1985, Gallery Trustees announced they had received a generous gift from Lord Sainsbury of Preston Candover and his brothers The Hon Simon Sainsbury and Sir Timothy Sainsbury. The brothers had expressed their wish to give the nation a new building on the land adjacent to the National Gallery, previously the site of Hampton's Furniture store, bombed in 1940 and left vacant ever since.

The new building would help provide for the Gallery's growing number of visitors, with improved facilities for lectures and temporary exhibitions as well as more top-lit galleries, a new shop and restaurant, a digital information room and an entrance at street level to relieve congestion and access problems at the Gallery's main Portico Entrance.

THE GALLERY TODAY

2,300+ paintings in the collection.

500+ staff work here to look after the collection and help the public to enjoy and be inspired by it.

4,500,000 people, on average, visit the National Gallery every year.

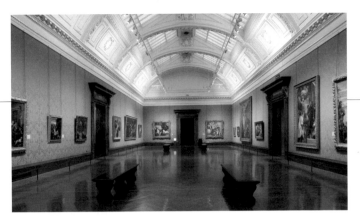

Left: Room 9 in the West Wing, after refurbishment in the 1990s.

1990s refurbishment

An extensive refurbishment programme of the main building and re-arrangement of the collection followed the opening of the Sainsbury Wing. Renovated largely through private donation, the aim of the refurbishment was to restore the main galleries to their original nineteenth-century decorative schemes. After World War II, a more neutral setting for the rooms was in vogue, and schemes had been painted over while suspended ceilings hid decorative plasterwork. The restoration in the 1990s saw false ceilings and partitions removed, walls decorated with richly ornate silks, and a consistent vocabulary of wooden floors, slate margins and marble skirtings and door cases re-established, to make the rooms worthy again of the collection they displayed. This approach extended to the newer North Galleries, which were refurbished to resemble the nineteenth-century rooms. The project also included the building of the Gallery's new Education Centre, which opened in 1999, its entrance on Orange Street.

The work highlighted the difficulties of having 4.5 million visitors a year in a building originally designed for a fraction of that number. This, in turn, paved the way for more redevelopment the following decade.

The East Wing development

This project, which began in 2003, made the Gallery's main building accessible to the public at street level for the first time, via the Getty Entrance in Trafalgar Square. The East Wing development also provided increased picture-hanging space by reinstating Central Hall as a gallery room, showcasing some of the most important paintings in the collection. Works by Titian and his contemporaries now provide visitors with an exhilarating start to their experience in the Gallery.

Above right: New East Wing development provides a grand entrance to the Central Hall as well as new visitor facilities.

Left: Proposal for decoration of the entrance staircase of the Gallery, by E M B Warren.

Further redevelopment included refurbishing the main Entrance Hall and restoration of the original nineteenth-century decorative scheme by J D Crace – a well-known interior designer of the late Victorian period – in the Central Hall. This had been covered up with marble cladding and white overpainting in 1969–70 as part of a deliberate policy to create a neutral backdrop for the paintings, but was restored after original nineteenth-century watercolours by Crace showed how it was intended to appear.

Enhanced access to the collection through the street-level Getty Entrance was also complemented by improved visitor facilities, including a new multimedia area, a modern shop, café and espresso bar. Designed by architects Dixon Jones, the East Wing development is the first step towards a wider plan to improve visitor facilities for the Gallery as a whole.

Funding the National Gallery

Who helps the National Gallery buy paintings? The greatest challenge the Gallery faces is maintaining the vitality of the collection through acquisitions. Nearly a quarter of the Gallery's paintings are the gifts or bequests of individuals. Over recent years, the Gallery has succeeded in many imaginative ways to enhance the collection.

Support for past acquisitions includes:

■ The Art Fund was established in 1903 to help acquire works of art for museums and galleries in the UK. In 1905, it played a crucial part in purchasing Velázquez's 'The Rokeby Venus' (detail, above), by raising £45,000 to outbid other buyers.

■ In 1923 Samuel Courtauld gave £50,000 for the purchase of Impressionist and Post-Impressionist pictures for the British national collections. Among the pictures bought with

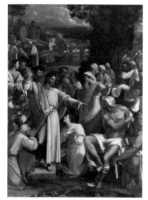

Above: *The Raising of Lazarus*, Sebastiano del Piombo, the Gallery's first official acquisition, with reference number 'NG1'.

the Courtauld fund was van Gogh's *Sunflowers* (1888). Over the following few years, many of these paintings became the core of the National Gallery's holding in these areas.

■ In 1985, philanthropist J Paul Getty Jnr, son of J Paul Getty

Snr, financier of the Getty Museum in California, established an endowment fund, 'the principle purpose of which will be to enable the National Gallery to acquire additional works of art.'

Left: The National Gallery and Trafalgar Square.

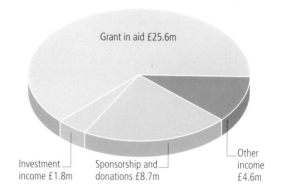

Income 2007/8

Grant in aid £25.6m

Investment income £1.8m

Sponsorship and donations £8.7m

Other income £4.6m

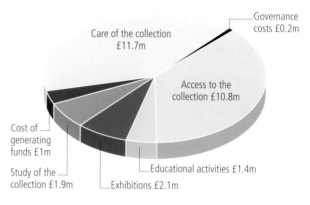

Operating Expenditure 2007/8

Governance costs £0.2m

Care of the collection £11.7m

Access to the collection £10.8m

Cost of generating funds £1m

Study of the collection £1.9m

Educational activities £1.4m

Exhibitions £2.1m

Funding today and in the future

The last decade has seen the National Gallery's collection enhanced with a number of important paintings. Education and outreach activities have increased significantly. The main floor galleries have been refurbished and services for visitors have been improved.

The bedrock of the Gallery's work will remain the permanent collection and resources will continue to be devoted to preserving, enhancing and studying the collection. The Gallery will seek in particular to find imaginative ways to present the collection to a broad and diverse public.

Support us

For further information on what kind of educational activities the funding provides, as well as how to help, please see pp. 108–9.

London: city of galleries

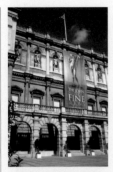

Royal Academy of Arts

Burlington House
Piccadilly W1J 0BD
www.royalacademy.org.uk
⊖ Green Park
The Royal Academy of Arts was founded by George III in 1768. It still provides training and exhibition opportunities for artists, but also mounts a regular programme of major art exhibitions.

The majority of the War Artists scheme's WWII works and the records of the War Artists Advisory are held at the **Imperial War Museum**, Lambeth Road, London SE1 6HZ, www.iwm.org.uk.

The National Gallery

Trafalgar Square
WC2N 5DN
www.nationalgallery.org.uk
⊖ Leicester Square
The nation's collection of western European painting, from about 1250 to the early twentieth century. Includes some of the world's favourite masterpieces.

National Portrait Gallery

St Martin's Place
WC2H 0HE
www.npg.org.uk
⊖ Leicester Square
Houses portraits of historically important and famous British people. The gallery, which opened in 1856, moved in 1896 to its current site at St Martin's Place, and adjoins the National Gallery.

British Museum

Great Russell Street
WC1B 3DG
www.britishmuseum.org
⊖ Holborn
One of the first museums established, the British Museum displays artefacts from scores of cultures all over the world.

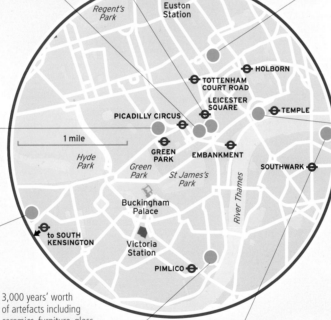

Map labels:
Regent's Park · Euston Station · HOLBORN · TOTTENHAM COURT ROAD · LEICESTER SQUARE · TEMPLE · PICADILLY CIRCUS · 1 mile · Hyde Park · GREEN PARK · EMBANKMENT · SOUTHWARK · Green Park · St James's Park · River Thames · Buckingham Palace · to SOUTH KENSINGTON · Victoria Station · PIMLICO

Courtauld Gallery

Somerset House, Strand
WC2R 0RN
www.courtauld.ac.uk
⊖ Embankment
or Temple
The Courtauld Institute of Art is one of the world's leading centres for the study of the history and conservation of art and architecture, and its gallery houses one of Britain's best-loved collections, famed for its strong collection of Impressionist paintings.

V&A Museum

Cromwell Road SW7 2RL
www.vam.ac.uk
⊖ South Kensington
V&A is the museum of art and design, showcasing

3,000 years' worth of artefacts including ceramics, furniture, glass, metalwork, photographs, sculpture and textiles.

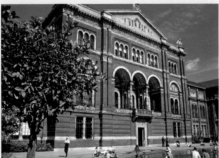

Tate Britain

Millbank SW1P 4RG
⊖ Pimlico
The displays at Tate Britain explore the development of art in Britain, and present contemporary art from the UK, including the annual Turner Prize.

Tate Modern

Bankside SE1 9TG
⊖ Southwark
Tate Modern is the nation's gallery of international modern art. It opened in 2000, in a disused power station.

Tate (www.tate.org.uk) is a family of four galleries – Tate Britain and Tate Modern in London, Tate Liverpool and Tate St Ives – that display selections from the Tate Collection.

Gallery life

How is the National Gallery run? It is governed by a Board of Trustees appointed by the Prime Minister. They form an independent body with an invaluable depth and diversity of expertise for the governance of the Gallery. There are also over 500 members of staff in the Gallery, over half of whom are security and warding staff. Other departments' areas of activity include the care, study, presentation and promotion of the collection, visitor services, educational activities and administration.

Below: Optical microscope with cross-sections of paint samples on screen.

Right: Fragile artworks are moved with care.

Curators

The curator's role is to research, care for and co-ordinate the display of artworks in their specialist area of the collection, supported by colleagues in the library, archive, scientific and conservation departments. The Curatorial Department also creates temporary exhibitions and displays which complement the National Gallery collection and give visitors an opportunity to see masterpieces from around the world.

Study and care

Looking after the pictures so future generations will enjoy them involves ensuring that the Gallery's environment is carefully controlled at the correct levels to preserve the collections. The paintings themselves are regularly monitored by the Gallery's conservators in case treatment is needed to prevent deterioration. New research by National Gallery curators, scientists and conservators is published every year in the *National Gallery Technical Bulletin*, which is available to purchase online or from our shops.

The Scientific Department

Renowned as a centre of excellence for the investigation of Old Master paintings, this department's activity underpins that of the Conservation Department (see box, right). In addition to international collaborative projects, it studies paints, varnishes and conservation materials, and develops research methods and specialist photography of artworks, such as X-rays.

Conservation

The Gallery started an in-house Conservation Department in 1946, which quickly established an excellent reputation that continues today. Over the years, this department has pioneered several new techniques that are now considered standard across the profession.

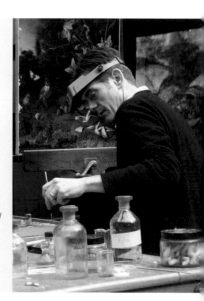

Shopping

A visit to the National Gallery doesn't have to end once you've seen the paintings...

Shopping at the Gallery

Each of the Gallery's three shops offers an individual selection from our huge range of collection-related merchandise. Every purchase helps the National Gallery care for its collection and venue, and supports its work with public programmes and events.

Level 0, Sainsbury Wing

Our largest shop has an extensive bookshop as well as an exclusive range of gifts, postcards, posters and Print on Demand – a facility that allows you to buy reproductions of your favourite Gallery works as posters, prints and gifts.

Level 2, Portico

The shop by the Gallery's main Portico Entrance offers a wide range of guidebooks, postcards, posters and gifts.

Level 0, Main Building

Visit our shop at the street-level Getty Entrance for an interesting selection of books and gifts.

Shops are open daily until 5.45pm or 8.45pm on Friday Lates.

Website information
The Gallery website – **www.nationalgallery.org.uk** – features all kinds of interesting information about the collection, the history of the Gallery and in-depth commentary about individual works of art.

Enjoy National Gallery publications

National Gallery Company publishes a wide selection of beautifully produced publications on both the Gallery's permanent collection and temporary exhibitions, including catalogues, academic titles, guides, gift books and DVDs. Our expanding list aims to encourage the widest possible range of readers to enjoy the collection and to deepen their appreciation and understanding of European painting.

For our latest titles and special offers, visit our online shop and picture library **www.nationalgallery.co.uk/shop**.

The National Gallery in Wartime
This richly illustrated book brings together previously unseen material from the National Gallery's archive.

One Hundred Details from the National Gallery
This magnificent re-issue of the landmark title by Kenneth Clark, still remembered for the famed BBC series, *Civilization*, contains stunning details from his favourite paintings in the National Gallery's collection.

If the Paintings Could Talk
A fascinating miscellany of facts, quotations and tales creates an alternative tour of the great art and artists in the National Gallery. Preface by broadcaster Andrew Marr.

A Closer Look
This series examines in straightforward terms different themes and subjects in painting, such as colour and conservation.

Boris Anrep: The National Gallery Mosaics
A beautifully illustrated book that discusses the history of the mosaics in the Gallery's Entrance Hall – as well as providing a fascinating biography of the artist.

Learn more and support your Gallery

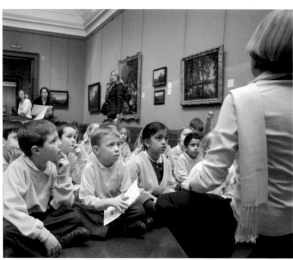

Education

From the outset, the National Gallery has been committed to education. In 1914 the Gallery appointed its first official lecturer, who guided over 11,000 visitors in his first year. By the 1920s a busy programme of daytime, evening and weekend lectures had been established, and in 1944 the first talks for children were introduced. The Education Department was established in 1974 and developed a wide range of activities targeted at school groups. Each year, the Education Department hosts on average about 80,000 schoolchildren at the Gallery. Students have always been admitted to the Gallery to study the collection, and to make copies of the pictures. A vibrant education programme continues today for schoolchildren, students and the general public, including free public talks, tours and workshops.

Free events

There is a daily events calendar on the National Gallery website.

- Guided tours – daily 11.30am and 2.30pm.
- 10-minute talks – quick insight into one painting, Monday–Friday, 4pm.
- After-work talks – 25-minute talks on one painting, every Friday evening at 6pm.
- Lunchtime talks – Tuesday to Saturday each week at 1pm, plus special lectures and films on some Mondays, and practical 'Talk and Draw' sessions every Friday.
- Painting of the Month – range of free talks on one painting.
- Art through Words – session for visitors with a visual impairment, last Saturday of the month, 11.30am.
- British Sign Language – interpreted events every month.
- Family Workshops and Talks – every Sunday with special holiday and half-term workshops. Art Workshops for 5–11s at 11am, repeated 2pm. Magic Carpet Storytelling for Under-5s, 10.30am and 11.30am.
- Belle Shenkman Music Programme – musicians from the Royal College of Music perform a different programme each week (admission free), thanks to generous support from the family of Belle Shenkman.
- Friday Lates, 6–9pm – a chance to relax and meet friends in the Sainsbury Wing foyer. Listen to live music while enjoying a drink from the bar before joining a talk or tour, visiting an exhibition or just viewing your favourite pictures in the collection.

Discovering the collection

• **ArtStart** is the National Gallery's award-winning interactive multimedia system, which allows you to explore the collection for information on every painting in the Gallery via high-quality touch-screens. It is available in the Espresso Bar and Multimedia Room on Level 0 in the East Wing.

• **Additional terminals** are also available in the Sainsbury Wing ArtStart room, the Sainsbury Wing foyer and on the link bridge that connects to Room 9.

• **Children's trails** are available from the information desks and can be collected when you visit.

• Portable **audio guides** with commentaries on more than 1,000 paintings in the collection are available. There is also a choice of themed tours, and an audio tour of the thirty highlights of the collection in Chinese, Dutch, English, French, German, Italian, Japanese, Korean, Polish, Portuguese, Russian and Spanish. Audio Guide Desks are located at the Portico Entrance and in the Sainsbury Wing.

• **The Sainsbury Wing bookshop** will help you discover a wide selection of publications on the Gallery's collection and temporary exhibitions, from catalogues, academic titles and illustrated guides to gift books and DVDs. See p. 107 for more information on the Gallery's other shops.

• **Adult group visits**: the Gallery's collection is a great resource for adult learners, and we have a team of skilled guides and facilitators who create interactive sessions to help your group to use paintings as a starting point for whatever activities you have in mind.

The Gallery and the regions

The National Gallery's aim is to encourage the public throughout the United Kingdom – and beyond – to value and enjoy its pictures. The Gallery regularly works with partners in museums around the country to support the increasing role the pictures play at all levels of public education, lifelong learning and enjoyment.

Support your gallery

There are so many ways the public can support the National Gallery and care of its collections: every purchase in our shops or refreshing break in our award-winning cafés contribute to the Gallery and its aims. Donations, legacies and corporate sponsorship are also extremely important to the running of the National Gallery. For more information, please see 'Support the Gallery', at www.nationalgallery.org.uk, and see p. 104.

Glossary

Allegory An image that represents an abstract quality or idea through a series of symbols or figures given symbolic meaning.

Baroque (From *barrocco*, Portuguese for 'irregular pearl'.) Initially a negative term to describe excessive ornamentation or complexity of line but later used to praise the highly theatrical artistic style popular throughout Europe during the seventeenth century, characterised by dramatic lighting and movement (see p. 26).

Cartoon (From *cartone*, meaning 'strong, heavy paper' or 'pasteboard' in Italian.) A full-size preparatory drawing made as a study or model for a painting, stained glass or tapestry. Frequently used to prepare frescos, cartoons often have pinpricks along the outlines of the design, through which chalk or charcoal was pressed, transferring the design to the surface to be painted.

Donor The patron of paintings. In Renaissance painting, a portrait of the donor was often included in the altarpiece they paid for, usually kneeling in veneration before the saints and the Virgin and Child.

En plein-air (French, meaning 'in the open-air'.) Initially, the term described quickly painted oil sketches, executed out of doors, which were taken back to the studio and used as models for the final painting. Later, *en plein-air* paintings were recognised or executed as finished artworks in their own right.

Façade A French word literally meaning 'frontage' or 'face'; generally describes one side of the exterior of a building, especially the front, but also sometimes the sides and rear.

Flanders The County of Flanders was a historical region in the Netherlands or Low Countries. Under French rule by the late twelfth century, then ruled by the dukes of Burgundy in the fourteenth century. In the late fifteenth century, Flanders became part of the Habsburg dynasty, and by 1556 came under the rule of the kings of Spain. Today, the historic county of Flanders is territorially divided up between France, Belgium and the Netherlands.

Flemish Describes artists working in the southern Netherlands or Low Countries after the Union of Utrecht in 1579, which united the northern provinces to form the Netherlands. Artists working in the northern Netherlands are generally referred to as 'Dutch'.

Fresco (From *affresco*, Italian for 'fresh'.) A wall painting technique, where pigment is applied directly to freshly laid plaster. As the plaster dries, the pigment bonds to the surface. A famous example of fresco is the ceiling of the Sistine Chapel (1508–12, St Peter's, Rome) by Michelangelo.

Frieze A band of either sculpted or painted decoration. Also refers to part of an architectural structure of mouldings and bands that lie horizontally above columns and below the cornice (a horizontal decorative ledge).

Gesso The Italian word for 'gypsum' or plaster of Paris, gesso consists of a white preparation of glue and burned gypsum. It was used as a ground to prepare a surface, for example a wooden panel, for painting.

Glaze A layer of paint, thinned with a medium (such as oil), so that it becomes translucent. A glaze can change the colour, cast or texture (gloss or matte) of the painted surface.

Grand Manner An idealised style derived from classical and Renaissance art taught in the academies throughout Europe from the seventeenth century onwards. In the eighteenth century, British connoisseurs used the term to describe paintings that incorporated these classical or ennobling qualities.

Grisaille (From *gris*, French for 'grey'.) Describes painting executed entirely in monochrome, usually in shades of grey or brown, particularly used in decoration to represent objects in relief.

Ground The preparatory layers of a painting used to prime surfaces such as canvas or wood for painting. Oil with white pigment is used for canvas, an oil ground or *gesso* is used for board or panel.

Impressionists Loosely associated group of artists working in and around Paris in the late nineteenth century. Characteristics include visible brushstrokes of bright colours, emphasis on light in its changing qualities and contemporary subjects. These works were mostly small-scale canvases, mainly painted outside (*en plein-air*).

Lake A lake pigment is produced by developing a dye with a binder, usually a metallic salt. Many lake pigments are susceptible to fading as the dyes involved are unstable when exposed to light.

Mannerism A term derived from the Italian *maniera*, meaning 'style' or 'manner'. An elegant, courtly and artificial (as opposed to naturalistic) artistic style developed around 1520–1600, particularly in Italy and Flanders. Stylistically, Mannerism was a reaction to the harmonious ideals and restrained naturalism of the High Renaissance.

Medium A term used to define the material with which a picture is painted, usually the binder in which colour is combined, such as oil or egg.

Memento mori (Latin for 'Remember that you are mortal' or 'Remember you will die'.) These are symbols or objects in paintings which remind the viewer of his or her own mortality, including allegorical symbols such as skulls, timepieces or wilting flowers.

Neoclassicism Describes a distinct movement, evident in all of the various arts, originating in the mid-eighteenth-century revival of interest in the art of ancient Greece and Rome, resulting in paintings of historical objects using smooth, severe forms that emulated antique sculpture.

Old Master A term applied to the great painters from the Renaissance period through to the eighteenth century.

Perspective The technique of drawing three-dimensional objects on a two-dimensional surface, giving these items accurate scale, distance and solidity. Mathematically-based perspective was developed during the Italian Renaissance by Filippo Brunelleschi (1377–1446).